La...

Writte... ...w
for Art... ...nd
their v... ...ng
fine a... ...n-
makin... .
As... ...ns
the le... ...of
expres... ...ge
of dis... ...an
engagi... ...th
the la... ...rs.
The a... ...ts,
bringi...
Wh... ...le
inforn... ...is
also d... ...es,
ensuri... ...ey
need t... ...al
resour... ...a
list of...

Law for Artists is an invaluable resource to professional practitioners and art graduates, as well as the academics who instruct them. This insightful publication, the first of its kind, helps introduce artists to the professional practice skills needed to ensure they are well-equipped to deal with working life.

Blu Tirohl is the editor-in-chief of the *Journal of Gender Studies*, lecturing in law for artists, photography, art, gender studies and research methods. She is a panel member on employment tribunals (UK Ministry of Justice).

Law for Artists

Copyright, the obscene and
all the things in between

Blu Tirohl

Routledge
Taylor & Francis Group

LONDON AND NEW YORK

First published 2015
by Routledge
2 Park Square, Milton Park, Abingdon, Oxon, OX14 4RN

and by Routledge
711 Third Avenue, New York, NY 10017

Routledge is an imprint of the Taylor & Francis Group, an informa business

British Library Cataloguing in Publication Data
A catalogue record for this book is available from the British Library

Library of Congress Cataloging in Publication Data
Tirohl, Blu, author.
Law for artists : copyright, the obscene and all the things in between / by Blu Tirohl.
 p. cm.
Includes bibliographical references and index.
1. Law and art – Great Britain. 2. Artists – Legal status, laws, etc. – Great Britain. 3. Copyright – Art – Great Britain. 4. Law and art. 5. Artists – Legal status, laws, etc. I. Title.
KD3720.T57 2014
344.41´097–dc23 2014022479

ISBN: 978-0-415-70253-9 (hbk)
ISBN: 978-0-415-70254-6 (pbk)
ISBN: 978-1-315-74210-6 (ebk)

Typeset in Bembo
by HWA Text and Data Management, London

Printed and bound in Great Britain by
TJ International Ltd, Padstow, Cornwall

To my parents and nieces and nephews:
Sara, Sam, Aria and Kosmo
(in order of age, not preference)

Contents

Preface

When I studied for an arts degree, commercial responsiveness was largely absent from the curricula and no-one had even heard of 'professional practice' studies. This meant that I left university with little knowledge of, for example, finance as a sole trader, how to contract and deal with commissions, and how to protect my work in a legal sense. When I began teaching in the arts, I was aware that not much had changed and, along with other academics at the time, tried to introduce these skills into arts education. It was an uphill struggle; we were constantly told that those skills were not academic enough and there was 'no room' on the curriculum. We were also aware that because our own education was lacking in this regard, we had to discover for ourselves other areas of subject knowledge. This lack of subject knowledge had led my undergraduate tutors to avoid the subject or to perpetuate unsubstantiated rumours. A particular rumour from fashion degrees at the time (still in existence today) is that if you change seven things on a garment you cannot be sued for appropriating someone else's *intellectual property* (see Chapter 1). I have also been told that 'it is illegal to photograph a police officer'; one of course has to be cautious around the police, given the powers the state grants them, but this is also not what the law says (see Chapter 4).

Once I had begun crow-barring lectures on intellectual property, freedom of speech and obscenity, on a piecemeal basis, into arts and media curricula, I decided to fill the many voids of my own ignorance and took a conversion degree in law and studied finance (this probably seems a little extreme). Whenever I wrote modules or degrees subsequent to that, I made room for these, sometimes dull, but necessary subjects. As I did so I was called upon to teach these subjects into other degree programmes in the arts and media and was constantly asked 'is there a book on this subject?'. There are many high quality texts in individual areas of study but none that bring the whole subject of law as it might affect artists into one book. Happily now, arts education is changing and the broader needs of students, who pay high fees for their courses, are starting to be recognised. There is still resistance from those tutors who prefer the safety of their subject-specific, critical skills which position the tutor as the oracle. Those tutors will not recommend this book.

What this book does not cover

When developing and researching this book, I quickly became aware that I had to separate *Law for Artists* from *Law for Broadcast*. This means that the rights and responsibilities of commercial film-makers, music producers, TV and radio producers and computer programmers, while referred to, are not detailed. There are books of use to students of these subjects already. This book would be twice as long had I attempted to include a comprehensive overview of *Law for Broadcast* and would have contained a lot of information of little use to artists; probably deterring them from reading it. So I have drawn a loose line between these two subjects. Some readers will find this line rather arbitrary and certainly there is information here of use to those from outside the primary readership.

Nor do I define the term 'artist'; art is practised, performed, created and disseminated through a range of media (traditional and digital). This book attempts, through the examples chosen, to anticipate the range of challenges arising in different media and the interdisciplinary nature of most creative practitioners.

Also missing from this text will be lengthy discussion on how laws should be changed; there are many solid debates about authorship and ownership, *creative commons*, cultural piracy, trespass, graffiti and the knowledge economy. Where there is a clash between postmodernity, as artists understand the term, and the law, in which postmodernity is not recognised, I will alert the reader to this but also recognise that these tensions represent the boundaries around which some of the best-known art has been, and still is, generated. The law creates particular problems both in the UK and the US for parody, and humour is seldom less humorous when it has to be explained to a lawyer.

Disclaimer

This book examines mainly English and European law as it applies to various types of artists. This information is not advice, and should not be treated as such. Every attempt has been made to ensure that, as far as is practicable, the information is true, accurate and as up-to-date as it can be at the time of going to press. You must not rely on this book as an alternative to legal advice; if you have a particular legal issue arising, or ongoing, you must seek professional advice without delay.

Acknowledgements

I must thank Jim T. and Shawn; colleagues, with whom it has always been inspiring to work and who helped such a lot with this project. I am indebted to Liz, Chris, John U., Mary, my sister and Paolo for accommodating me during various parts of the research and writing process. I am grateful to the British Library and its staff (who support and assist researchers so fantastically) and Lancaster University Library (with its rare facility of access for non-members). I also thank Sav who, while often a pesky nuisance, has always given me much to think about when it comes to the law and art. I also thank the publishers for their time in this project.

The author and the publishers would like to thank the following for permission to reproduce copyright material:

- All illustrations (produced especially for this book) © Chris Stephens
- *Be nothing* © Savage, 2007
- The bottom of Park Street, Bristol © Banksy, Bristol, 2006. Photo credit: Shawn Sobers.

Abbreviations

AC	Appeal Cases Reports
ACID	Anti-Copying in Design Association
ALCS	Authors' Licensing and Collecting Society
All ER	All England Law Reports
BBFC	British Board of Film Classification
CA	Court of Appeal
CDPA	Copyright, Designs and Patents Act 1988
CDR	Community Design Regulations/Regulations on Community Designs
Civ	Civil (case)
CJEU	Court of Justice of the European Union/European Court of Justice
CLA	Copyright Licensing Agency
Cr App R	Criminal Appeal Reports
Crim	Criminal (case)
Crim LR	Criminal Law Review
CTMR	Community Trade Mark Regulations
DACS	Design and Artists Copyright Society
DPA	Data Protection Act 1998
DPP	Director of Public Prosecutions
ECHR	European Convention on Human Rights
EPC	European Patent Convention (1973, 2000)
EPO	European Patent Office
EWCA	England and Wales Court of Appeal (electronic reports)
EWHC	England and Wales High Court (electronic reports)
IP	Intellectual Property
KB	King's Bench
LDMA	literary, dramatic, musical, artistic
MPAA	Motion Picture Association of America
OHIM	Office for Harmonization of the Internal Market
QB	(Reports of the) Queen's Bench
PACE	Police and Criminal Evidence Act 1984
RDA	Registered Designs Act 1949

RIPA	Regulation of Investigatory Powers Act 2000
SI	Statutory Instrument
TMA	Trade Marks Act 1994
TRIPS	Trade-Related Aspects of Intellectual Property Rights 1995
WIPO	World Intellectual Property Organization
WTO	World Trade Organization

Introduction

It would not be unfair to say that Richard Driscoll's 2012 film, *Eldorado*, received some rather damning reviews despite a well-known cast. Chris Bell describes the film as 'so terrible its director was jailed' (Bell 2014: 8). After being found guilty of tax fraud, Driscoll was sentenced to three years imprisonment at Southwark Crown Court in June 2013.[1] He was also banned from being a director for seven years, to which film writer M.J. Simpson quips: 'Some people were disappointed to learn this meant a company director – not a film director' (Bell 2014: 11).

The aims of this book

This book aims to address a gap in book provision for artists, art students and art lecturers by bringing together information which is normally found in a wide range of legal textbooks (aimed at law students and lawyers), and explain it in a way which demonstrates its applicability to the creators of artistic works in the UK and Europe. Legal rules and creative practice often sit at odds with one another, as Wade remarks: 'The former seeks to impose order on chaos, while the latter is predicated on it' (2008: 1).

There are some sound books dealing with the individual topics discussed in this book but the objective here was to bring these together in one place. There are some excellent textbooks from the US in this field but North American law and English law, though similar, are distinct, so such books are of more academic interest to UK and European practitioners. This book hopes to better equip artists to engage with aspects of the world which will at some point impact on how they do their work; namely the range of law that can impact on creative practice. While the focus is on UK law, practitioners will also be given sufficient information to understand how European law affects them and how English law contrasts with US law. Consequently, examples will be drawn from the UK, Europe and the US, as well as occasionally from other legal jurisdictions.

With this in mind, this chapter sets out to alert the reader to the language and ideas that are necessarily used throughout the book. I believe that it is the least interesting area for the reader and if you understand the basics of the UK and European political and legal systems you may want to dive into the chapter that most addresses why you picked up this book in the first place.

Using this book

In contrast with books aimed at law students, this book does not require you to understand or recognise the terms it uses. I have therefore included, as well as a glossary of abbreviations, an explanation of the key terms that appear. This means that this book uses those terms that law students and lawyers are expected to know but hopefully in a way that makes the book accessible to lay-users. When such terms appear for the first time in a chapter they will appear in italics so that the reader knows that they can be found in the glossary. Also in italics will be all terms in Latin (which also appear in the glossary), since phrases in Latin persist in English law.

There are some references used here that a reader will come across when a legal principle, or 'the law', is stated. The first is the *Act*, *Statutory Instrument*, Regulation or Directive that determines the law. Statute law is often abbreviated here with its date, but the relevant section numbers appear in endnotes. The second type of references you will see are the names of particular cases where a statute was interpreted in a way which sets a *precedent* in that particular field of law. Since this textbook is not aimed at law students, the names of parties and the date is given for each case and the other supplementary information about the case appears in the endnotes. The use of *v* in cases means 'against' or 'versus' but is pronounced as 'and' by lawyers; the law makes use of such tricks to identify its outsiders.

Legal systems

Legal systems are, at their simplest, rules which define the rights of (and impose duties on) individuals and 'legal bodies' (such as corporations). Such a system is first determined by those in power (nowadays the rules are often set out in writing) and then enforced (ultimately by physical coercion if necessary but usually by some lesser sanction). When looking at any particular law we might want to know to whom it gives a right and on whom it imposes a duty. Ultimately though it is what the law actually does with the facts in question that will determine the effect of a piece of law. We must immediately distinguish pure facts from legal facts; these are not the same. Even if we ignore the predisposition of many to simply perjure themselves, 'pure' facts seldom emerge in the courts.[2] So when encountering reports of court judgements, a reader will see phrases like 'the following facts were found', and these 'facts' may well be remote from the actual circumstances that led to the court case.

The source of English law

There is no founding written document underpinning English law; it is one of only a tiny number of legal systems that has no written constitution. Documents exist historically of course, such as the Magna Carta, but none of these comes anywhere close to a citizen of England or Wales being able to boast of their

'constitutional rights' (one of the few residual provisions of the Magna Carta which is of relevance today is 'To no one will we sell, to no one deny or delay right or justice'). The Bill of Rights (1689) conferred *parliamentary supremacy* (over the monarch) but the monarch still, through convention, has many prerogatives; she cannot be tried or called to give evidence, she can declare war, she can dismiss ministers and dissolve Parliament, she can refuse to give assent to an Act of Parliament, she can give pardons (through the Home Office), and these are just a few of her powers. The *Crown*, however, cannot create a new criminal offence without the say-so of Parliament (Case of Proclamations 1611).

The English legal and political system is made of a *judiciary* (judges, juries, magistrates and so on, whose role it is to declare and interpret law and find facts); a *legislature* (the *House of Lords* and *House of Commons*); and the *executive* (the government in power; here made up of the Prime Minister, the Cabinet and the Civil Service). This tri-partite structure is not atypical of many power systems around the world, and hypothetically these bodies should operate independently from one another, though in reality powers overlap. For example, the Queen has a function in Parliament, the Government and the Royal Courts of Justice; she appoints the Prime Minister, invites her to form a government and has the power to dissolve Parliament. The Prime Minister takes on a function in both the legislature and the executive (controlling the legislative programme and setting the agenda for Cabinet) and also appoints senior judges. Of the multiplicity of tasks and skills required of a Prime Minister, Hennessy (2000) once remarked that human beings do not come like that. This being so, it is surprising how many souls have had the self-belief to offer themselves to the role.

There are many examples of clashes between the executive, judiciary and legislature. In M v Home Office[3] (1994), M was deported to Zaire having failed in his asylum application but subsequent to an apparent undertaking by *counsel* for the Home Office that he would not be. M was not returned to the UK, in breach of a court order. The Secretary of State for the Home Office (then, Kenneth Baker) was held to have acted in *contempt* since the Home Office had formed the view that the courts did not have jurisdiction over 'a minister of the crown'. On appeal, the House of Lords (now called the Supreme Court) held that while immunity from such *injunctions* applies to the Crown,[4] it did not apply to ministers exercising power on behalf of the Crown. Lord Templeman pointed out in observations made for the written judgement that the alternative was that 'the executive obey the law as a matter of grace and not as a matter of necessity'.[5] Responsibility for the decisions of the Home Office rests with the Minister, whether or not the Minister in question drove the decision; however, in this case the Secretary of State for Home Affairs, rather than Baker personally, was held to be in contempt, reversing the lower courts' decisions. In law, reporting this story would be told in more accurate legal detail but would end here and the reader would never learn what happened to M. The separation of law as a subject from the human interest that pays for it is not always helpful so I will finish the history by stating that M disappeared among rumours of his torture and execution.

Since members of the executive cannot make up law as they go along, it makes sense that the judiciary should not be permitted to do so. However, in Shaw v DPP,[6] Shaw, who had created a directory of prostitutes, had been convicted of a variety of offences including 'conspiracy to corrupt public morals' which was not a statutory offence. On appeal, the House of Lords held (by majority) that the Courts had the right to act in the interests of protecting the 'moral welfare of the state' from acts which are 'novel and unprepared for', and could therefore create a new offence. It is worth noting the rational approach taken by the minority in this case (Lord Reid) that if this vestigial power existed it should not be used now, furthering that Parliament was 'the only proper place' for such matters to be settled, and adding that 'where Parliament fears to tread it is not for the courts to rush in'.[7] Subsequently, the House of Lords has circumvented the principle set out by the majority in Shaw v DPP.[8] In addition, while the judiciary is 'independent', it may not question the validity of an Act of Parliament, only interpret it. In Pickin v British Railways,[9] a case involving two apparently contradictory statutes, the latter in time extinguishing rights given by the former, the court ruled that the rights lost were a matter for Parliament and not for the court. This was the case no matter how the law had come into effect, and even if parliamentary procedure had been violated in introducing a law.

It is now more problematic for a UK government to create retrospective legislation which involves making something illegal (or legal) that was previously legal (or illegal), and applying the new law to something done before the law changed. Such *ex post facto* law, in the case of criminal law, is contrary to the European Convention of Human Rights 1950 (Article 7) which was only transposed directly into British law via the Human Rights Act in 1998. In Burmah Oil v Lord Advocate,[10] where British troops had destroyed property to prevent enemy capture during World War Two, Burmah Oil successfully sued the government for recovery of compensation (as it was permitted to do where private interests had been damaged through lawful war-time action). Almost immediately Parliament passed the War Damages Act 1965 which retrospectively exempted the government from liability in the circumstances given. In the US retrospective, legal changes are specifically forbidden via its constitution;[11] this is the case in many states around the world with a written constitution such as Russia, Canada, Ireland and throughout Scandinavia and Europe. German law[12] succinctly describes the idea as not making something punishable if it was not punishable at the time it was done.

Under the English legal system, many parties have degrees of immunity not afforded to the average citizen; the Queen has diplomatic immunity and Members of Parliament enjoy *parliamentary privilege* under the Bill of Rights meaning that action cannot be taken against them for slander or contempt of court in relation to statements made in the course of parliamentary activity (see Chapter 3). This currently applies in *Westminster* but not all the devolved institutions of Scotland and Wales. Parliamentary privilege is not without its critics since it is open to abuse. With this privilege comes a convention that members of the Houses of Commons and Lords cannot use certain words and

phrases that imply another member of the house is lying (they are also not permitted to clap). Words that have shown themselves to be inappropriate for use in the Houses of Parliament include blackguard, coward, hypocrite, idiot, rat, swine and wart. Members have been suspended for using them. The press, on the other hand, may use these terms to describe members of the legislature, if it can be shown on balance that such a term has been fairly used (see Chapter 3).

Describing the privileges that various members of the legislature, executive and judiciary enjoy does not even begin to recognise the practical differences that those with considerable wealth, and the power that accompanies money, experience under the law. Even today ethnic minority citizens (particularly young males) have a greater chance of enjoying a random police search, as well as experiencing arrest, prosecution and prison[13] (Bowling and Phillips 2003).

A written constitution has obvious advantages; it regulates the relationships between the organs of authority and their powers, and also defines the relationship between the state and the individual. It does all this clearly and directly. In the absence of a written constitution, it is very difficult to find in any real sense the actual rights of citizens, and consequently the absence of a written constitution can result in a failure to safeguard citizens fairly. In the case of Derek Bentley,[14] there was a review of the Home Secretary's decision to refuse a pardon to Bentley. This came several decades after the execution of Bentley and reminds of us of the pointlessness of long-winded, legal processes to the individual. The possibility of error has been one of the most compelling arguments for not re-introducing capital punishment across Europe (Bentley was given a full pardon in 1998, 46 years after his death).

An unwritten constitution is indeterminate, diffused through the often peculiar traditions, customs and practices of the state in question, and indistinct from ordinary law (rather than supreme to it as is the case with a written constitution) but it is infinitely flexible and no one government can bind a subsequent government; this is referred to as *Parliamentary Supremacy*. The possible exception to Parliamentary Supremacy (sometimes referred to as *sovereignty*) under English law is the European Communities Act 1972, which gave supremacy to European law on matters regulated by the Community. Once the UK had enacted the European Communities Act 1972, it was under an obligation to ensure that its own laws were compliant with the laws, directives and regulations of, what was then, the European Community. Where English law is not in accordance with European legislation, the latter has force.[15] The courts are permitted, in certain circumstances, to seek guidance from the *Court of Justice of the European Union* (Luxembourg) on matters of European law.

Though there is common ground, the Scottish and Northern Ireland legal systems operate differently from that in England and Wales; here you will see the latter referred to as 'English law' (and I apologise to Welsh readers for this). The Acts of Union 1707 and 1800 created the Kingdom of Great Britain and Ireland but recognised the different legal systems in place throughout it. Where Scottish law or Northern Ireland law is significantly different from English law,

this will be signalled in this book. The Republic of Ireland separated from the UK in 1922 through partition (part of the North retaining its status as part of the UK). The Channel Islands are *Crown Dependencies* (the Queen being referred to as the Duke of Normandy) but not part of the UK or the European Union; they have their own legal systems which are a cross of English and Norman law (you will see the term *Bailiwick* to describe the areas that Channel Islands laws cover).

English law also operates in other legal jurisdictions, particular those from the former British Empire, and has been important in the development of a significant number of legal systems throughout the world. As a consequence, the reader will see cases referred to from other jurisdictions, not because they set precedents in the UK but because they raise debate which may influence how the law develops.

Categories of law

Academics talk of *public law* (disputes with the Crown via a government department) and private law, both involving *civil* action with its focus on compensation rather than punishment. Civil cases involve an aggrieved party; the *claimant* (previously referred to in English law as the *plaintiff*) taking legal action against another; the *defendant* or *respondent*. The burden of proof required for a party to succeed in a civil case is the *balance of probabilities* (more likely than not). Much of this book deals with civil law; cases are identified by the names of the claimant and defendant separated by a *v* followed by the year. In addition to civil cases, however, you will see reference to criminal law. There are crimes *codified* by statute in English law (though some exist in *common law*). When a crime is committed, the police (or other authorised bodies) investigate and collect evidence, make recommendations to the Crown Prosecution Service (or equivalent body), who, if a case against an individual is compelling enough, take action on behalf of the Crown to pursue it through the Director of Public Prosecutions. The burden of proof in a criminal case is *beyond reasonable doubt* which is a higher threshold than that required for civil cases. Criminal cases appear as R v Accused Party and the year (R meaning *Regina* – the current monarch being female; *Rex* is used in cases determined during the reign of a king).

As well as public and private law, academics also refer to *statutory* and *case law*. For a statute to be introduced as law, a bill must go from the government to the House of Commons which, after its formal first reading, a full debate on its second reading and any agreed amendments on a third reading might, if it is not rejected by majority vote, pass it for scrutiny by the House of Lords who may pass it or turn it back. The House of Commons is elected while the House of Lords is not. If the House of Lords repeatedly refuses to pass a bill then the Parliament Act 1911 gives power to the government to force a bill through in the next parliamentary session.[16] If the House of Lords passes a bill, it will become law on signature of the monarch. The verbose wording of many acts illustrates the tensions between including those eventualities intended to be covered by a new law, and ensuring that the law is specific enough to exclude

situations not intended to be covered by it (but which a lawyer might exploit for the benefit of a client).

The other type of law you will see referred to, in contrast to statutory law, is *case law*. The English legal system has a structured hierarchy of courts which historically participated in the development of new law. When a senior court rules about the decision of a lower court as to how a law should be interpreted, this is said to set a *precedent* which binds the courts beneath it. The superior courts are not bound by the decisions of inferior courts and must rely on statute and previous cases to interpret how the law applies. The rules of *statutory interpretation* are referred to as the *canons of construction* in some academic textbooks; do not let this mislead you into thinking they are hard and fast and written down somewhere. The courts might look at the literal or ordinary meaning of the wording of a statute or take an approach which avoids an absurdity in law, if the wording of the statute is ambiguous (the *golden rule*). Another rule for statutory interpretation was determined in Heydon's Case[17] which is referred to as the *Mischief Rule*; it examines what the law was before the statute, what 'wrong-doing' the statute was intended to defeat and the remedy invented to cure this. Ultimately, the rules of statutory interpretation are to determine the presumed intention of Parliament.[18]

You will also see reference to *common law* and *equity* in this book. Common law refers to the legal principles that came out of the courts' decisions. Equity developed alongside common law in the fifteenth century through parties petitioning the monarch directly. These petitions were subsequently delegated to the Lord Chancellor, leading to the creation of the Court of Chancery which now controls such areas as *trust law*, land, property and some commercial work. Equity was seen to supplement common law rules when these were viewed as defective in some way, so parties could pursue a case through the common law courts and, if no remedy was available, they would take it 'to equity'. The Judicature Acts 1873–1875 reformed this two-stream system and the common law courts and the courts of chancery merged. This did not mean, however, that all common law and equitable law rules merged. There are some areas of law covered in this book which emerge from equity rather than statute; this makes following the logic of some precedents a rather frustrating task.

The structure of the courts

The court structure in the UK is complicated and explained here only to the extent that enables the reader to understand the description of cases that appear in subsequent chapters. *Courts of first instance* or courts of original jurisdiction include the County Courts, the tribunals and the Magistrates' Courts. The County Court deals in general with civil cases (as do the tribunals which were set up as an alternative to the civil courts) such as breach of contract, *tort*, debts, personal injury, consumer law, bankruptcy, undefended divorces, small claims and some family law. The focus of the Magistrates' Court is on criminal law hearing over 95 per cent of criminal cases. Criminal cases are divided into:

offences triable only by indictment (those cases that can only be heard by a judge and jury in the Crown Court such as grievous bodily harm, aggravated burglary, murder and rape); *summary offences* (which can be dealt with by a Magistrates' Court without a jury such as road traffic offences); and *offences triable either way* (which can be dealt with by either a Magistrates' Court or the Crown Court such as less serious assaults and criminal damage).[19] The County Court and the Magistrates' court are the lowest layer of the court structure.

Above the Magistrates, the Crown Court can hear questions of fact or law against either sentence or conviction from the Magistrates. Following a trial on indictment (Crown Court), the route of appeal is to the Court of Appeal (Criminal Division) if either the Court of Appeal or the trial judge give 'leave to appeal' to the defendant.[20] If the prosecution wishes to appeal, it may ask for a referral by the Attorney General on a point of law following an acquittal (though the acquittal itself will be unaffected).[21] If there are allegations of jury intimidation then the prosecution may appeal a jury's findings.[22] Under these circumstances, if the acquittal is *quashed* then a new case will begin.

The High Court of Justice is a more superior court than those so far discussed (though not superior to the Court of Appeal). Some cases go straight to the High Court but it also hears appeals from the County Court (it therefore has both *original* and *appellate* jurisdiction). It hears mainly civil cases. The High Court is sub-divided into several categories and divisions (including Family, Administrative [Judicial Review], Chancery [Land and Property] and the Queen's Bench). Above this are those courts with solely appellate jurisdiction. The first is the Court of Appeal (based in London) which is divided into the Criminal Division and the Civil Division. The Court of Appeal is normally bound by its own decisions and binds the courts beneath it. There are some exceptions to the self-binding rule such as when the Court of Appeal's rulings conflict with a later Supreme Court ruling, or where it has made a decision *per incuriam* (through lack of care such as ignorance of a statute or ignorance of the existence of other binding precedent). The Criminal Division of the Court of Appeal hears appeals from the Crown Court. It might also hear referral cases from the Attorney General (such as those involving a lenient sentence, or where there has been an acquittal but some clarification of the law is sought[23]). The Civil Division of the Court of Appeal hears appeals from the High Court, the appeals tribunals and certain types of County Court decisions.

The final court of appeal under the control of English law is the Supreme Court. This was, until recently, confusingly called the House of Lords, though it is not the same body as the House of Lords that passes or rejects parliamentary bills. The Supreme Court hears appeals for both civil and criminal law for England, Wales and Northern Ireland from the Court of Appeal. It also hears appeals from Scotland. Most appeals in the UK stop at the Supreme Court. The Court of Appeal and the Supreme Court do not hear evidence or witnesses. They primarily hear legal argument from counsel (barristers); the recent steps to televise the work of the appeal courts will leave those expecting revelations and high drama disappointed. The determinations made by these courts are

known as speeches or opinion, and each judge can give a separate speech but it is from a majority 'vote' that the final decision is made. Until 1966, the House of Lords (now the Supreme Court) was bound by its own decisions but this is no longer the case[24] and where there are issues of public policy or the principal of justice is at stake, it may overturn its previous precedents, but not statutory law.

Occasionally you will see reference to the term *judicial review*; this is the process by which a court can scrutinize a *public body* to ascertain whether they have acted within or outside of the legal powers conferred upon them. A judicial review checks the legality of the decision-making process, whether the decision was outside the powers of the body making it, whether the decision was irrational/unreasonable or whether there was procedural impropriety.[25]

Judges within the English legal system are referred to in certain ways. Since the court formerly known as the House of Lords changed its name to the Supreme Court (1 October 2009), the judges are called Justices of the Supreme Court (instead of the *Law Lords*). The name of a judge working at Supreme Court level is pre-fixed by Lady or Lord though, of the twelve justices, only one is female: Lady Hale. The Justices of the Supreme Court sit in groups of at least five (the minimum being three). The Court of Appeal is made up of the Lord Chancellor, the Lord Chief Justice, the Master of the Rolls (President), the President of the Family Division of the High Court, the Vice President of the Chancery Division, some Justices of the Supreme court and senior judges (referred to collectively as the Lords Justices of Appeal). High Court Judges (made up often of members of the Court of Appeal and the Supreme Court) are more senior than the *Circuit Judges, Recorders* and District Judges (who sit in County and Crown Courts). The Crown Courts make use of judges and juries (though not in every criminal case). The Magistrates' Courts throughout England and Wales are staffed by Lay Magistrates (Justices of the Peace), Stipendiary Magistrates, qualified staff that are now referred to as District Judges (Magistrates' Court) and Justices' Clerks (qualified staff who advise each bench of magistrates).

The European Courts

In 1973, the UK became a member of the European Economic Community (as it was then called) through the European Communities Act 1972. Certain types of case, if relevant to European law, can be referred from the Supreme Court to the Court of Justice of the European Community (CJEU) in Luxembourg. The CJEU is a court of reference, not appeal. The CJEU personnel include one judge from each member state of the European Community, a president of the court and a number of 'advocates general' (who advise on issues of fact and issues of law). The primary aims of the CJEU are to ensure that member states fulfil their treaty obligations, to decide on disputes between member states relating to treaty obligations, to ensure that community institutions act lawfully and to make authoritative rulings on the interpretation of European Community law. The English courts are bound by CJEU decisions under the European Communities Act 1972.[26]

The Council of Europe established the European Convention on Human Rights and Fundamental Freedoms in 1949 (before it established the European Union in 1957). Where there is a question relating to the European Convention on Human Rights, an appeal can be made to the European Court of Human Rights based in Strasbourg (not to be confused with the CJEU). In 1998, the UK government introduced the Human Rights Act 1998 which obliges Parliament to make law that is compatible with the Convention,[27] and obliges a court to ensure compatibility of English law with convention rights unless it is prevented from doing so by legislation (in which case it can make a declaration of incompatibility[28]). Courts operating in the UK must take Strasbourg case law into account in their decision-making process.[29]

Civil law systems

The English legal system has been influential throughout the world; it sets up party against party in an adversarial way. This has led to some of the more unfortunate stereotypes seen in the media of swaggering, arrogant, aggressive and tricksy lawyers. Most judges and lawyers are not like this but the stereotype based on a dwindling minority makes for more dramatic cinema and television. Not all legal systems rely on the adversarial, common law principles however. The most common of the other types of legal system is the *civil law* system. For those of you with good retention of information, you will be alert to the term 'civil' appearing in two different contexts, with two different meanings. Above, I contrasted civil law with criminal law. In this section the term 'civil' is being used to describe a specific type of legal system operating outside of the UK. The English legal system has more in common with the law of the US, Canada, South Africa, Australia and New Zealand than it does with nearer geographical and political neighbours. Civil law systems are common in much of Europe,

Russia, Latin America, large parts of Africa and Scandinavia. These systems of law have their origins in Roman law and rely on the codification of legal rules. In these systems judicial precedent (as discussed above) is not the key operating principle since case law is subordinate, in such a system, to statutory law. Civil law requires a more inquisitorial approach from its lawyers, judges and juries, rather than the adversarial approach common to English legal systems. In some civil law systems, often referred to as 'hybrid' systems, case law does play a role; a key example of this for this text is Scotland. The Supreme Court in England still hears final appeals originating from Scotland.

Chapter abstracts

Chapter 1, *Art as intellectual property*, describes the key categories of copyright, design rights, trademarks and patents. The section on copyright will explain how it arises and what benefits are attached to it, followed by an explanation of the kind of activities that constitute infringement, what defences can be used and what remedies are available to the injured party. Copyright will be of particular interest to film-makers, photographers, graphic designers, animators, illustrators and fine artists, but it also underpins some of the principles of design rights so there will be few readers who will not benefit from understanding copyright. The section on design rights will be of particular interest to fashion, textile, graphic and product designers, though much of copyright law will also apply. It is acknowledged that the reality of the fashion industry frequently puts it at odds with the law as described here. Commercial practice is based on transitory trends which filter from high-end fashion to high-street fashion (and back again) and this means that the law has created some particular frustrations in this field. Design law will be divided into registered, unregistered, European and English design rights along with a section on the problems of copyright in this field. By virtue of these five categories, this area of law is complex. There are short sections explaining trademarks and patents; the comparative brevity of these sections reflects the lack of immediate need in early career artists for these types of protection but seeks to identify when an artist might decide the point at which they will become useful. Some applicable criminal law in the field of intellectual property will also be examined.

Chapter 2, *The obscene and the unseen*, looks at the key regulatory frameworks that potentially restrict creative practitioners in their work. This will be of particular interest to fine artists, photographers, animators, graphic designers, illustrators and film-makers. The subject is opened with the ideas of property ownership outlined in Chapter 1 and how this has impacted on appropriative art, and then moves on to the different mechanisms for restricting the expression of artists by those who do not like what they have to say, or how they say it. Since this field is not solely regulated by law, the philosophical tensions between free speech and the concept of causing offence is explored around the various power systems that come to bear on the creation and dissemination of work. This is then examined through the legal rules that have been used to underpin these,

and how these are now balanced with Article 10 of the European Convention on Human Rights: the right to freedom of expression.

Chapter 3, *The use and misuse of private information*, deals with the different legal mechanisms for controlling the dissemination of information about others; it will be particularly useful to those working in freelance photography and film and writers. The first section in this chapter looks at contract (since this has played a role in how information is protected) but this section is of relevance to all readers since it outlines the basic principles that underpin contract law; if an artist works for others a contract is formed (whether they realise it or not). Breach of confidence, how copyright might protect personal information, passing off, defamation and privacy are then explored. The balancing act required between the right to freedom of expression (as discussed in Chapter 2) and the right to a private life (Article 8 of the European Convention on Human Rights) is examined. The discord, between information which is public and information that is considered private, creates a grey area of personal information in which the public might be interested but which it might not be in the public interest to circulate.

Chapter 4, *(Un)commissioned art: tortious and criminal liability*, looks at *torts* and crimes. The concepts of duty of care, breach of duty of care, causation and damage are necessary to this section, as are the various defences that arise in the field of tort. This chapter will be of use to those involved in public art, installation work and street artists. Concepts relating to tort enable the reader to better understand the lines between civil and criminal causes of action in law. The concept of trespass, theft and criminal damage will be discussed here, as well as the sanctions imposed on those found to have committed a crime.

Though setting no precedents in the UK, the US legal system has generated significant case law involving artists. Chapter 5 provides a brief overview of the American legal system and then examines significant variations in law in relation to the English and European law covered in the previous chapters. The list of distinguishing features is by no means exhaustive so the focus is on particular differences that will be of interest to those wishing to do further research, or those whose artwork is available globally and likely to be affected by American law. The use of the internet determines that this affects increasing numbers of artists.

Notes

1 http://www.bbc.co.uk/news/uk-england-cornwall-23124017
2 Most readers will know someone capable of lying to further their own self-interest; if you do not know someone like this, then it might be you.
3 M v Home Office [1994] 1 AC 377, [1993] UKHL 5, AC [1992] QB 270.
4 Crown Proceedings Act 1947.
5 M v Home Office [1994] 1 AC 377, 396.
6 Shaw v DPP [1962] AC 220, [1961] 2 WLR 897.
7 Shaw v DPP [1962] AC 220, 58.
8 Knuller v DPP [1972] 3 WLR 143.

9 Pickin v British Railways Board [1974] UKHL 1; [1974] AC 765.
10 Burmah Oil v Lord Advocate [1965] AC 75.
11 US Constitution Article 1, Section 9, Clause 3.
12 German law Article 103.
13 www.nacro.org.uk
14 R v Secretary of State for the Home Department *ex p* Bentley [1994] QB 349.
15 Factortame v Secretary of State for Transport (No 2) [1991] 1 AC 603.
16 for those interested in how this works it is worth looking at the passage of the Fox Hunting Bill through the Houses of Parliament.
17 Heydon's Case (1584) 76 ER 637.
18 In Pepper v Hart [1992] 3 WLR 1032 the Lords confirmed that the Courts were entitled to look at parliamentary debate in *Hansard* to determine Parliament's intention if the legislative language is unclear.
19 Criminal Justice Act 1982 Section 37 as amended by the Criminal Justice Act 1991 Section 17(1).
20 Criminal Appeal Act 1995.
21 Criminal Justice Act 1972 Section 36.
22 Criminal Procedure and Investigations Act 1996 Sections 54–55.
23 Criminal Justice Act 1988 Sections 35–36.
24 Lord Gardiner LC Practice Statement 1966.
25 Associated Picture Houses v Wednesbury Corp [1948] 1 KB 223 (CA).
26 European Communities Act 1972 Section 3.
27 Human Rights Act 1998 Section 19.
28 *ibid.* Sections 3–4.
29 *ibid.* Section 2.

Bibliography

Bell, C. (2014) Is this the worst film ever made?', *The Sunday Telegraph Seven*, 6 April: 8–11.

Bowling, B. and Phillips, C. (2003) Policing ethnic minority communities, in T. Newburn, ed. *Handbook of Policing*, Cullompton, UK: Willan Publishing, 528–555.

Darbyshire, P. (2005) *Darbyshire on the English legal system*, 8th edn., London: Thomson/ Sweet & Maxwell.

Gillespie, A. (2012) *The English legal system*, 4th edn., Oxford: Oxford University Press.

Hennessy, P.J. (2000) *The Prime Minister: the office and its holders since 1945*, London: Penguin.

Partington, M. (2006) *Introduction to the English legal system*, 3rd edn., Oxford: Oxford University Press.

Simpson, M.J. (2012) *Urban terrors: new British horror Cinema*, Hailsham, UK: Hemlock Books.

Turpin, C. (2002) *British Government and the constitution: text, cases and materials*, 5th edn., London: Butterworths/LexisNexis.

Wade, A. (2008) 'A healthy tension', *The Guardian (supplement) Media law*: 1.

Walker, D.M. (1981) *The Scottish legal system: an introduction to the study of Scots law*, 5th edn., Edinburgh: W. Green & Sons Ltd.

White, R.M., Willock, I.D. and MacQueen, H.L. (2013) *The Scottish legal system*, 5th edn., London: Bloomsbury Professional.

1 Art as intellectual property

Introduction

In 1980, Frusen Glädjé (but for the accent on the 'e', this means 'Frozen Joy' in Swedish) were sued unsuccessfully in the US by Häagen-Dazs (which is not Danish for anything)[1]. Häagen-Dazs claimed that Frusen Glädjé had infringed its intellectual property rights by promoting a product associated with Scandinavia, with which neither party appeared to have any links. Häagen-Dazs did not succeed, in part because in marketing a product trading on Nordic origins that it did not have, it had not come to litigation with *clean hands*. The ice-cream manufacturers appeared to be claiming a right in the use of wording made to look 'a bit Scandinavian'.

There are few creative practitioners for whom intellectual property is not relevant. While philosophical and critical reception may be ample reward for many, we would be naive if we believed that artists do not have to make a living. Some of what a creative practitioner earns will come from the physical objects sold. These are known as tangible objects, physical property, chattel, *personalty*, the concrete *thing* – you will see a range of terms for these. These tangible objects, though, can carry something else that gives them value; it is intangible but embedded in the creative work and cannot exist without it. This intangible thing has a separate legal existence to the tangible thing and is referred to as *intellectual property* (IP). It only comes into existence when the idea that the creative practitioner has is reduced to a tangible form. The creator of an artwork is generally the first owner of the IP attached to it. If you tell another person of your idea and they develop it for commercial exploitation, you may have no protection in intellectual property law. In Brighton v Jones,[2] for example, a director's suggestions to a playwright did not entitle the former to claim co-authorship of the work. Sometimes breach of confidence, or the formation of a contract, will give rise to protection for those who have conveyed ideas to others; this is looked at in Chapter 3.

Section 1: a brief history of intellectual property

In the Australian case of Twentieth Century Fox and Matt Groening v South Australian Brewing[3] there was a successful claim by Twentieth Century Fox

and Groening that led to the restraint of specified breweries from dealing with a drinks can associated with the animated series, *The Simpsons*.[4] A range of accusations, that often accompany intellectual property infringements, were made such as deceptive conduct, passing off and breach of Australian trade law. The use of the name Duff was particularly pertinent to the case; the attachment by one of the fictional characters (Homer) to this beer being notable.

The most important source of IP law, internationally, is the Berne Convention 1886[5] which outlines principles for its member state signatories. It provides the owners of IP with the right to start legal action in any jurisdiction that is a signatory to the Convention ('reciprocal protection'). In its earliest form, Berne outlined some basic features of IP: that it should not be subject to excessive formality, that protections should be automatic and that there should be some exceptions permitting the use of protected work by others where there is no conflict with the author's rights. In 1961, the Rome Convention extended these rights to phonogram producers, performers and broadcasters. In addition to the Berne Convention, there is a UN Agency which supervises IP Treaties; the World Intellectual Property Organization (WIPO) based in Geneva (established in 1967) and a 1995 agreement on Trade-Related aspects of Intellectual Property Rights (TRIPS) implemented much of the Berne agreement more widely.[6] TRIPS is operated through the World Trade Organization (WTO).

IP law was developed to control what can be done to/with/about a work of art or science. It is not necessarily sold when the physical object is sold; in English law it is only conveyed (given or sold) if there is something in writing which states that this is so. There are four forms of intellectual property in English law and these are *copyright* (Section 2), *designs* (Section 3), *trademarks* and patents (Section 4). Copyright and designs are the two forms of IP that will be most important for the readers of this book so much more time will be spent on these. However, there are circumstances in which some artists will need to know of the principles of trademarks and patents so these are also covered to a more limited degree.

The detail in which you read each section will depend on what type of creative practitioner you are; in particular, whether you consider yourself an artist or a designer. Section 2 (copyright) will have particular relevance to students of the fine, graphic, plastic or three-dimensional and photographic arts as well as print-makers, illustrators, film-makers, animators and curators. Section 3 (design rights) will have more applicability to textile, fashion, furniture, interior and jewellery design students, although an understanding of copyright is also important to this field (it means that the latter group of creators have twice as much reading to do). Section 4 (trademarks and patents) has more applicability to product designers and those intending to work in global fashion and textiles; an understanding of design rights is still important. It is unlikely that you will want to read all sections in one sitting.

IP is a powerful asset to have control over; mostly, you will be advised not to give it away or sell it and this means reading a contract before signing it (see Chapter 3). If someone exploits your intellectual property without your

consent, it can be expensive to prevent them from doing so and gain the monies you should have had from its use.

Section 2: copyright

In 2006, mathematician and graphic artist Robert Dixon argued that a piece of his work was the source for Damien Hirst's print *Valium*. The work by Dixon appeared in the 1991 book *The Penguin dictionary of curious and interesting geometry*. These images can be seen at http://www.standard.co.uk/arts/can-you-spot-the-difference-7190471.html. Since the research trail goes cold for this case during 2006, it might be assumed that the case was settled before legal action was taken.

Copyright protects the expression of an idea, not the idea itself. This is widely referred to as the 'idea–expression dichotomy' (Bently and Sherman 2009: 182); it creates difficulty for those seeking to understand case law, and sometimes it may appear that a court gave protection to an idea rather than the expression of it. If the reader becomes confused then they are in good company; the idea–expression dichotomy goes to the heart of many contemporary debates about IP.[7] For example, in the case of Temple Island v New English Teas,[8] an image of a red bus on a monochrome London landscape was held to be protectable under IP law and since there was a substantial similarity between the work of the defendant and that of the claimant, the patents County Court found an infringement. Since the existence of colour on a black and white background has a long history in photography, this case may seem rather odd. The images can be seen in the original judgement at http://www.bailii.org/ew/cases/EWPCC/2012/1.html

By far the most important Act of Parliament you will see referred to here is the Copyright, Designs and Patents Act of 1988 (CDPA). The subject matter protected by the CDPA is literary, dramatic, musical and artistic works (LDMA); these are referred to as *authorial works*. The term 'author' is used widely but generally it can be interchanged with 'creator' or 'artist'. There is also protection under the CDPA for the creators of film, sound-recordings, broadcast and published editions/typographical work which are referred to as *entrepreneurial works*.

Among the rights protected in relation to this form of IP are the rights: to reproduce the work; to issue copies of it; to communicate the work to the public; to make derivative works or adapt the work; and to authorise others to do any of these things. Sometimes these are referred to as 'economic rights' or the rights of exploitation. On top of these matters an author has additional 'moral rights' over their work which include the right to object to derogatory treatment of their work, and the right to be named as the author of a work, even when the copyright has transferred to someone else.

Copyright generally lasts for the life of the author plus seventy years (see Copyright Duration section below). After copyright has expired, a work enters the *public domain*. For copyright to subsist in a work there is no need to affix

a © sign but it may be wise to do so, as well as to sign and date a work where possible. However, affixing such a notification to a work does not guarantee that a court will find the *subsistence* of copyright. Copyright protection is available irrespective of artistic merit; in principle, this means that an individual judge cannot give better protection to something she likes over something less well regarded; though occasionally, an opinion on a matter other than law will leak out in a judgement just the same.

Authorial works: artistic

The loves of shepherds by Glenn Brown (nominee for the Turner Prize 2000) was described as derived from a science fiction book cover by illustrator Tony Roberts (*Double Star* by Robert Heinlein). The case for copyright infringement was settled out-of-court.[9] These images can be seen at http://www.epuk.org/The-Curve/456/visual-plagiarism?pg=2. Now, when Brown displays the works associated with that of Roberts, the words 'After Anthony Roberts' appear with its title.[10]

The CDPA distinguishes three categories of artistic work[11]: (i) graphic works, (ii) works of architecture and (iii) works of artistic craftsmanship. Graphic works can include painting, drawing, diagrams, maps, charts, plans, engravings, etchings, lithographs, woodcuts (or similar), sculpture, collage and photographs (but excludes film which is covered separately). The second category of works of architecture covers buildings and fixed structures as well as the models or other graphic works of these.[12] The third category of artistic craftsmanship can include handcrafted jewellery, tiling, pots, windows, iron gates, hand-knitted items and crochet. However, if a work falls into this class there is a requirement, on whoever claims the right, to demonstrate both the aesthetic nature of the work *and* the craftsmanship (or skill) required. This places some works at the mercy of a judge's aesthetic opinion; you would not ask a dentist what she thought the problem with your car was. In Hensher v Testawile Upholstery,[13] a chair was found not to have artistic appeal and there was additional discussion as to the special skill required to produce the item (that is, whether it fulfilled the 'craftmanship' required). In Merlet v Mothercare,[14] a baby cape was found to not be intended as a work of artistic craftsmanship as it was solely utilitarian. The courts look for evidence of creativity and they may do so under the guidance of 'experts' but being 'pleasing to the eye' may not be sufficient to meet the threshold.[15] In Vermaat & Powell v Boncrest,[16] a patchwork bedspread was found not to meet the criterion of creativity required.

The case law for enabling an understanding of what does and does not fall into the category of artistic works is large in number. What follows are a few examples to illustrate this minefield before anyone can begin to consider who owns a copyright and whether someone is exploiting it unlawfully: Adam Ant's make-up of the 1980s was not a painting;[17] the author of a photograph is the person who causes it to be taken[18] (this is not necessarily the person who presses the shutter) and flipbooks do not appear to qualify for protection.[19] In

New Zealand, the mould to make frisbees was found to be an engraving (that is under a category of artworks qualifying for copyright protection)[20] but New Zealand law, though related to English law, sets no precedent. In English case law such a mould was found not to be an artistic work in Metix v Maughan[21] but it was an artistic work in the case of Breville v Thorn (yes, Breville who make toasted sandwich makers).[22] In the latter case, protection as an artistic work was granted[23] but only if the mould went beyond its functional effect. Breville sits at odds with a case involving the storm-trooper helmets from *Star Wars*[24] where the helmets were not considered to be sculpture[25] and therefore not protected.[26]

Authorial works: literary

A literary work is any work in print (other than a drama or musical – see below) which is written, spoken or sung[27] (a song is both a literary *and* musical work). This protection applies irrespective of the quality of the work; for example, exam scripts have been found to be literary works.[28] The test of what constitutes a literary work is set out in the 1894 case of Hollinrake v Trusell[29] as works in print, which offer information, instruction, intelligible meaning or 'pleasure, in the form of literary enjoyment';[30] no further guidance is given on the meaning of pleasure. Names and titles (including song and film titles) are difficult to protect[31] though these can sometimes be protected under trademark law, breach of confidence or passing off (see Chapter 3 and below).

Authorial works: dramatic and musical

Dramatic works include scripts for films and plays, choreographic works, dance and mime, and recordings of these.[32] The main criterion for inclusion in this category is that the work is 'capable of being performed'.[33] Static objects are not covered and computer games are not 'performed'[34] so cannot be dramatic works. Musical works are those defined as consisting of music exclusive of any words (the melody); the words being protected as literary works.

Entrepreneurial works: films, sound-recordings, broadcasts, published editions

The 2010 work (ongoing) *What do you want from me (I asked you a thousand times)* by British artist Savage has been exhibited in galleries and film festivals in Europe and the US. It is made up of roughly 352 clips (the number varies) containing solely the phrase 'What do you want from me' sourced from films made for cinema. Under US law the 'transformative' argument argued under 'fair use' (see Chapter 5) might be a defence for this artist in a copyright claim, and even under some European jurisdictions parallel defences are available. However, under UK law the defence of 'fair dealing' (see below) is more limited. The moving image piece can be viewed at http://vimeo.com/38084075. The work does not compete in the same market as the films in question; its most obvious message being the repetitive and unimaginative scripting of many

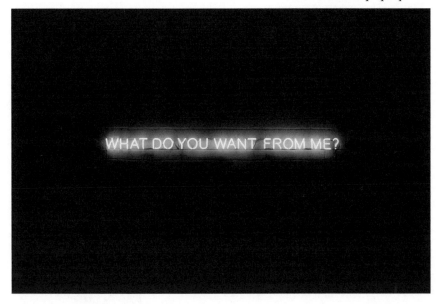

Be nothing © Savage 2007

Hollywood films. The artist was approached by some film companies in relation to permission for use; however, some of these have already waived their rights (date of interview 29 March 2013). In addition, the artist argues that the work is of archival interest which may raise the public interest defence (discussed in Chapters 2 and 3).

Before 1988, film was protected as a category of 'dramatic work'.[35] Film can now potentially enjoy protection under two categories of work: 'cinematographic' and 'dramatic' (so they can be both authorial *and* entrepreneurial works).[36] At the start of every legally produced and sold film, you will see a notice of the possible sanctions for its reproduction and other forms of IP infringement. A soundtrack is part of a film and the showing of the film requires only the permission of the film's IP owner.[37] However, soundtracks are protected independently if they are played without the film.

Broadcasts are a communication by 'electronic transmission of visual images, sounds and other information…'[38] and must be capable of being lawfully received by the public at a time determined solely by the person making that transmission. At first glance this would appear to exclude transmissions made over the internet but the CDPA makes provisions for these separately.

Published editions are 'typographical arrangements'[39] and are peculiar to English law. It is the combination of design and type, dictating the appearance of a work already available to the public that qualifies a published edition for protection. This means that a work in which copyright no longer subsists might enjoy protection if the particular design in which it appears meets the requirements for protection as a published edition.

Requirements for copyright protection in authorial works

Material form

Though literary, dramatic and musical works do not have to be registered to enjoy protection (since protection is 'automatic'), they must be recorded in writing or some other tangible form.[40] However, if an original recording has been destroyed, a work is still protected as long as the fact of a copyright infringement (such as copying a work) can be shown.[41] What can also be important in evidencing the creation of work is the use of what are widely known as 'sketchbooks' which detail the research that went into producing an artistic work. While patent law is less relevant here, McManus notes the importance of the use of laboratory notebooks in evidence (2012: 105); it is suggested here that a creative practitioner's sketchbooks are of similar importance.

Permanent fixation may not be a requirement for artistic works which may strike the reader as odd. Invariably, artistic works exist in some physical form but the law potentially allows, for example, that an ice sculpture be protected. Evidence of the work's existence through another medium such as photography or film is of assistance. Kinetic art has created some problems in Australian law; in Komesaroff v Mickle,[42] a work involving sound, liquid and bubbles was found not to have the essential qualities required for copyright subsistence. This does rule out the possibility that some kinetic artworks might qualify for protection.

The work must be original

For the purposes of the law, the reader must set aside any notions of originality from a critical or aesthetic perspective but the law requires that an authorial work be 'original' for copyright to subsist.[43] A work does not have to be inventive, novel or unique for copyright to subsist; in the case of Sawkins v Hyperion, the court remarked that 'a work may be complete rubbish and utterly worthless [but might still be original in a legal sense]'.[44] Novelty *is* a requirement of patent and trademark law (see below) so the reader needs to understand this distinction when hovering around the borders of categories of IP.

In defining the term 'original', English law has tended towards individuality of expression rather than originality in the underlying idea.[45] The creator, however, must have used some skill or effort in the production of the work for copyright to subsist.[46] The concept of 'intellectual creation', originating from the author, is now widely used to determine whether a work is original in a legal sense. This test was set out by the Court of Justice for the European Union (CJEU)[47] who stated that a test examining the skill, effort and the 'author's own intellectual creation'[48] should be used to determine a work's originality.

Photography and originality

This CJEU-developed test has been particularly useful in determining IP subsistence in photographs. Photographs had (prior to the CDPA 1988) a bumpy ride with intellectual property law. In a nineteenth-century case (Graves' Case), concerning whether a photograph could be defined as a work of art, it was remarked that 'it is difficult to say what can be meant by an original photograph. All photographs are copies of some object'.[49] The case was concerned with the Fine Art Copyright Act 1862 Section 1, which afforded copyright to paintings, drawings and photographs that depicted other artworks. The court determined that a photograph of an engraving of a picture enjoyed copyright protection. The recognition that this skill is capable of creating copyright for the photographer has more recently been underlined in a 2001 case, Antiquesportfolio.com v Rodney Fitch,[50] in which the High Court held that photographs of three-dimensional antiquities were protectable due to the choices that the photographer had to make in the production of these works. There is no reason to suppose that the court would not extend such protection to photographs of two-dimensional objects. However, under the Copyright Act 1956, the person who owned the photographic materials owned the copyright in the photograph. This appears to equate to the person who owned Picasso's paint owning the copyright in his paintings. Subsequent to CDPA 1988, the law recognised the effort and skill present in photographic works, but the law on the status of snapshots and how museums and galleries photograph exhibits is less clear. A European Direction relating to photographs[51] requires that original photographs enjoy copyright protection but allows each member state to determine whether it provides protection to non-original photographs.

Requirements for copyright protection in entrepreneurial works

Though film, sound, broadcast and published editions need to exist in material form, they do not need to be original for copyright to subsist (as long as they are not themselves copies from another work).[52] This means that the requirement for skill, labour or effort (used to evaluate a work's originality) is also set aside. Photographs of a film can constitute copyright infringement.[53] The rights in place for the protection of copyright in entrepreneurial works are significantly fewer than those available for authorial works.

The owner of copyright

Regardless of whether a work is authorial or entrepreneurial, the person making a claim for copyright infringement must have the right to do so, and generally this will be because they own the copyright and fall under the jurisdiction of English law. The concept of *first ownership* of copyright was developed under English law, and often the author will be the copyright's first owner.[54] The author is the person who creates the work.[55] An author may assign their copyright to someone else by written contract and it can also be bequeathed in a will. In an odd case involving parties purporting to be capable of communicating with the dead, a person working as a clairvoyant was found to be the author of words transmitted to her.[56] Paradoxically, this can be construed as an admission that the origin of the words was not the dead party alleged to be present at the séance, but the charlatan in question. If the dead party was the author of the words then it is arguable that their beneficiaries would own the copyright (for seventy years subsequent to their death). However, the dead person would not have created the authorial work during their lifetime and the court in this case remarked frivolously that it had no jurisdiction over the afterlife.

In the case of literary, dramatic, musical and artistic works, the question of who the author is usually creates little difficulty since the presumption in law is that the name appearing on a work is that of the author.[57] The burden of proof in court will lie with any person who contests authorship; it is for them to show that the presumed author is not the creator of the work in question.

Entrepreneurial works, however, do present some problems here; the person who made the work and the person who contributed creatively to the project are often not the same person. There has been some attempt to harmonise some European civil codes which tend towards finding that the person who enables a project to be done owns the IP. In English law, the director of a film is recognised to have equivalent status to the producer (they are 'joint authors').[58] Since films can be authorial and entrepreneurial under the law, reading cases can sometimes be confusing in this field. The amendments that place the rights for film with the producer and the principal director came into effect 1 July 1994.

Joint authorship involves the collaboration of two or more authors where their contributions cannot be readily separated. To qualify as a joint author, a party must have made a non-trivial contribution, of the right quality, to the

work's originality but this does not have to be equal in other respects (for example, with regard to time spent on the work's creation). The intentions of the authors is not always important for joint authorship to be found as long as the result is a collaborative work. Even a hazy plan can satisfy the requirement for collaboration; physical proximity between authors is not necessary.

Parties other than the author who might own the copyright

Aside from the circumstance in which an author might have conveyed copyright to someone else, the employer/employee relationship gives rise to an exception to the rule that the author is assumed to be the first owner of copyright. If an employee produces an authorial work in *the course of their employment* then copyright is owned by the employer; unless the employment contract states otherwise and such an agreement can be, rather unusually, oral or implied as well as in writing.[59] The length of copyright for a work owned by an employer will still be determined by the length of the life of the employee which is at least motivation for an employer in possession of a valuable right to have more than a passing interest in the health of past and present employees.

The copyright in commissioned works now belongs to the author[60] but prior to 1988 the commissioner of a piece of work was the first owner of copyright, so reading some case law in this field can be confusing. Even subsequent to the 1988 Act, case law has deviated from this principle; in a 1999 case the existence of a 'constructive trust' (a principle of *equity* as referred to in the introductory chapter and glossary) was recognised which meant that the commissioner of a work was 'beneficially entitled' to the copyright.[61] There is a notable exception with regards to the rights of those commissioning work; the moral right of privacy in wedding videos and photographs[62] prohibits the author issuing such work to the public without permission from the parties who commissioned her.

Rights that the copyright owner has

It is for a copyright owner to exploit their work for profit, and as such they are granted certain rights over works. These include the rights to reproduce a work, to distribute it, to issue copies, to rent it out, to transfer it into other media, to adapt/translate it and the right to authorise others to do any of these things (collectively these are referred to as 'primary rights').[63] Anyone found to have exploited these primary rights without permission (and without a recognised defence) will be held to have committed a primary infringement.[64] There are, again, variations depending on the type of work that is protected; for example, the right to show or perform work does not apply to artistic works (if you buy a painting you have the right to exhibit it without the owner of copyright's permission). Works that are on public display may be included in another work without licence (whether incidentally or otherwise).[65] Adverts for the sale of works of art are also permitted to contain images of that work.[66]

Rights of reproduction

The right of reproduction[67] is probably the oldest and most important right available to a copyright owner, and infringement will be found whether the reproduction is permanent or temporary. Once it is shown that the defendant's work is a copy of the claimant's work and that copyright subsists then it is assumed (unless the defendant can show otherwise) that the defendant article was made at a time when copyright in the claimant article already existed.[68] For literary, dramatic, musical and artistic works, the concept of copying includes 'non-identical' copies. How different a piece of work has to be for infringement *not* to be found is a matter of case law but there must be sufficient 'objective similarity' in the defendant work for the copyright owner to make a claim.[69] This similarity can be in relation to the whole of the claimant's work or a substantial part of it[70] (see section on infringements).

The law has attempted to keep up with new technologies in respect of copying copyrighted works so computer storage, without authorisation or defence, will be an infringement. More importantly, in anticipation of changing technologies, the CDPA 1988 used as much neutral terminology in relation to technologies including such phrases as 'any material form',[71] and recognises infringement regardless of whether something is produced in 2-D or 3-D.[72]

It is not an infringement to make a 2-D representation of a building, model, sculpture or work of artistic craftsmanship that is displayed in a public place.[73] You may, however, see signs in places to which the public has access prohibiting photography and this is lawful if the land owners wish to make this a condition of persons being on their land.

There is a narrower definition of reproduction for entrepreneurial works (song lyrics being protected as 'authorial works' – see above) so writing out a recorded speech or describing a film in detail is not infringement, and one

film having similar content and style to another is not infringement. Case law has indicated that using new actors to copy a film shot for shot is not an infringement.[74] Only an exact facsimile of a typographical arrangement (or part of it) will be an infringement.

The right to make derivative works from artistic works belongs to the work's copyright owner. An authorised derivative work may have its own copyright if: the skill and judgement invested satisfy the originality requirement;[75] effort has brought about a change in characteristic which the raw material did not possess; and this change is 'visually significant'.[76]

Authorization rights

Only the copyright-holder may authorise others to undertake the restricted activities listed above.[77] Generally, litigation involves those who make money from unauthorised activities such as copying, but there have also been attempts to take action against those persons who supply the types of equipment that could enable an infringement. The leading case for this is CBS Songs v Amstrad[78] where the suppliers of twin-tape recorders were found not to be 'joint infringers' with the public to whom it sold these, or to have authorized unlawful copying. In this case, the advert for the product actually alerted the consumer to the potential illegality of the act of recording something from a pre-recorded source.

Copyright duration

The duration of copyright is dependent on whether the work is authorial or entrepreneurial. There is debate as to whether copyright should exist in *perpetuity* and, with regard to weighing the interests of authors against those of parties wishing to access information, changing law in the UK, US and Europe has swung firmly in favour of copyright owners.

After amendment to the CDPA in 1996, copyright for literary, dramatic, musical and artistic works subsists for the life of the author plus seventy years.[79,80] The clock starts to tick from the end of the year in which the author dies[81] and it is the end of the life of the longest surviving author that dictates the subsistence of copyright.[82] Since films are treated as authorial works, copyright duration is dependent on the length of the life of the principal director, author of the screenplay, director of cinematography or the composer of the score[83] (whichever is the later in time) plus seventy years. If the identities of these persons are unknown, the duration is seventy years from when the film is made[84] or (if the film is made available to the public) from the year of its availability.[85]

For unknown authors of literary, dramatic, musical and artistic work, the duration of copyright is seventy years from the year of the work's creation or from the year in which it was made available to the public.[86] If the author's name is disclosed before this time elapses then duration of copyright is for the life

of that author plus seventy years.[87] The duration of copyright in typographical arrangements/published editions is limited to twenty-five years from when the work was first published.

Prior to 1996, unpublished literary, dramatic and musical works, not in the public domain, enjoyed a copyright duration of fifty years from the date of publication.[88] Potentially, this meant that unpublished works enjoyed eternal copyright if they were never published, so the law was formulated such that if a work was unpublished on an author's death and remained so until 1 July 1989 then copyright would be fixed for 50 years from 1 January 1990 until 31 December 2039.[89] This has now been extended to 31 December 2058.[90]

For entrepreneurial works with no identifiable author, such as sound-recordings and film, copyright lasts for fifty years from the year in which they are made or, if they are published/broadcast, from the year of publication or first being played in public.[91] Broadcasts with no identifiable author have a copyright duration of fifty years from first broadcast and typographical arrangements enjoy a copyright duration of 25 years from first publication.

Publication rights in works no longer in copyright

A publication right lasts for twenty-five years and is granted automatically to any person who, after the expiry of copyright, publishes an unpublished literary, dramatic, musical or artistic work or film.[92] There is no publication right in unpublished paintings, drawings, sculptures and photographs created before 1862 or in works by an artist who died before 1855.

Moral rights

Moral rights protect the non-financial interests that an author might have in a work. They include the right to be named as the author of the work when it is copied or shown (attribution rights) and also the right not to be named as the author of an unrelated work (false attribution). There is also a limited right to protect the integrity of a work through objection to destruction, excessive criticism or derogatory treatment. An infringement of a moral right is actionable by any author[93] or their heirs.[94] Moral rights last as long as copyright, with the exception of those rights relating to false attribution which last for life plus twenty years[95].

Although the right of attribution ('paternity') cannot be assigned[96] to others (as copyright can), it can be waived[97] in writing,[98] regardless of to whom copyright has been assigned or who owns the physical object.[99] The right of attribution must be asserted in writing by the creator of work to the party who has shown it without attribution,[100] without delay.[101]. The attribution must be clear[102] and in the form the artist wishes.[103] Architects are permitted to request the removal of their name from a work[104] or that their name appear on a work,[105] and that they be named when the building is drawn, filmed or photographed and the resulting work published or broadcast.

For an infringement of the attribution right to be found, it must be shown that the author was not identified in circumstances that required it: when a work is exhibited, published commercially or broadcast. For literary and dramatic works, the right arises whenever works are published commercially, performed, broadcast, translated or adapted[106] or when a work is sold (including a screenplay) but oddly this is not a requirement for rental copies of such a work.

The right of integrity allows an author to object to derogatory treatment of their work. This right is only available to authors of literary, dramatic, musical and artistic works and to the director of a film[107] but it does not apply in the case of current event reporting[108] (allowing legitimate criticism of artworks to take place). The right of integrity is not available in the case of translations of literary or dramatic works and arrangements of music involving no more than a key change.[109]

For infringement of the right of integrity to be found, it must be shown that there was derogatory treatment of a work within the scope of protection. The term 'treatment' refers to additions, deletions, alterations and adaptations that affect the work's meaning. For the treatment to be found to be also 'derogatory'[110] the work must be distorted/mutilated in a way that is prejudicial to the reputation ('honour') of the author. How the public might reasonably

perceive the author's reputation after seeing the mistreated work may be relevant in determining cases; the mere fact that the artist is angry will not be sufficient since the test is an *objective* one.

The circumstances in which the author can expect to be protected from derogatory treatments include those circumstances where work is made available to the public (spoiling on its own will not give rise to liability)[111] which will include publication of a work and, for artistic works, exhibition or the inclusion of the work in a film.[112] For film and sound-recordings, a right of integrity will be infringed when a work is issued to the public[113] or shown.[114] No liability arises if otherwise derogatory treatment was undertaken to avoid another category of offence (such as offending public decency – these types of offences are detailed in Chapter 2). In the case of employees whose work has been subject to derogatory treatment then the authorisation of the copyright owner will be a defence[115] but if the employee is named then liability can still arise unless there is a disclaimer.[116]

Infringements

Primary infringements

Hirst's *Hymn* (1999) was a 20-foot reproduction in bronze of a piece from a children's anatomy set designed by Norman Emms (a designer of *Thunderbird* models) for toy manufacturer, Humbrol. The matter was settled out-of-court.[117] It is reported that Hirst was required to pay monies to children's charities to settle the case. The Hirst sculpture can be seen at http://www.damienhirst.com/hymn; the Emms model can be seen at http://news.bbc.co.uk/1/hi/uk/699641.stm.

Identical copying and piracy will always be infringement of copyright but most cases that get to court hinge on more nuanced matters. It is for a claimant to show (on the balance of probabilities) that the defendant carried out one of the activities controlled by the copyright-holder. This does not mean that the defendant's work must be directly derived from the claimant's work[118] but rather that there is a causal link. Since direct evidence of copying is rare, the finding will be a matter of inference; a defendant is not protected if there has been subconscious copying so whether the defendant has had access to the claimant's work will be important. If a claimant can show that the defendant has repeated a meaningless error then this will be evidence of direct copying,[119] but such ease of proof is rare.

A claimant must show that a 'whole or substantial part'[120] of *their* work has been exploited. This substantiality test might involve a court assessing quality and quantity (since 'substantial' here is not to be confused with 'large'). In Warwick Film Productions v. Eisinger,[121] it was observed that 'the question is whether the defendants' film reproduces a substantial part of the [plaintiff's] book, not whether the reproduced part of the [plaintiff's] book forms a substantial part of the defendants' film'.

Protected and unprotected elements of a work

The criterion of originality means that copying the unoriginal elements of work is not infringement.[122] Predicting what might be the unoriginal elements is risky since, in the event of litigation, it will be a court that distinguishes the protectable from the non-protectable parts. In Kenrick v Lawrence,[123] for example, it was noted that a new combination of unoriginal elements might be protectable.

In the case of Newspaper Licensing Agency v Marks & Spencer,[124] the test of similarity was performed 'by reference to the reason why the work is given copyright protection'; this being that the skill and judgement evidenced the author's intellectual creation. Bently and Sherman (2009: 194) make note of the courts' tendency to go straight to the substantiality test rather than first examining which aspects of a work qualify for protection.

Secondary infringements

Secondary infringements take place when someone other than the primary infringer involves themselves in a restricted activity. Those who knowingly assist a primary infringer are accessories, as are those who distribute unlawful copies or enable their production. Secondary infringements might include importing, selling, hiring and transmitting infringing articles, as well as the making, possessing and the selling/hiring of equipment enabling primary infringements, or offering to do any of these acts.[125] As long as the alleged infringing copy passes the test for primary infringement[126] and the secondary infringer has knowledge of this, or reason to know of it,[127] then the claimant may bring an action against a secondary infringer. Secondary infringement of the moral right of integrity will be found if a party knowingly (or where they should have known), possesses, sells, hires, exhibits or distributes a work that infringes the author's moral rights.[128]

Defences

Widely referred to as ground-breaking in twentieth-century art, Duchamp's *Fountain* (urinal) (1917) is also given as an example of work in which copyright cannot subsist since the physical object is purported not to be of Duchamp's own intellectual creation. In addition, it has a utilitarian function so cannot enjoy protection as a design (see Section 3). If copyright cannot subsist in a work then a defendant has to demonstrate this fact alone, and a case will fall. If Duchamp's ready-mades were industrially made and placed in galleries, it may be that copyright did not subsist. The first work was 'lost' and is recorded in a photograph by Stieglitz. If though, as Shearer (2000) suggests, Duchamp made the urinal himself and only recorded it as 'ready-made', copyright subsists and will not expire (if my calculations are correct) until 1 January 2019. What is clear from Stieglitz's photograph, however, is that Duchamp signed the work in the name of 'R. Mutt' and what seems like a minor act results in a product of Duchamp's intellectual creation.

Ignorance of the law is no defence, though reasonable ignorance of the subsistence of copyright may have a bearing on the damages awarded. Some readers may be alarmed at the scope of the CDPA and what they may have already done in violation of it. There are, however, some defences available to claims for copyright infringements. In English law, there is a list of 'permitted acts',[129] and the courts have also developed some common law defences. Once an infringement has been shown then it is for the defendant to raise one of the recognised defences. A recent and influential aspect of European law on defences in English law is found in Article 10 of the European Convention on Human Rights (the right of Freedom of Expression) which is covered in greater detail in Chapter 2.

Independent creation

A claimant cannot claim there has been an infringement if, through 'independent creation', a defendant guilelessly creates a similar work (this distinguishes copyright law from patent law; where 'independent creation' cannot be used as a defence). Once the burden of proof has shifted then the defendant may be able to demonstrate that the work is not derived from the claimant's. For example, they may show that they were inspired by the same source materials as the claimant, that the similarity was by chance or that their work was constrained by a factor unknown to the claimant.

Fair dealing

The concept of fair dealing covers acts done for the purpose of private study and research,[130] for criticism or review[131] and for the reporting of current events.[132] The term 'dealing' refers to the act of making use of a work rather than its more colloquial meaning.

Bearing in mind the prevalence of sketchbooks in academic study of the arts, and all that these contain, I am mindful of the status of these in relation to the private study defence. These are, on the one hand, an essential tool to project developing which acknowledge influence over the work, and evidence its advancement for those assessing it. On the other hand, it is hard to assure anyone that all that sketchbooks contain will comply with the 'private study' defence. For example, the defence of private study and research applies to literary, dramatic, musical and artistic works as well as typographical arrangements but not to broadcast, sound-recordings or film.[133] This creates particular problems for students whose primary influences come from entrepreneurial works. The research defence is only operative if the research is done for non-commercial purposes.

The importance of fair dealing for the purposes of criticism and review, or the reporting of events, is that it prevents a copyright owner from controlling who reviews their work and how they do so. The work reviewed must be publicly available in order for this defence to apply, and there must be a sufficient acknowledgement of the author[134] unless, in the case of news reporting and current affairs, it is not practical to do so.[135] There is no requirement for criticism

to be 'fair', as long as use of the work is fair; this means that the user must support what is said and cannot rely on excessive parts of the work to make a point.[136]

During the 1990s, the beneficiaries of Matisse claimed a copyright infringement by Phaidon who had included the work in an alphabetised book of artists. Phaidon argued that the purpose of the work was criticism or review.[137]. The Matisse estate argued that the brief of description of Matisse's work could not constitute criticism. The case was settled prior to trial and the defendant paid a licence fee (Stokes 2012: 153–154).

For the purpose of reporting events and news, the 'event' must be current rather than historical to qualify for protection, and it must relate to a non-trivial contemporary issue. The use of the work must be no more than is necessary for reporting purposes. The CDPA allows for incidental inclusion of works in film and photographs,[138] though in IPC Magazines v MGN[139] the attempt to use this defence failed where a magazine appeared in a television advert for a competitor publication. The use of a musical track cannot be 'incidental'.[140]

Library, educational and public interest defences

The defence of 'library use'[141] recognises (non-profit) libraries, educational establishments, museums and archives as institutions in need of special protection from infringement claims. Anything copied by these institutions must be at cost and for the purposes of non-commercial research or private study, and the amount copied must be a 'reasonable proportion'.[142] Libraries and archivists are also covered by other legislation.[143]

Educational copying[144] must be done by the person giving or receiving the instruction, and it must be non-commercial, as well as not reprographic in nature.[145] In the absence of a licence, educational establishments may copy reprographically 1 per cent of a literary, dramatic or musical work per quarter per year, and there must be sufficient acknowledgement of the author.[146] There is also some protection against infringement claims for those instructing on film-making courses.[147]

In all cases the interests of the public (particularly now that the concept of 'freedom of expression' is transposed into English law) must be weighed against the rights of the owner to profit from a work (this is examined in Chapter 2). Also important will be the motives of the defendant: whether they have been honest and whether they could achieve what they did by different means. Acknowledgement of the original author, as far as is practical by a means that a reasonable audience could identify the author, will also be relevant.[148] What proportion of a copyrighted work has been copied, and how this impacts on the market for the original, may be a determinative factor[149] but there are no absolute guidelines.

Works contrary to public policy do not enjoy IP protection

A work must not fall into a category of work excluded from IP protection on public policy grounds; for example, if it is 'obscene', 'libellous', or 'immoral'

(see Chapter 2 for further discussion of these subjects). Copyright in any work that is created in breach of a fiduciary duty, or in breach of confidence (see Chapter 3), will be held in trust for the person to whom that duty is owed. Copyright in graffiti work is problematised by the fact that much work of this type is produced through a criminal act; this subject is explored in Chapter 4.

Exploitation, assignment and licensing

The sale of the art object does not surrender copyright to the purchaser. The copyright owner is the person who reaps the rewards of the labours of the author, and this is why artists are advised to not surrender it lightly. In the case of bankruptcy of an artist, copyright passes to the receiver or trustee and it may also transfer to another party by testamentary disposition (in a will). If copyright is joint-owned (for example, by joint authors) then, in the event of the death of one of these, ownership of it passes to the beneficiaries not the surviving author (this includes copyright in unpublished works[150]).

The copyright owner can also transfer copyright to someone else entirely while they are alive; this is called 'assignment' (the person who gains the copyright is referred to as the 'assignee'). Assignments of copyright are only valid if they are in writing, signed and the work is identified sufficiently, though this can be done by a relatively informal document.[151] The assignee of copyright may directly sue an infringer. It may be, however, that the terms of their assignment prohibit them from selling the copyright on to anyone else; this is similar to buying a house but never being able to sell it. Partial assignments (by time, territory or type of activity) are also possible.

Copyright can be mortgaged as security for a debt and this assigns ownership to the mortgagee (the person lending the money) during repayment of the debt. The use of copyright to secure a loan must be in writing, signed and registered.[152]

Alternatively, the first owner of copyright may wish to grant a licence to someone while retaining copyright for themselves[153] (the person who gains the licence is the 'licensee'). The most potentially valuable type of licence is an 'exclusive' licence which is a promise by the copyright owner not to exercise their rights in relation to the work in question, and not to grant others a licence to do so. Exclusive licences grant the licensee a right of action against anyone who does the thing that only they are permitted to do[154] but the copyright owner may also take action.[155] An exclusive licence can also be mortgaged as a security for a debt.

One-off licences (permission) are usually cheaper and, if you are lucky, free. Such non-exclusive licences can be informal (even oral), and can be express or implied. Implied licences sometimes arise from carelessly worded contracts but generally the courts are reluctant to surrender the assets of a copyright owner acting in good faith. There are other forms of implied licences though; if you buy a dress pattern, by implication you are permitted to make the dress. If the licensee does things that the copyright owner did not permit in the contract then the latter might sue for breach of contract or infringement of copyright

or repudiate the contract entirely. Compulsory licences (those imposed by the courts) are rare since they deprive the copyright owner of their bargaining power.

Section 3: design rights

One of the leading cases for 'substantiality' in copyright is Designers Guild v Russell Williams (Textiles)[156] which concerned patterns of stripes and flowers on the claimant's and defendant's fabrics (the fabric patterns being named *Ixia* and *Marguerite* respectively). Ultimately, the case, examining copyright in textile design, was determined by the House of Lords and focused on whether a substantial part of the source work had been copied rather than whether the two fabrics looked similar. There are many untruths circulated casually in fashion and textiles courses in the UK, and this is the source of one of these. This is the idea that if you have made seven changes to an object you cannot be found to have committed an infringement. There was some reference before the case went to the House of Lords to a search for 'seven similarities'[157] but do not allow this to mislead you.

It is sometimes difficult to decide whether a work might be covered through copyright or a design right; a rough rule seems to be that if you are planning to make something in multiples of more than fifty then design rights might be of more interest. Anything that is done to a product to make it more attractive to the consumer might give rise to a design right but an understanding of copyright is also important for designers of any category. The practices of the fashion industry, as based on transitory trends which pass between high-end fashion and high-street fashion, sit in tension with intellectual property law.

The five categories of design right discussed here will be: UK Registered Design Rights; Registered Community Design Rights; Unregistered Community Design Rights; Copyright protection in a design; and UK Unregistered Design Rights. The methods chosen for implementing European directives and regulations on design in English law[158] have led to design protection which, at best, keeps lawyers in business. The procedures and privileges associated with different categories of design right vary, as does their duration. Nothing I have had to research for this book appears more likely to lose its currency as quickly as a description of design law. There is extremely limited protection available to European designers in the US.

UK Registered Design Rights

The Registered Designs Act 1949 (RDA) created a process by which several designs could be registered through one application. Application for this is made to the Design Registry (which is part of the Patents Office)[159] and there is a fee for this. Registration must be by the person who claims to own the design (the 'proprietor'), or their representative, who must provide two copies of a 'representation' of the design and a description of the product to which it will

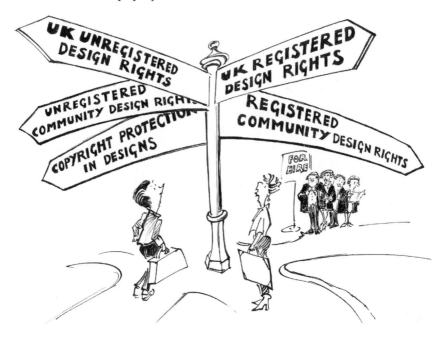

be applied (though this will not necessarily restrict the proprietor from taking action against a competitor who applies, for example, the surface design of a curtain to a cushion cover). The signed application must identify the features of the design for which protection is sought and contain a disclaimer indicating that these are new and individual in character. A specimen may be included.

The Design Registry has a three-month processing period in which it might refuse the application on the following grounds:[160] that the application does not comply with the Registry's rules; that the person making the application is not the proprietor or their authorised agent (even if the rightful proprietor has not objected);[161] that it does not fulfil the criteria for a 'design';[162] that it is contrary to public policy or morality;[163] or that the design is, in fact, an emblem.[164] At this point the design right cannot be refused on the grounds that it lacks individuality. If an application passes through the process then the Registry issues a certificate[165] and the design is published. Applicants may delay publication for up to twelve months but once it is published, anyone can inspect it.[166] Once registered, the proprietor enjoys all the rights associated with a Registered Design Right (RDR).

Registered Community Design Rights

In 2002–2003, a European Community system for designs with its own design office[167] (known as the Office of Harmonization for the Internal Market

(OHIM) in Alicante) was established. European legislation[168] defines a design as the appearance of whole/part of a product resulting from features of lines, contours, shape and/or texture. European design protection is available for industrial or handicraft items.

Applications for a Registered Community Design (RCD) can be made directly to the OHIM[169] or indirectly through any member state of the European Community.[170] An application to OHIM must contain a signed request for registration; the name and address of the applicant (or that of their representative); a visual representation of the design; an indication of the products for which the design is intended; a description of the design; a request for deferment of publication in the *Community Designs Bulletin* (if needed); and citation details for the designer (a 'designers attribution'[171]). Specimens are only accepted if deferred publication is requested.[172] Generally only one design can be the subject of an application but applications for multiple designs (no more than 999) may be made if they are intended for products of the same class.[173] The application can be in any of the languages of the European Community but it must also be made in one of the languages of the OHIM office which are currently Spanish, German, French, English or Italian.

The image presented to the office can be in monochrome or colour,[174] from up to seven viewpoints.[175] If a written description is included, this can be up to 100 words.[176] It must be clear from the application the novelty element for which the right is sought, and this can include a disclaimer as to the parts of the design for which no protection is sought. Once registered, a Community Registered Design appears in the *Community Designs Bulletin* unless the applicant defers publication which can be done for up to thirty months,[177] in which case a specimen may be supplied.[178] During the deferral period, protection of the design is limited to the rights given to an unregistered design.

There is no examination by the OHIM of a design's novelty or individuality[179] but if it is noticed that the subject matter is not a design[180] or contrary to public policy and morality, the OHIM will notify the applicant who must remedy this or withdraw the application.[181] If, however, the application fulfils all the formal requirements of the OHIM then registration and publication follow. The *Community Designs Bulletin* includes visual representations, information about the products to which the design will be applied and the name of the designer.[182] Once published, the design may be challenged as lacking novelty or 'individual character' by another party.

An RCD in the community and an RDR in the UK can exist concurrently.[183] The work of the Design Registry in the UK has been declining; this may be due to the community-wide right being cheaper, its allowance for multiple designs and the length of its deferral of publication.

Challenging Registered Designs in UK and the EU

The threshold for the registration of a design is quite low and there are correspondingly fairly weak rights associated with it. In order to be protectable

the design must be: new and have original character; it must be visible when the product is in use; the applicant must be the owner of the design; and it must not conflict with a pre-existing right (such as copyright or a trademark). As the examination process is limited, much importance is placed on challenges to the validity of designs that occur after registration. So if the design is not new then this can either be challenged through the invalidity proceedings of the OHIM (or equivalent member state office) or through a claim/counterclaim in legal proceedings.

There are various circumstances that exclude the possibility of a design right: products for which the design is dictated solely by function;[184] products which are interfaces or interconnections between products[185] and designs contrary to morality.[186] One of the reasons that designs solely determined by their function are excluded here is that these are often a matter for patent law, which is more costly and complex. In determining the distinction between a novel, individual design and a functional item, the court or registry will look at the question of whether *only* that configuration could have performed the function in question; if the same could be achieved by another means then the item is probably a design rather than an invention.

Novelty and individual character

If no identical design has been made available to the public before application (or in the case of an unregistered design which later becomes the subject of an application, the date on which it is made available to the public) then the design will fulfil the requirement of novelty.[187] The owner of a registered design who is challenged must define the element in the design that is novel. The date that the application was made or the date on which the design became public (where there has been deferral of registration or market testing[188]) will allow a court or the design office to compare it with what else was available at the same time.[189] For a Community Registered Design to be found invalid on the grounds of novelty, it must be almost the same as something else already available to the public.

However, invalidation can also be brought about through a design lacking 'individual character'.[190] To satisfy the requirement of individual character, the overall impression created to the informed user must be that it is different[191] from that given by similar items[192] in the 'existing design corpus'.[193] The 'informed user' is not necessarily skilled in the industry but familiar with existing designs, related products and how much freedom a designer has.

The tests for novelty and 'individual character' may seem very close; however, the test for novelty is a test for how similar something has to be in order to infringe someone else's design right, whereas the test for individuality looks at the differences that lead to the informed user being able to discriminate it from others.

Ownership of the design

If an applicant, or rights-holder, is not entitled to the design right claimed[194] then the person who is entitled can invoke their rights[195] through court action for Community Design invalidity. An application can also be made in the UK to have a registration declared invalid on these grounds[196] or a court may order rectification of the design register.[197]

Conflicts with a previous right

Conflicts with existing intellectual property rights will give rise to either a refusal of registration or a declaration of invalidity.[198] The Community Design Regulations only recognise this as a basis for invalidity action if it is brought before the OHIM by the lawful owner of the earlier right.[199] If it appears as a matter in court, this is generally because it is being argued as a counterclaim by the earlier rights-holder as a defence in infringement proceedings. For conflicts with other IP rights, the Design Rights Directive permits an 'appropriate authority' of a member state to pursue action.[200]

A design that conflicts with a distinctive 'sign' is not registrable as either a RDR[201] or a CDR.[202] This stipulation is in place for those designs that come into conflict with trademarks. This is the case throughout the European Community except in Sweden.[203] Action for conflicts with emblems of particular interest in individual member states can be brought by appropriate officials of that state.[204] In the UK, this can be used as grounds either for refusal of registration or a declaration of invalidity.[205] Conflicts with copyright protected works are grounds for invalidation in the UK and the EU.[206] Action can only be brought by the owner of copyright.

Rights that accompany registered designs

A designer seeking to protect a design is viewed, in law, as less creative than an artist seeking copyright protection (I do not assert that this is fair; the reader should not confuse the law with fairness). Design is often done in teams who respond to a brief and 'solve' it and the designer is more restricted by market forces, whereas an artist is seen to determine tastes. Consequently, the personality of the designer is viewed as less present in the work so regulations protect the design not the designer. The duration of design rights is not linked to the life of a designer but to the date on which the design entered the public domain. There are no moral rights in design rights law.

Who the rights-holder is depends on whether the design is a UK or EU registered one. In the UK, the creator[207] of the design is its proprietor[208] except where that design was created by an employee in the course of their employment; in this case, the employer owns it.[209] If the design was commissioned for money, or *money's worth*, the commissioning party owns it[210] (the opposite of copyright ownership in commissioned works). For RCDs, the proprietor is the designer

(or their beneficiaries)[211] except where the design is created by an employee in the course of their duties, or under instruction, in which case this will be the employer[212] unless the contract of employment states otherwise.

At the time of writing, Community law is silent on ownership when work is commissioned so the contract for such a commission will be key to this. Potentially, because of these subtle differences in community and English law, the person entitled to be named as the proprietor in the UK may be the person who commissioned the design but under Community law the proprietor may be the person who created the design. For a CRD, the designer has the right to be named on the register[213] unless this right is waived,[214] whether they are its owner or not.

As is the case for copyright, an RDR and a CRD can be assigned to someone else, mortgaged or licensed (granting someone permission to use it on specified terms). All of these must be done in writing.[215] An *assignee* or *transferee* (the party to whom design rights are conveyed) and the design rights-holder have the right of action against an infringer but a *licensee* does not. Designs rights can be inherited and contracts of employment may lawfully vary ownership of a design.

The duration of both types of registered design rights is for periods of five years from filing (twenty-five years in total). For the period in which the design is registered, the proprietor has a monopoly right to exploit the design and to prevent others from using it. 'Use' covers making, offering for sale, putting on the market, exporting, importing and stocking.[216]

Defences to infringement action

There are some exceptions to the exclusive rights conferred on the owner of a registered design. A person cannot be liable: for an act done privately for non-commercial purposes; for an act done in the course of experimentation; and for the reproduction of a design for citation and teaching. This is the case as long as such uses do not prejudice the owner's economic interests, and as long as the source of the design is acknowledged.[217] This will give some solace to textile and design practitioners whose sketchbooks are key to project development.

Unlike copyright though, because a design is registered, if a defendant (through their own research) arrived at the same design without plagiarism, they have little defence against infringement action. Where the owner of the right has deferred registration, action is confined solely to the *copying* of a design[218] and not the other 'uses' listed in the previous section. Under Community law,[219] as long as this type of 'infringing' party has acted in good faith then they may continue activities they were doing before the date of registration or the date on which the design entered the public domain. This right to 'continue to do' something cannot be licensed to others but it can be transferred when a business is sold.

Another distinction between UK and Community law in relation to Registered Designs is that in the UK the proprietor may not sue for infringements

of a design that occur between application and registration.[220] The proprietor however will have a right of action for infringement of the *Unregistered Design* in this period (see below).

Unregistered Community Design Rights

The Unregistered Community Design Right has been available under the Community Design Regulations since 2002 and recognises the transient nature of the fashion industry, while also providing a testing period for those who have not yet decided whether to register their design. Unregistered Community Designs Rights are automatic and exist from when a qualifying design is made publicly available. This design right lasts for three years and, unlike the Registered Community Design, only protects its owner from direct copying.[221] The criteria for a protected design are the same for Unregistered and Registered Designs;[222] it must be novel in comparison to other products at the date on which it is made available to the public;[223] have individual character; and be visible on use. The tests for these are of the same character as those used for registered designs. However, the nature of the comparison made in the eyes of the 'informed user' is not based on the application to the registry (since this will not have taken place); this test is instead based on a comparison between the design that the owner claims qualifies as an unregistered community design and the alleged infringing design.

Similarly, the exclusions are the same for an Unregistered Community Design Right as they were for a Registered Community Design Right so a design will not be recognised if: its features are dictated solely by its function; it is part of an interface with other parts; it is a design contrary to morality; or it conflicts with an earlier design right. The owner of the unregistered design right will be the same as set out for registered designs.

The defence of 'independent creation' is available to any alleged infringer of an Unregistered Community Design, and the plausibility of the design being unknown to them must also be considered. There are safeguards in place against the possibility that a design could not have been known in the normal course of business and in the specialist circles in which the alleged infringer operated.[224]

Karen Millen v Dunnes Stores[225] was the first test of Community law involving an unregistered community design right for clothing. It concerned two Karen Millen shirts and a black knitted top introduced to the UK and Irish markets in 2005 by the chain Mosaic Fashions. Dunnes then released similar items under the name Savida. The defendant stated that the designs were not original and failed to fulfil the novelty requirement for a design right, arguing that they were similar to designs previously on the market. Having regard to colour, texture and material and hearing evidence of the different impression created by the Karen Millen garments in the informed user, the High Court found for the claimant. The defendant was restrained from selling the infringing articles, ordered to deliver up any unsold items and to account for profits to the claimant (an explanation of these is given in the section on remedy).

Copyright protection in a design

A 1986 case, Merlet v Mothercare,[226] concerned itself with whether a cape for a pram was a work of artistic craftsmanship or whether a design right might exist for it. The rain-cosy which had been copied by Mothercare had a utilitarian function (it had been originally made to protect the claimant's baby from rain) so it could not be protected as a work of artistic craftsmanship (above). Merlet failed in her claim but had she instead tried to show infringement of her design drawings then she might have succeeded. Not all the rights described here were available to Merlet at the time of her case.

Copyright is widely regarded as the superior form of intellectual property distinguishing artists from 'mere' designers. However, when you consider that copyright protection extends to art of the dubious quality, this belief is highly questionable. The CDPA attempted to overcome the problems of protection for functional designs by giving indirect protection through (two-dimensional) design documents that describe them, and extending copyright protection to three-dimensional reproductions of that document.[227] Potentially, copyright might be used either by directly protecting an article as an artistic work or indirectly through the protection given to the author of, for example, the preliminary sketches evidencing the creation of a design. The design document will be an artistic work only if the article is also an artistic work or an item of artistic craftsmanship. The reader is reminded, however, of the originality criteria to be satisfied in copyright law, and the CDPA provides that copyright is not infringed through the making of an article from a design document when that design is for anything other than an artistic work.[228] For this type of copyright to subsist and be actionable, there must be a design document (or model embodying the design) of the type described by the act[229] which relates to aspects of the object's shape and which the defendant has copied. Copyright cannot subsist, in the method of construction, an item solely for surface decoration or if the shape of an article is such that it must fit, match or be interchangeable.[230] With this in mind, the reader may be able to make slightly more sense of the Breville, Metix and Lucas film cases discussed in the copyright section.

The CDPA makes provision for copyright subsistence of twenty-five years[231] for such works, used in industrial production of more than fifty articles,[232] from when the articles are first marketed.[233] The moral right of integrity is available to the creator but not that of attribution.[234] It cannot be an infringement of a design right to do anything which is an infringement of copyright in the same work.[235]

Attempts to side-step the law and revive IP rights that have expired using this type of law was observed in a case involving Lego bricks which was registered as a design in 1956.[236] Lego claimed copyright infringement against the defendant for which the court would have to have found that the bricks had aesthetic appeal above their functional feature. Lego argued that later modifications made to the design drawings attracted copyright protection. The case went against the claimant and held that the bricks attracted a design right (which had expired).

UK Unregistered Design Rights

While UK Registered Design and Unregistered Community Design rights protect the overall appearance of designs (excluding those aspects determined by function), a UK Unregistered Design Right provides short-term protection of three-dimensional functional designs[237] and arises automatically once a design is created.

The UK Unregistered Design Rights system offers protection to non-aesthetic designs, designs that are not clearly visible, and purely functional designs. There is no Unregistered Design Right in the method for how a shape is constructed[238] which prevents designers from avoiding the payment required for patent protection. Features that are designed to allow the object to connect with another feature in order for the object to perform its function ('must match') are also excluded.[239] Surface decoration also falls outside of this type of protection.[240]

To claim protection as a UK Unregistered Design, the article must be original and not 'commonplace',[241] as determined through an examination of similarities to other designs in the appropriate design field. Ownership of a UK Unregistered Design Right rests with the designer,[242] with the exceptions of where the design was commissioned[243] or was produced in the course of employment by an employee.[244] The designer is not the person with the idea or the person who acts on instruction but the person who 'creates' the design.[245] The duration of a UK Unregistered Design Right is fifteen years from the end of the year of the design's creation or, if it is made available to the public within five years of its creation, ten years from this date.[246] To qualify for protection in the UK, the designer must be a qualifying person[247] or have been commissioned or employed by such a person,[248] or the design must have been marketed by such a qualifying person.[249]

UK Unregistered Design Rights owners have the exclusive right to reproduce a design for commercial purposes[250] and to authorise others to do this.[251] Similarity between articles is insufficient to show a primary infringement; the article must have been copied. For businesses operating in the same market, with the same constraints, articles are likely to be quite similar so establishing a causal connection can be difficult. The test is one of 'substantial similarity'[252] determined through the eyes of a typical customer whose overall impression is that the articles are the same. For a secondary infringement to be found, the defendant must know (or be in a position to have known) that an article with which they were dealing was an infringing one.[253] Secondary infringements include import, possession, sale, exposure to sale and export.

In Lambretta v Teddy Smith,[254] the claimant produced an article of clothing evocative of 1970s sportswear in its choice of colours (blue body, red arms, white zip) and the position of these in relation to the claimant's logo. Lambretta brought an action for infringement of a UK Unregistered Design Right and/or infringement of artistic copyright against Teddy Smith who appeared to have copied the garments. Since surface decoration of an object is not covered by the UK Unregistered Design Rights system[255] and colour combinations were

found to be neither shape nor ornament, the articles were not protected as a UK unregistered design or in copyright. One of the Court of Appeal judges noted that the shirt would have qualified for protection as an Unregistered *Community Design*, if this had existed at the time the shirt colours were copied.

Some closing thoughts on designs and copyright

If the ruling of CJEU in Infopaq is taken to a logical conclusion[256] and 'intellectual creations' are protectable then the difference between designs (qualifying for design rights) and artistic works (qualifying for copyright protection) might eventually disappear. The case of Abraham Moon v Andrew Thornber[257] involved two fabrics (*skye sage* and *spring meadow)* which can be seen at http://www.harbottle.com/abraham-moon-sons-limited-v-thornber-others-infringement-of-fabric-design-ticket-stamps/. The Patents County Court held that the 'ticket stamp' (the loom instructions that produce a fabric design) was an artistic work (and a literary work).[258]

Section 4: trademarks and patents

This section will sketch out the characteristics of forms of intellectual property which will be of less immediate relevance to those from an art, design or media background. However, the ideas are of use to those who wish to ensure that they do not infringe the rights of others and in suggesting the point at which practitioners will need to seek the advice of a trademark or patent lawyer.

Patents

In 1976, UK inventor Arthur Paul Pedrick applied successfully for a patent for a chromatically sensitive cat-flap.[259]

Patenting involves the disclosure of technical information in exchange for exclusive rights to use an 'invention' for up to twenty years. This disclosure is done by an application demonstrating that an item meets the requirements for a patent. Patents are awarded conditional to the subject matter's novelty and the 'non-obviousness' of the inventive step involved in its production. A patent can be granted by the UK Intellectual Property Office (formerly known as the Patent Office; many academics and lawyers still use this term) or the European Patent Office (EPO) based in Munich. The inventor may need to make multiple applications by different legal jurisdiction though a single 'bundle' of applications can be made to the European Patents Office giving protection in all states party to the European Patent Convention 1973.[260]

The task of drafting a patent application is complex and involves an abstract, a description of the invention, the claims made and any design documents or drawings.[261] The abstract gives a summary describing the technical field, the problem the subject matter seeks to resolve, the solution and the subject matter's principal use. The written description clearly explains how the subject matter

differs from previous inventions.[262] The description must be done in a way that someone 'skilled in [that] ... art'[263] could make the subject matter; this is called the 'enabling disclosure'.

In order to be patentable the subject matter: cannot be immoral or contrary to public policy; it must be novel (meaning that it does not form part of the current 'state of the art');[264] its production must involve an inventive step,[265] 'non-obvious' to someone skilled in the art (without the benefit of hindsight);[266] and it must be capable of industrial application.[267] In the UK, a 'full application' can be preceded by 'early filing' which allows uncertain applicants twelve months' grace to consider their position.

On application, a search is done in relation to the subject matter's novelty; it cannot be 'novel' if it has already been made available to the public, except if there has been publication of the material in 'breach of confidence'.[268] The application is published for public inspection (within eighteen months of filing). Within six months of publication, the applicant must formally request substantive examination, at which point the application passes to either the European Patent Office or the UK Patent Office. Assuming the patent application is successful, there is a grant of patent and publication of it in the *Patent Bulletin*. Anyone can apply for revocation of a patent through 'oppositional proceedings'. The basis of oppositional proceedings can include: a patent has been granted to the wrong person; an insufficiently detailed enabling disclosure (such that someone 'skilled in the art' could not make the product); or if there has been an impermissible amendment during the application process.[269] Aesthetic and non-technical subject matters along with discoveries, scientific theory[270] and mathematical methods cannot be patented.

Since a patent confers the exclusive right to make, use, sell, dispose of or import the invention for up to twenty years, who files an application first is important (though some amendments are permitted during the process). The owner of a patent has monopoly control over it; they can sue for infringement,[271] assign it, license it, mortgage it and make it the subject of a testamentary disposition (will). All of these types of transfer can be registered. If a competitor has, through 'independent creation', arrived at the same invention but has not filed an application, they will lose commercial control over it (though not necessarily their right to use it). The owner of the patent is the inventor,[272] unless this was an employee in the course of their employment.

Direct infringements include using a patented product or process, manufacturing it, selling it or importing it. Indirect infringement involves offering the means to do direct infringements.[273] There are some defences to infringement action[274] such as private non-commercial use, experimental use (to test a hypothesis for example), repairs and pleading prior use (that the alleged infringer was using the subject of the patent prior to patenting). Occasionally compulsory licences are issued in relation to the subject matter of a patent for which the owner is compensated financially. This might happen in instances where a business has either abused their monopoly or underused the subject of the patent.[275]

Trademarks

In 2006, a trademark dispute arose between Lindt and Hauswirth (Swiss and Austrian chocolatiers respectively). The dispute concerned who could manufacture and sell chocolate bunnies covered in gold-coloured paper, with a red ribbon around their neck. Lindt had registered the design as a three-dimensional trademark while Hauswirth stated that their rabbit had been on sale for fifty years.[276] The chocolate bunnies can be seen at http://ipkitten.blogspot. co.uk/2012/04/bunnies-austrian-supreme-court-delivers.html. Hauswirth were prohibited from the sale and manufacture of their bunnies in 2012 after six years of litigation; they planned to redesign their bunnies in consultation with Lindt and Sprüngli. Since 2012 I have done significant research into chocolate bunnies, several of which appear to be a whisker away from infringing Lindt's trademark rights but which, so far, have not been the subject of legal action.

Trademarks are symbols placed on, or that relate to, one trader's goods or services in order to distinguish them from those of another trader. This area of law concerns itself with words, images, symbols, signs, composites or anything of this type used to associate a business with its product.

In addition to trademark law, the common law offence of passing off applies to this field. Passing off prevents a trader from deceitfully passing off their goods as those of another trader, and in the process exploiting the other trader's reputation and the good-will in the consumer that the other trader has built up. English law on trademarks has been extended so that a trader no longer has to provide evidence as to the good-will of its consumers, or misrepresentation by another business, which is required for passing off. Passing off law is therefore now used mainly to protect unregistered trademarks and rights relating to 'personality' (see Chapter 3). In 2013, singer Rihanna succeeded in action against

clothing chain Topshop (Arcadia) for sale of T-shirts featuring an image of her, without authorisation. Arcadia were found to have passed off the clothing and the court observed that buyers may have been deceived into buying the product in the false belief that the singer had endorsed them.[277]

Community Trade Mark Regulations (CTMR) 1996 confer on traders the right to make a single application for a trademark in Europe.[278] The Trademark Law Treaty 1994[279] provides protection for well-known trademarks in jurisdictions in which they are not registered so that others may not register them.[280] Additionally, trademarks likely to cause confusion in the consumer are prohibited.[281]

Trademark registration is costly and time-consuming but confers on the owner a monopoly right over that mark. The UK Trademarks Registry in Newport, Wales (part of the UK Patent Office), the European Community Registry at the OHIM (Trade Marks and Designs Section) in Alicante and WIPO in Geneva all provide processes for trademark applications. Although registration can be done by the owner of the trademark, most commercial enterprises use a trademark lawyer. A UK application is filed with the name, address, details of goods/services for which the trademark will be registered, a visual representation of the mark and a declaration as to use of the trademark.[282] To succeed in a trademark application, the goods or services must be capable of classification into one or more of the defined classes of goods or services for trademarking.[283],[284]

In the UK, the registrar conducts a search and then, if there are no grounds for refusal, the trademark is published in the *Trade Marks Journal*.[285] There is a three-month period in which other parties can make observations about, or oppose, the mark. The registration is then published in the *Trade Marks Journal* and the trademark will enjoy ten years of protection after which it may be renewed for ten-year periods;[286] there is no maximum period for which a trademark can exist.

The OHIM in Alicante provides for the registration of a trademark on a European Community-wide basis.[287] Applicants can also be made to OHIM via a national registry. A Community application contains the same type of information required of the UK registry. An examination is then done by OHIM for absolute grounds of refusal[288] and a search is done for similar marks. The mark is published in the *Community Trade Marks Bulletin*[289] which provides third parties with the opportunity to make observations, or objections to, the mark. Registration is for ten years[290] and is renewable in *perpetuity*.[291] For an international application to be made to WIPO (Geneva), a trademark application must have been made in a country party to the Madrid Protocol 1989; referred to as the 'national basis for application'.

Criteria for a sign or mark are similar across all application processes. The subject matter of the application must be a sign that can be graphically represented, and which is capable of distinguishing goods or services from those of another undertaking.[292] The trademark cannot be a shape which results from the goods themselves[293] since this might lead to many indistinguishable trademarks all looking like the goods associated with them.

Signs can be words, names, designs, letters, numerals or shapes which must be visually perceptible (there has been a negative CJEU ruling on the status of smells and taste[294]). Colours create particular difficulty; in the case of Dyson v Registrar of Trademarks,[295] a transparent collection bin for a vacuum cleaner as a trademark was recognised as having the potential to prevent other manufacturers making transparent vacuum cleaner parts.

There are absolute grounds for refusing a trademark which include it: being non-distinctive; descriptive or too generic;[296] 'devoid of distinctive character';[297] or deceptive as to the quality or origin of goods.[298] Trademarks can also be refused on the grounds that they are contrary to public policy or morality[299] or prohibited by law.[300] Relative grounds for refusal are concerned with conflicts of the sign with other signs and third-party rights[301] but registration of similar marks for similar goods and services is only prohibited where confusion is likely to occur in the minds of the public.[302] If the goods or services are dissimilar then refusal of registration will only occur if the earlier mark is one of particular repute and the later mark would take unfair advantage of this or where a trademark might be detrimental to a prior mark's reputation.[303] An application made in 'bad faith' will be rejected, such as when the applicant has knowledge of a third party who may wish to use a similar sign (these are called 'ghost applications').[304]

Relative grounds for refusal[305] can also be employed to have a registered trademark declared invalid;[306] these include marks being identical or similar to unregistered trademarks in use. A trademark can be revoked if it has not been used for five years[307] or suspended if it is used to mislead the public.[308] Certain emblems are protected such as coats of arms and the Olympic symbol.[309]

Since the introduction of the Human Rights Act 1998, all grounds for exclusion have to be balanced against the right to freedom of expression[310] so something done in 'bad taste' will not be grounds for refusal. OHIM has in the past rejected the phrase 'screw you' for a clothing and sunglasses trademark but not for sex toys.[311]

Trademarks can be assigned to others, licensed, mortgaged and the subject of testamentary dispositions (wills). The owner (or exclusive licensee) of a trademark has sole rights to use it and may bring action for infringement.[312] Community trademarks can be enforced in national courts (usually in the country that the defendant is domiciled). UK registered trademarks are enforced in the UK.

There is no need for the defendant trader to have knowledge of the trademark or to have copied it in order for infringement to be found.[313] Liability is *strict* (as with registered designs and patents). Infringement involves use of a registered trademark (or one that is similar) in the course of trade in identical, or similar, goods and services,[314] taking unfair advantage of a trademark or causing damage to the distinctive character or reputation of a mark of repute.[315] The concept of contributory infringement[316] covers secondary participations in trademark abuse such as where the person applying the mark to the materials has actual or constructive knowledge that this is unauthorised.

There are defences to an infringement action[317] which include demonstrating the existence of a conflicting right that invalidated registration such as the subsistence of copyright or a registered design right.[318] Protection also extends to the use of a defendant's own name and address in the course of business.[319] A trademark may also be used by a competitor in fair comparative advertising.[320]

Section 5: remedies for intellectual property infringements

To take legal action against a party with significant financial and human resources takes significant mettle on the part of the lone litigant, particularly if the other party is prepared to be dishonest. Invariably, a claimant will find out quite by accident that their intellectual property has been infringed and will need to start gathering evidence at that point. In the age of electronic communications, such evidence can quickly disappear. Equally, the internet has enabled IP infringements on a wide scale not envisaged when the original laws relating to IP were formulated. There are recognised difficulties for copyright law in relation to global communication mechanisms, both in terms of how IP is protected and how readily it can be violated.

At the point of discovery of an IP infringement, *without prejudice* discussions might begin and lead to an *out-of-court* settlement being reached for relatively little money. Judicial mediation is an underfunded, but extremely valuable, tool in the UK which permits parties, under the guidance of a specially trained judge, to settle matters without the need for a hearing. There are statutory provisions intended to protect parties from unjustified threats to sue in relation to IP[321] except in cases of copyright infringement, passing off and breach of confidence. Practical considerations will almost certainly include which party has the economic resources to withstand a finding of liability; there is little point in a moral victory against someone who cannot pay damages, unless an injunction is the primary motive for taking action. Other considerations will be who is responsible for the infringement and in what way; for example, employers are vicariously liable for the acts of their employees who can be named as the second defendant. For indirect, or secondary, infringements, the claimant must be able to show that the infringer knew, or should have known, that they were dealing in infringing goods. For copyright, patents and trademarks, legal action must be brought within six years of the discovery of the wrongful act.[322]

Evidence collection and pre-trial processes

The owner of an IP right can apply for a court order requesting that information relevant to legal action be disclosed.[323] Such information might include the name and addresses of potential defendants, relevant dates, details of imports and information as to the source of goods. Search orders can be obtained;[324] a claimant's solicitor is permitted without notice (if there is a *prima facie* case for infringement and providing that a supervising solicitor is present) to inspect a

defendant's premises to seize, or copy, subject matter which is alleged to infringe their client's IP rights. The reason this is done without notice is to prevent the destruction of evidence. A freezing order (a *Mareva injunction*) can also be sought through the courts permitting the retention of property, or the freezing of assets, pending litigation. Trap orders permit a potential claimant to obtain evidence without a court order[325] in order to prevent the destruction of evidence. The police must be notified of the intent to do this before such an attempt to obtain the evidence, and since such seizure must be in a public place, this provision has only limited use. The 1995 TRIPS rules[326] allow seizure of any imported goods carrying a trademark unlawfully[327] (in the case of the UK, this would be done by HM Customs).

Before trial, the possibility of an interim injunction curtailing the activities of the defendant on a temporary basis is arguable by the claimant.[328] If a defendant is found to be liable subsequent to trial then this may become permanent. Interim injunctions ('interlocutory relief') can deal with the problems caused by the delay between the claimant's discovery of an infringement and the full hearing. Such interim relief is available if it is 'in the interests of justice'.[329] An application by the claimant for an injunction is through sworn written evidence which is not, at the interim relief hearing, *cross-examined*. The court must balance any irreparable consequences that might result from granting interim relief or failing to grant it. Since a poor determination at interim relief stage can affect the possibility of effective remedy at the end of a trial, it is unsurprising that in 1975 the House of Lords (now called the Supreme Court) determined the approach to this.[330] To obtain interim relief, a claimant must have a *prima facie* case (one in which there is a 'serious question to be tried'[331]) and the court must apply the 'balance of convenience' test which looks at the consequences of granting interim relief and those of not granting it for both sides. The introduction into English law, in 1998, of Articles 10 and 12(3) of the European Convention on Human Rights modifies this test. The courts are still required to look at the seriousness of the legal question and the claimant's prospects of success, but must not attempt a 'mini-trial' prejudging the final outcome, and must consider how else the *status quo* might be maintained.[332] If, in the event of a finding for the claimant, damages would be an adequate remedy then it is unlikely that an injunction will be given. If the kind of damages that might arise from the defendant's activities are of the type that cannot be compensated financially then an injunction is more likely. The question of whether a defendant could pay the appropriate damages is also important; a small business is more likely to be the subject of an injunction curtailing a specific activity. This means that the rich are favoured over the poor and we are reminded that the law is often, despite its complicated structure and internal regulation, rather a blunt tool.

TRIPS[333] and Community law[334] require states to facilitate the prevention of imports of goods which infringe IP. In the UK, a rights-holder can apply to the Commissioners of HM Revenues and Customs[335] to prevent such imports. TRIPS requires member state action to be sufficiently severe to act as

a deterrent to future infringements. A defendant can agree to the destruction of the offending goods without the need for further legal action (this is known as the simplified procedure).

Burden of proof

In the case of a patent, a registered trademark or a registered design right, it is for the defendant to show that the rights of the claimant are invalid. For unregistered design rights and copyright, the author must show the legitimacy of ownership, that the work is original and *prima facie* evidence that the defendant's work is derived from their own. The testimony of experts is sometimes used in IP hearings; for example, in relation to the criteria for filing a patent, whether a 'substantial part' of a copyrighted work has been reproduced or the likelihood of 'confusion' arising in the mind of potential consumers in action for trademark infringement.

Types of final remedy

Final injunction

Where an infringement is found then a final injunction prevents the future infringing activities by the defendant.

Delivery-up and/or destruction

The remedies of delivery-up (forfeiture to the claimant) and destruction of goods are provided for in a variety of Acts of Parliament.[336] The defendant often chooses whether to deliver-up or destroy the offending articles (unless they have been shown to be unreliable in court). An order for the removal of offending trademarks can be made but this does not extend to third party owners of infringing articles (that is, people who bought the articles in good faith).

Damages and licence of right

Damages can take the form of either a licence of right (a compulsory licence paid for by the defendant) or the lost profits the claimant suffered. The recovery of financial damages is provided for in law regulating intellectual property[337] but it should be compensatory rather than punitive. The aim is restore the victim of infringement to the position they would have been had their IP not been infringed.[338]

In the case of registered designs and patents, innocence of mind is no defence to liability but it might reduce the damages paid to the claimant. A defendant who was unaware that an IP right existed, and had no grounds for supposing it, will be unlikely to pay more than the appropriate royalties. Similarly a defendant who reasonably believed that neither copyright, nor an unregistered

design right, existed might be dealt with more leniently in respect of remedy (if indeed they are found liable at all). For trademark infringement and passing off, damages are rewarded regardless of the defendant's innocence of mind.

Infringement can cause both financial loss and a depreciation of the value of an IP right so, in the case of knowing infringements, it is intended that damages reflect the prejudice suffered.[339] Lost profits may be difficult to calculate but should reflect whatever the claimant lost due to having to compete with the goods/services offered by the infringer. The claimant may be left to choose between lost profits and royalties/compulsory licence, though sometimes the two calculations are combined. Rarely, the courts will award exemplary damages where there has been a cynical disregard for the claimant's intellectual property rights (for example if the defendant simply decided that the profit made would exceed the compensation that might eventually be payable should the claimant take action and succeed in it).

Account for profits

Account for profits is an *equitable* remedy (see Introduction) available at the court's discretion when damages are difficult to calculate or have not been suffered,[340] and where the material has been used commercially. The courts will look at the net profits of the defendant company (deducting production costs) and consider what proportion is attributable to the infringement.[341] Account for profits is not available in the case of 'innocent' infringers (those without intent) in the case of patents, passing off, registered design and trademark infringement.

Statutory damages

The CDPA makes provision for such damages 'as justice requires'.[342] It is unclear from the act whether these are intended to be compensatory, exemplary or restitutionary. They are not available in addition to 'account for profits'.[343] They may be awarded if the acts of the defendant were deliberate and cynical, if the impact of the defendant's activities on the claimant were particularly damaging or if the defendant had refused to purchase a licence from a reasonable claimant.

Crime and punishment

Actions for criminal IP infringements are brought by the police or a relevant public authority. The standard of proof in criminal action is 'beyond reasonable doubt' (a higher threshold than the 'balance of probabilities' required in civil action). Counterfeiting and piracy are becoming more widespread,[344] and a rights-holder can put information before a Magistrates' Court or ask the police (or other authorised body) to take action which will lead to the involvement of the Crown Prosecution Service/Department of Public Prosecutions (who decide whether to prosecute the case).

Statutory offences

Under the CDPA, there is a maximum penalty of ten years' imprisonment, as well as a fine of up to £50,000, for making and/or dealing in, copyright infringing articles[345] or dealing in illicit recordings.[346] Most sanctions imposed are less severe; for example, in the case of Lewis[347] the person who ran an offending computer bulletin board was sentenced to twelve months in prison.

There are few criminal sanctions for the infringement of patents and designs; the exception being falsifying the patent register, falsely representing ownership of a patent or falsely representing a design to be registered (punishable by a fine).[348] It is a criminal offence to state that a trademark is registered if it is not,[349] and on summary conviction a fine of up to £1,000 can be imposed. For trademarks, it is an offence to apply to goods, packaging or business materials, any sign that is identical to, or likely to be mistaken for, a registered trademark.[350] This can carry a sentence of up to six months or a fine of up to £5,000. If a defendant has acted honestly, or in a reasonable belief that what was done was not unlawful, then this is a legitimate answer to action. Fines, delivery-up, confiscation and compensation may be ordered for trademark infringement and, in contrast to civil action, there is no time limit.[351]

Trades descriptions

It is an offence to place a false description on goods and/or offer these for sale,[352] unless the party who did so did not reasonably know of the infringement.[353] The maximum prison sentence for this offence is currently two years. Goods might be seized by the police.[354]

Notes

1 Häagen-Dazs Inc v Frusen Glädjé Ltd 493 F Supp 73 Dist. Court, SD New York 1980.
2 Brighton v Jones [2005] FSR (16) 288.
3 Twentieth Century Fox Film Corporation & Matt Groening Productions Inc v the South Australian Brewing Company Ltd & Lion Nathan Australia Pty Ltd NG 155 of 1996 Fed No 365/96.
4 http://www.law.harvard.edu/faculty/tfisher/PILFoxvAus.htm.
5 Berne is sometimes referred to as the Universal Copyright Convention.
6 Except Article 6.
7 For example Nova Productions Ltd v Bell Fruit Games [2006] RPC(14) 379.
8 Temple Island Collections Ltd v New English Teas Ltd & Nicholas John Houghton [2012] EWPCC 1; [2012] ECDR 11.
9 *Copyright act row as the Times reveals Turner prize artist's inspiration* (The Times 28/11/2000) and *Sci-fi artist sues over Turner plagiarism* (The Times 11/4/2001). http://www.theartnewspaper.com/articles/Art-and-copyright-whats-at-stake/17203.
10 http://www.newyorker.com/online/blogs/culture/2014/02/the-multimillion-dollar-magazine-illustration.html.
11 CDPA 1988 Section 4(1).
12 *ibid.* Section 17(3).

13 Hensher v Testawile Upholstery (Lancs) [1976] AC 64.
14 Merlet v Mothercare [1986] RPC 115.
15 Vermaat & Powell v Boncrest Ltd. [2001] (5) FSR 49.
16 *ibid.*
17 Merchandising Corporation v Harpbond [1983] FSR 32.
18 Nottage v Jackson (1883) 11 QB 627.
19 Nova Productions Ltd v Mazooma Games [2007] EWCA Civ 219.
20 Wham-O v Lincoln Industries [1985] RPC 127 [New Zealand].
21 Metix v Maughan [1997] FSR 718.
22 Breville Europe v Thorn EMI Domestic Appliances [1995] FSR 77.
23 CDPA 1988 Section 4.
24 Lucas Film Ltd & anor v Ainsworth & anor [2011] UKSC 39; [2009] WL 466697; [2009] EWCA Civ 1328; [2008] EWHC 1878 (Chancery Division).
25 CDPA 1988 Section 4.
26 *ibid.* Section 51.
27 *ibid.* Section 3(1).
28 University of London Press v University Tutorial Press [1916] 2 Ch 601.
29 Hollinrake v Truswell (1894) 3 Ch 420.
30 *ibid.* para. 61.
31 Francis Day & Hunter v 20th Century Fox [1940] AC 112.
32 CDPA 1988 Section 3(1).
33 Norowzian v Arks (No. 2) [2000] EMLR 67.
34 Nova Productions Ltd v Mazooma Games [2006] RPC (14) 379.
35 Copyright Act 1956.
36 Norowzian v Arks (No. 2) [2000] FSR 363.
37 CDPA 1988 Section 5B(3)(a).
38 *ibid.* Section 6(1).
39 *ibid.* Section 8(1).
40 *ibid.* Section 3(2).
41 Lucas v Williams & Sons [1892] QB 11.
42 Komesaroff v Mickle [1988] RPC 204.
43 CDPA 1988 Section 1(1).
44 Sawkins v Hyperion [2005] 1 WLR 3281 para 31.
45 Macmillan v Cooper (1923) 93 LJPC 113.
46 Ladbroke v William Hill [1964] 1 All ER 465, 469.
47 Infopaq International A/S v Danske Dagblades Forening C-5/08 [2009] I-6569; [2009] ECDR 16; [2012] Bus LR 102.
48 See also Recital 171 Duration Directive 93/98/EEC.
49 Graves' Case (1869) LR 4 QB 415, para. 723.
50 Antiquesportfolio.com PLC v Rodney Fitch & Co Ltd [2001] FSR 345.
51 Duration Directive 93/98/EEC, as amended by Directive 2006/116/EC.
52 CDPA 1988 Sections 5A(2), 5B(4), 6(6), 7(6), 8(2).
53 *ibid.* Section 17(4).
54 *ibid.* Section 11(1).
55 *ibid.* Section 9(1).
56 Cummins v Bond [1927] 1 Ch 167.
57 CDPA 1988 Section 104.
58 *ibid.* Section 9(1)(aa)-(ab).
59 *ibid.* Section 11(2).
60 *ibid.* Section 215.
61 Durand v Molino [2000] ECDR 320.
62 CDPA 1988 Section 85.
63 *ibid.* Sections 16–21.
64 *ibid.* Sections 16(1) & 16(2).

65 *ibid.* Sections 62–64.
66 *ibid.*
67 *ibid.* Section 17.
68 *ibid.* Sections 27(4).
69 Francis Day & Hunter v Bron [1963] Ch 587, para 623.
70 CDPA 1988 Section 16(3)(a).
71 *ibid.* Section 17(2).
72 *ibid.* Section 17(3).
73 *ibid.* Section 62.
74 Norowzian v Arks (No 1) [1998] FSR 394.
75 Macmillan v Cooper (1924) 40 TLR 186.
76 Interlego v Tyco Industries [1989] AC 217.
77 CDPA 1988 Section 16(2).
78 CBS Songs v Amstrad [1988] 2 All ER 484.
79 CDPA 1988 Section 12.
80 Duration of Copyright and Rights in Performance Regulations 1995 SI 1995/2397.
81 CDPA 1988 Section 12(2).
82 *ibid.* Section 12(4).
83 *ibid.* Section 13B(2).
84 *ibid.* Section 13B(4)(a).
85 *ibid.* Section 13B(4)(b).
86 *ibid.* Section 12(3).
87 *ibid.* Section 12(4).
88 Copyright Act 1911 Section 17.
89 CDPA 1988 Schedule 1 Para 12.
90 Duration of Copyright and Rights in Performance Regulations 1995 SI 1995/2397.
91 CDPA Sections 13A(2) & 14(2).
92 European Duration Direction 1995 (Article 4).
93 CDPA1988 Section 103.
94 *ibid.* Section 95.
95 *ibid.* Section 84.
96 *ibid.* Section 94.
97 *ibid.* Section 79(3).
98 *ibid.* Section 87.
99 *ibid.* Section 78(3)(a).
100 *ibid.* Section 78(1).
101 *ibid.* Section 78(5).
102 *ibid.* Section 77(7).
103 *ibid.* Section 77(8).
104 *ibid.* Section 80(5).
105 *ibid.* Section 77.
106 *ibid.* Section 77(7)(a).
107 *ibid.* Section 80(1).
108 *ibid.* Section 81(3).
109 *ibid.* Section 80(2)(a).
110 *ibid.* Section 80(1)(2) and Section 80(2)(b).
111 *ibid.* Section 80.
112 *ibid.* Section 80(4)(a).
113 *ibid.* Section 80(3)(a).
114 *ibid.* Section 80(3)(b).
115 *ibid.* Section 82.
116 *ibid.* Section 178.
117 *Hirst pays up for Hymn that wasn't his* (Guardian 19/5/2013) http://www.theguardian.com/uk/2000/may/19/claredyer1.

118 CDPA Section 16(3)(b).
119 Waterlow Directories v Reed Information [1992] FSR 409.
120 CDPA 1988 Section 16(3).
121 Warwick Film Productions v. Eisinger [1969] 1 Ch. 508, 533.
122 Ashmere v Douglas Home [1987] FSR 553; Johnstone Safety v Peter Cook [1990]
 FSR 161, 178.
123 Kenrick v Lawrence (1890) 25 QBD 99.
124 Newspaper Licensing Agency Ltd v Marks & Spencer Plc [2003] 1 AC 551, 559,
 para 19.
125 CDPA 1988 Sections 22–26.
126 *ibid.* Section 27(2).
127 *ibid.* Section 25(1).
128 *ibid.* Section 83.
129 *ibid.* Part I, Chapter III.
130 *ibid.* Section 29(1).
131 *ibid.* Section 30(1).
132 *ibid.* Section 30(2).
133 *ibid.* Section 29.
134 *ibid.* Section 30(1).
135 *ibid.* Sections 30(2)–30(3).
136 Hubbard v Vosper [1972] 2 QB 84.
137 CDPA 1988 Section 30(1).
138 *ibid.* Section 31(1).
139 IPC Magazines v MGN [1998] FSR 431.
140 CDPA 1988 Section 31(3).
141 *ibid.* Sections 37–44.
142 *ibid.* Section 39.
143 Copyright (Libraries and Archivists) (Copying of Copyright Material) Regulations
 1989, the Information Society Directive Article 5(2)(i) and the Public Lending
 Rights Scheme (Rental Directive, Article 5); see also CDPA 1988 Section 40A.
144 CDPA 1988 Section 32(1).
145 *ibid.* Section 178.
146 *ibid.* Section 32(1).
147 *ibid.* Sections 32(2) & 32(4).
148 *ibid.* Section 178.
149 Universities UK v Copyright Licensing Agency Ltd [2002] RPC 693.
150 CDPA 1988 Section 93.
151 *ibid.* Section 90(3).
152 Companies Act 1985.
153 CDPA 1988 Sections 1 and 90(1).
154 *ibid.* Section 101A, SI 2003/2498.
155 *ibid.* Section 102.
156 Designers Guild Ltd v Russell Williams (Textiles) Ltd (t/a Washington DC) [2000]
 FSR 121; [2001] ECDR 10.
157 Designers Guild v Russell Williams [1998] FSR 803.
158 Registered Designs Act 1949 and the CDPA 1988.
159 RDA 1949 Section 3(R).
160 *ibid.* Section 3A.
161 *ibid.* 3A(3), 3(2) and 3(3).
162 *ibid.* Section 3A(4)(a).
163 *ibid.* Section 3A(4).
164 *ibid.* Schedule A1.
165 *ibid.* Section 18.
166 *ibid.* Section 22(2).

167 Regulations on Community Design 6/2002.
168 Article 3 of the Community Design Regulations.
169 CDR Article 36(2).
170 *ibid.* Article 35(1).
171 *ibid.* Article 18.
172 *ibid.* Article 5(1).
173 *ibid.* Articles 37 & 2(2).
174 *ibid.* Article 4.
175 *ibid.* Article 4(2).
176 *ibid.* Article 1(2)(a).
177 *ibid.* Article 50.
178 *ibid.* Article 5.
179 *ibid.* Article 11.
180 *ibid.* Article 3(a).
181 *ibid.* Article 47.
182 *ibid.* Article 14.
183 *ibid.* Article 95.
184 Designs Directive Article 7; CDR Article 8(1); RDA 1949 Section 1C(1).
185 Designs Directive Article 7(2).
186 *ibid.* Article 8.
187 Designs Directive Article 4; CDR Article 5(2); RDA 1949 Section 1B(2).
188 Designs Directive Article 6(2); CDR Article 7(2)(b); RDA 1949 Section 1B(6)(c)–(d).
189 Designs Directive Article 6; CDR Article 7(1); RDA 1949 Section 1B(5)(a).
190 Designs Directive Article 3(2); CDR Article 4(1); RDA 1949 Section 11ZA(1)(b).
191 Designs Directive Article 9(1); CDR Article 10(1); RDA 1949 Section 7(1).
192 Designs Directive Article 5(1).
193 *ibid.* Recital 13.
194 *ibid.* Article 11(1)(c).
195 *ibid.* Article 11(3).
196 RDA 1949 Section 11ZA(2).
197 *ibid.* Section 20(1A)(c).
198 Designs Directive Article 11(1)(d).
199 See Pepsico Inc's Design (No ICD 000000172) OHIM.
200 Designs Directive Article (4)(b).
201 RDA 1949 Section 11ZA(3).
202 CDR Article 15.
203 Sweden Act No. 2002:270, Article 4(4)(b) amending the Swedish Design Protection Act 1970: 485.
204 Designs Directive Article 11(2).
205 RDA 1949 Sections 1A(4)(c) & 112A(1).
206 RDA 1949; CDR Article 25(1)(f)(3); Designs Directive Article 11(2)(a).
207 RDA 1949 Section 2(3).
208 *ibid.* Section 2(1).
209 RDA 1949 Section 2(1B); CDPA 1988 Section 213.
210 RDA 1949 Section 2(1A); CDPA 1988 Section 213.
211 CDR Article 14(1).
212 *ibid.* Article 14(3).
213 *ibid.* Article 18.
214 *ibid.* Article 36(3)(e).
215 RDA 1949 Section 19; CDR Article 32.
216 Designs Directive Article 12, CDR Article 19; RDA Section 7(1); RDA 1949 Section 7(1).
217 Designs Directive Article 13(1).

218 CDR Articles 19(2) & 19(3).
219 *ibid.* Article 22.
220 RDA 1949 Section 3C(1).
221 CDR Articles 19(2) & 19(3).
222 Directive Article 1(a); CDR Article 3(a); RDA 1949 (Section 1(2).
223 Designs Directive Article 4; CDR Article 5(2); RDA Section 1B(2).
224 Designs Directive Article 6(1); CDR Article 7(1).
225 Karen Millen Ltd v Dunnes Stores & anor [2007] IEHC 449.
226 Merlet & anor v Mothercare Plc [1986] RPC 115.
227 CDPA 1988 Sections 213(1),(2) & (4).
228 *ibid.* Section 51.
229 *ibid.* Section 51(3).
230 *ibid.* Section 213(3).
231 *ibid.* Section 52(4)(a).
232 *ibid.* Section 52.
233 *ibid.* Section 52(2).
234 *ibid.* Section 79(4)(f).
235 *ibid.* Section 236.
236 Interlego v Tyco Industries [1989] AC 217.
237 CDPA 1988 Part III.
238 *ibid.* Section 213(3)(1).
239 *ibid.* Sections 213(3)(b)(i) & (ii).
240 *ibid.* Section 213(3)(c).
241 *ibid.* Section 213(4).
242 *ibid.* Section 215(1).
243 *ibid.* Section 215(2).
244 *ibid.* Section 215(3).
245 *ibid.* Section 214.
246 *ibid.* Section 216(1).
247 *ibid.* Section 218.
248 *ibid.* Section 219.
249 *ibid.* Section 255.
250 *ibid.* Sections 226(1) and (2).
251 *ibid.* Section 226(3).
252 *ibid.* Section 226(2).
253 *ibid.* Section 233(2).
254 Lambretta Clothing Company Ltd v Teddy Smith (UK) Ltd [2004] EWCA Civ 886.
255 CDPA 1988, Part III.
256 Infopaq International A/S v Danske Dagblades Forening C-5/08 [2009] I-6569; [2009] ECDR 16; [2012] Bus LR 102.
257 Abraham Moon & Sons ltd v Andrew Thornber Ltd & ors [2012] EWPCC 37.
258 CDPA 1988 Section 51.
259 http://worldwide.espacenet.com/publicationDetails/biblio?CC=GB&NR=142669 88&KC=&locale=en_ep&FT=E.
260 Community Patent Co-operation Treaty 1970, European Patent Convention 1973, Community Patent Convention 1975 and the European Patent Convention of 2000 to which there are currently 34 signatories/member states.
261 European Patent Convention of 2000 Article 78(1); Patent Act 1977 Section 14(2).
262 Patents Act 1977 Section 14(5).
263 EPC 2000 Article 83; Patent Act 1977 Section 14(3).
264 EPC 2000 Article 51(1); Patents Act 1977 Section 2(1).
265 Patents Act 1977 Section 3.
266 EPC 2000 Article 52(1); Patents Act 1977 Section 1(1)(b).
267 Patents Act 1977 Section 4.

268 *ibid.* Section 4(4)(b).
269 *ibid.* Section 72.
270 Biotechnology is covered by Directive 09/44/EC and is not discussed here.
271 Patents Act 1977 Section 60(1).
272 *ibid.* Section 7(2)(a).
273 *ibid.* Sections 60(1)-(2).
274 *ibid.* Sections 60(5)(a)-(i).
275 UK and European Competition Law EU Regulation 2006 816/2006.
276 Chocoladefabriken Lindt & Sprüngli AG v Franz Hauswirth GmbH C-529/07.
277 *The Evening Standard* 31 July 2013: 7; Fenty v Arcadia Group Brands Ltd [2013] EWHC 2310.
278 See also the Trade Marks Directive 89/104/EEC and the Trade Marks Act 1994 implementing this into English law.
279 Trademark Law Treaty 1994 Article 2.
280 Paris Convention 1883 Article 6.
281 *ibid.* Article 16.
282 TMA 1994 Section 32.
283 *ibid.* Section 34.
284 The Nice Agreement for the International Classification of Goods and Services 1957 defined thirty-four classes of goods and eight classes of services.
285 *ibid.* Section 38.
286 *ibid.* Section 42.
287 Community Trademark Regulations 1996 Article 2.
288 *ibid.* Article 7(1).
289 *ibid.* Article 40.
290 *ibid.* Article 46.
291 *ibid.* Article 47.
292 CTMR 1996 Article 4; TMA Section 1(1).
293 CTMR 1996 Article 7(1)(c)-(e); TMA 1994 Sections 3(1)(c) & 3(2).
294 Ralf Sieckmann v Deutsches Patent-und Markenamt, Case C-273/00 [2002] ECR 1–11737).
295 Dyson Ltd v Registrar of Trademarks Case C-321/03 [2007] 2 CMLR (44) 303.
296 CTMR 1996 Article 7(1)(b)-(d); TMA 1994 Section 3(1)(b)-(d).
297 CTMR 1996 Article 7(1)(b); TMA 1994 Section 1(1)(b).
298 CTMR 1996 Article 7(1)(g); TMA 1994 Section 3(3)(b).
299 TMA 1994 Section 3(3)(a).
300 *ibid.* Section 3(4).
301 *ibid.* Section 5(1).
302 *ibid.* Section 5(2).
303 *ibid.* Section 5(3).
304 CTMR 1996 Article 7; TMA 1994 Sections 3(b) and 3(3)(a) & (b).
305 CTMR 1996 Article 8; TMA 1994 Section 5(1)-(4).
306 CTMR 1996 Article 51; TMA 1994 Section 47(2)(g).
307 CTMR 1996 Articles 51–52; TMA 1994 Section 47.
308 CTMR 1996 Article 50(1)(c); TMA 1994 Section 46(1)(d).
309 TMA 1994 Section 4.
310 Article 10 European Convention on Human Rights.
311 Kenneth, Case R 495/2000-G [2007] ETMR (7) 111.
312 TMA 1994 Sections 23, 30 & 31.
313 TMA 1994 Sections 10(1)-(4); CTMR 1996 Article 9.
314 TMA 1994 Sections 9(1), 10(1) & 10(2).
315 *ibid.* Section 10(3).
316 *ibid.* Section 10(5).
317 CTMR 1996 Article 12; TMA 1994 Section 11.

318 TMA 1994 Section 5(4).
319 CTMR 1996 Article 12(c); TMA 1994 Section 11(2)(a).
320 Directive on Misleading and Comparative Advertising (MCAD), Directive 2006/114/EC.
321 Patents Act 1977 Section 70, Trade Marks Act 1994 Section 21, Registered Designs Act 1949 Section 26 and the Copyright, Designs and Patent Act 1988 Section 253 in the case of unregistered designs.
322 Limitation Act 1980, Section 2.
323 Civil Procedure Rules 1998 r31.
324 Civil Procedure Act 1997 Section 7 and the Civil Procedure Rules 1998 r25.
325 CDPA 1988 Sections 100 & 196.
326 Trade-Related Aspects of Intellectual Property Rights 1995 Part III.
327 Paris Convention 1883 Article 9.
328 CTMR 1996 Article 98; CDR 2002 Article 89.
329 CPR 1998 r25.1(a) & r25.2(2)(b).
330 American Cyanamid v Ethicon [1975] AC 396.
331 *ibid.* 407.
332 Cream v Banerjee [2004] 3 WLR 918 (HL).
333 TRIPS Articles 51 & 52.
334 European Union Infringing Goods Regulations No. 1383/2003.
335 CDPA 1988 Section 111.
336 Patents Act Section 61(1)(b), the Trade Marks Act Sections 15 and 16 and the Copyright, Designs and Patents Act 1988 Sections 99, 108, 195, 199, 204, 230 and 231.
337 Patents Act 1977 Section 61(1)(c), the Trade Marks Act 1994 Section 14(2), the Registered Designs Act Section 24(2) and the Copyright Designs and Patents Act 1988 Sections 96(2), 191(3) and 229(2).
338 Indata Equipment Supplies Ltd v ACL Ltd [1998] FSR 248.
339 Intellectual Property (Enforcement etc.) Regulations 2006, SI 2006/1028, Regulation 3.
340 Patents Act Section 61(1)(d); RDA Section 24A; TMA Section 14(2); CDPA Section 92(2).
341 Guidance was given in Celanese International Corporation v BP Chemicals [1999] RPC 203; [1999] 22(1) IPD 22002.
342 CDPA 1988 Sections 97 and 229(3).
343 Redrow Homes Ltd & Others v Bett Brothers & Others [1998] 1 All ER 385; [1998] UKHL 2, [1999] AC 197.
344 Copyright and Trade Marks (Offences and Enforcement) Act 2002.
345 CDPA 1988 Section 107–110 as amended by the 2002 Act.
346 CDPA 1988 Section 198.
347 R v Lewis [1997] 1 Cr App R (S) 208.
348 Patent Act 1977 Sections 109–110; RDA 1949 Section 35.
349 TMA 1994 Section 95.
350 *ibid.* Section 92.
351 Powers of Criminal Courts Act 1973, Sections 35 and 43, the Magistrates' Court Act 1980 Section 40 and the Criminal Justice Act 1988 as amended by the Proceeds of Crime Act 1995.
352 Trades Description Act 1968 Sections 1–2 & 34.
353 *ibid.* Sections 24 & 28(3).
354 Many of the Trades Descriptions Act provisions in this area are now replaced by the Consumer Protection from Unfair Trading Regulations 2008, which implemented the European Community Unfair Practices Directive; see also Copyright (Customs) Regulations 1989.

Bibliography

Adrian, A. (2013) Mickey Mouse wants to live forever: Guernsey's Image Rights Ordinance will make that possible, *European Intellectual Property Review*, 37(7): 397–401.

Bate, S. and Hirst, D. (2011) Copyright, moral rights and the right to one's image, in M. Warby, N. Moreham and I. Christie, eds. *The law of privacy and the media (Tugendhat and Christie)*, 2nd edn. Oxford: Oxford University Press:, 393–430.

Bently, L. and Sherman, B. (2009) *Intellectual property law*, 3rd edn, Oxford: Oxford University Press.

Black, G. (2011) *Publicity rights and image: exploitation and legal control*, Oxford & Portland, Oregon: Hart Publishing.

Davies, G. (2010) *Copyright law for artists, photographers and designers (essential guides)*, London: A&C Black Publishers Ltd.

Fry, R., Wienand, P. and Booy, A. (2000) *A guide to copyright for museums and galleries*, Abingdon: Routledge.

Hart, T., Fazzani, L. and Clark, S. (2013) *Intellectual property law*, 6th edn. Basingstoke: Palgrave MacMillan Law Masters.

Jassin, L.J. and Schechter, S.C. (1998) *The copyright permission and libel handbook: a step by step guide for writers, editors and publishers*, New York: John Wiley & Sons Inc.

Landes, W.M. (2000) *Copyright, borrowed images and appropriation art; an economic approach*, Chicago, IL: University of Chicago Law School.

McManus, J.P. (2012) *Intellectual property: from creation to commercialization, a practical guide for innovators and researchers*, Ireland: Oak Tree Press.

McCutcheon, J. (2008) The new defence of parody or satire under Australian Copyright Law, *Intellectual Property Quarterly*, 2: 163–192.

Okpaluba, J. (2002) Appropriate art: fair use or foul, in D. McClean and K. Schubert *Dear Images: art, copyright and culture*, London: Ridinghouse/Institute of Contemporary Arts, 197–224.

Shearer, R.R. (2000) Duchamp: ready-made case for collecting objects of our cultural heritage, along with works of art, *Tout-fait*, (3)1, December, available online at http://www.toutfait.com/issues/issue_3/Collections/rrs/shearer.htm (accessed 30 October 2014).

Stokes, S. (2012) *Art and copyright*, 2nd edn, Oxford & Portland, Oregon: Hart Publishing.

Wadlow, C. (2004) *The law of passing off*, 3rd edn. London: Sweet & Maxwell

2 The obscene and the unseen

Introduction

Dubin refers to artists as 'symbolic deviants in our society' (1992: 2), and to some extent our expectation of artists has been that they lead restless lives. The lost ears, the syphilis, the drug-taking, the alcohol, the subversive acts, the debauchery, the arrest history; if they do not have at least one of these characteristics, we might be reluctant to acknowledge them as artists. With this comes the potential for transgression in their work which historically has the potential to admit them, under the umbrella of the *avant garde*, into mainstream culture. Beyond a degree of transgression though (no-one has a measure for this), they will come into conflict with the moral wings of society who have a range of tools at their disposal to prevent the artist from showing what they create.

It is the moral wing of society (under the guise of 'public policy', 'public morals', religion and 'decent society') that has determined the significant methods for controlling what is seen and heard. Where the repression of art has been most successful there is little evidence remaining, and so there is a reliance on second-hand accounts of artefacts. The terms used to rationalise restricting the publication or dissemination of such artefacts have been diverse; blasphemous, sacrilegious, heretical, obscene, immoral, and seditious are just a few. Themes that invite censorship have included sex, sexuality, the body, death, race, religion, politics, language and crime. The accusation that an artefact is taboo can also be an elixir of publicity and the values reported to be under threat are seldom commonly held.

This chapter will outline the key regulatory frameworks that can be exploited to restrict creative practitioners in their work and how these are balanced against other rights. The tensions between freedom of expression and the concept of causing offence will be explored here in relation to the power systems (both legal and ecclesiastical) that have controlled the dissemination of creative works. The subject will be opened by relating the ideas here to the concepts of ownership already outlined; since nothing that is obscene, immoral, defamatory, blasphemous or seditious can benefit from intellectual property rights. In addition, IP regulations, while protecting the creators of works, impose

significant restrictions on others and this too will be considered. This chapter will be of particular interest to curators, graphic artists, illustrators, print-makers, fine artists, those creating site-specific work, photographers, animators and film-makers.

While US law has a history of protecting free speech (see Chapter 5), the corresponding protection in the UK has only been available since 1998 when the European Convention on Human Rights (ECHR) was transposed into English law. Article 10 protects (in balance with other rights and duties) freedom of expression and case law on this will be examined here. It should be remarked at the outset that it is a less powerful right than that of free speech in the US.

The use of copyright in the restriction of expression

Work contrary to public policy

Nothing that is obscene, libellous, immoral or contrary to public policy in some way can be protected by copyright (or other types of IP). In Glyn v Weston,[1] copyright did not subsist in the literary work *Three Weeks* since it was deemed to be 'grossly immoral' and to excuse 'adultery'. The defendant's film (*Pimple's Three Weeks*) was described by the court as 'vulgar to an almost inconceivable degree' which held that, even if copyright had subsisted, the film was not sufficiently similar to the book to infringe it. In order to determine the extent of its similarity, the film must have been watched by the judge in some detail even though he had already determined the absence of copyright. In the case of the book *Spycatcher*,[2] Peter Wright could not enforce copyright since he had breached a duty of confidence owed to the Crown in its creation. The Official Secrets Acts[3] forbid disclosure of information obtained during certain types of employment as do several other Acts of Parliament such as the Abortion Act 1967.

There is some discussion on the exact effect of immorality and public policy exclusions as to whether this is that copyright does not exist at all or that *equity* (see Introduction) will not enforce the copyright that subsists. This distinction is of little interest to readers here but what is important is that an author does not enjoy economic rights that arise from any work created found to be contrary to public policy. So while controversy might stimulate interest in a work, it is only if the work is ultimately found *not* to be in excluded categories that an author can hope to cash in on such publicity.

Referring to the work of others

The right to reproduce, distribute or make derivative works from copyrighted materials is controlled by the owner of the right[4] which means that copyright can be a powerful tool in controlling specific areas of artistic practice such as collage. This is not an absolute right of control and is qualified[5] to achieve 'a proper balance between the protection of the right of a creative author and

the wider public interest'.[6] The Copyright, Designs and Patents Act 1988 confirms that these public interest rights include fair dealing for the purpose of criticism of review,[7] and fair dealing for the reporting of current events[8] except if the copyrighted work is a photograph; this protects news and editorial photographers from having their work used without payment. In a European case involving a non-news photograph of a young girl (Natasha Kampusch) who was kidnapped in 1998 (but who escaped in 2006), a portrait photograph was held to be protected and the copyright found to be infringed when it was used without permission or payment in the Austrian and German press. The court found that only if the press had been assisting police to circulate the girl's image would such a case go against the photographer.

The use of statutory defences to infringement requires sufficient acknowledgement of the copyright owner unless this is not practical.[9] In the case of Beloff v Pressdram, *The Observer* sued *Private Eye* in relation to dissemination of the contents of an internal memo.[10] The judge observed that the existence of copyright in unpublished works 'bestows a right to prevent it from being published at all; and even though an unpublished work is not automatically excluded from the defence of fair dealing, it is yet a much more substantial breach of copyright than the publication of published work'. *Private Eye* would enjoy better protection post-1998 but this case was heard in 1973. The copyright in an unpublished work *will* be infringed if it is reproduced for the purposes of criticism or review since this is only permitted when 'the work has been made available to the public'.[11]

While it is available as a defence in copyright infringement cases, the term 'public interest' is not defined in the CDPA.[12] In a case involving the sale of photographs of Diana, Princess of Wales and Dodi Al Fayed shortly prior to their deaths, obtained without permission as a result of an employment relationship,[13] the Court of Appeal underscored the absence of the definition by remarking that the 'circumstances in which the public interest may override copyright are probably not capable of precise categorisation' (the finding went for the legitimate owner of the images).

Nineteenth-century cases involving 'public interest' tended to note that there is 'no confidence as to the disclosure of iniquity',[14] though such cases dealt largely with acts of a criminal nature. During the twentieth century, the public interest defence, against a variety of forms of action, has become established in its own right. Information that might be in the public interest includes the reporting of crime, wrong-doing, misconduct (particularly in public office), as well as health and safety issues. In Lion Laboratories v Evans,[15] involving internal correspondence suggesting that the manufacturers of breathalysers had cause to question their accuracy, the claimants were first successful in restraining publication of the information under copyright law and 'breach of confidence'. On appeal, however, it was held that since individuals had been successfully prosecuted for drink-driving on the grounds that the device was perceived to be accurate, the issue was of public interest and some of this correspondence could be published.

Restricting innovation

In their 2008 work, Boldrin and Levine make compelling arguments against intellectual property through a well-cited description of the litigation, and patents, of Watt who is associated with the invention of the steam engine. They observe that rather than contributing to the advancement of human knowledge, Watt stagnated progress through 'trading off rival inventors' (2008: 1), and that Watt's *rent-seeking* behaviour (2008: 4) effectively held up the industrial revolution by a couple of decades through the suppression of competitor research. Watt, they argue, kept prices high for the use of his engine which prevented others from developing better equipment, and also refused to issue licences to particular competitors.

Barro and Sala-i-Martin observe that intellectual property rights are: 'a trade-off between restrictions on the use of existing ideas and the rewards to inventive activity' (1995: 290) but Lessig (2004) questions whether the monopoly rights that accompany intellectual property ownership are the only way to reward innovation. Boldrin and Levin further Lessig's argument and contend that the creators of property rights can be protected in the absence of intellectual property which they label an 'unnecessary evil' (2008: 7). Boldrin and Levin (2008) divide IP privileges into 'first right' (the right to buy and sell copies of ideas) and the 'second right' (to control how other people make use of the copies). It is the latter right that they take issue with since, they state, it is this that creates a monopoly over an idea. The foundations of intellectual property lie in the protection of the tangible expressions of ideas, not the ideas themselves.

Boldrin and Levine further dispute that intellectual property rights are the *cause* of innovation, 'but rather an unwelcome consequence of it' (2008:17). They observe that it is competition that leads to innovation and that monopoly rights over an idea create a situation of low availability and high price (2008:10). They take little issue with trademarks, and remark that copyright appears to have less economic significance since it offers enrichment to a few without preventing people getting access to vital resources such as medicines (2008: 97). With regards to patent, they say that 'most great inventions are cumulative and simultaneous' (2008: 208), and that the 'first to patent is the one who benefits from the research of others' (*ibid.*). However, they do observe that copyright is 'excessively long' (2008: 97), that creativity would thrive without it and that it is awarded irrespective of quality; but, they do not argue that it is *anti-competitive* in the way that patents are. They add, however, that while copyright has 'zero impact on artistic production' (2008: 100), the post-life persistence of copyright enriches only dominant corporations. There has been evidence already, during the course of this text, that copyright can impact on artistic production in a negative way before its post-life existence begins.

Comparing intellectual property to the effect of the English enclosures acts (which effectively excluded others from the use of land by force), Hyde refers to a parallel 'enclosure of culture' (2012: 45) through the creation of intellectual property. Hyde references a quote attributed to George Bernard Shaw which succinctly identifies the differences between physical and intellectual property:

> If you have an apple and I have an apple and we exchange apples then you and I will still each have an apple. But if you have an idea and I have an idea and we exchange these ideas then each of us will have two ideas.
>
> (*ibid.*)

Hyde observes that the distinction between discovery and invention has been eroded. He gives examples of the abuse of monopoly privilege to control the legitimate intellectual activity of others (2012: 236–237), and these include a refusal by Whistler's niece for his first biographer to use the painter's letters, NBC's refusal to license a video clip of President George W. Bush for use in a Greenwald documentary about the Iraq war and Harvard University's refusal to allow authors of a book permission to print a screen-shot of a web-posting by Harvard President (Summer) which included remarks about women in science.

The particular problems of postmodernity and parody

The age of postmodernity broadened the use of appropriation and other creative strategies by artists to reference ideas that engage their viewers with contemporary issues. Recognised throughout art history, and criticism, are a collection of highly critiqued, art movements which create their own problems and questions for intellectual property debates. These include dada, surrealism,

collage, pop-art or any movement which deconstructs modernist notions of originality and authorship. Consequently, there has been dispute about the freedom of ideas, as well as the proposal of alternative licensing methods. Though they present solutions outside of the realm of current law, these debates are useful to artists who are required to engage with them and who might need to think about them in the production of their work. Intellectual property rights restrict what persons, other than the owner of the IP, might do to, or with, a work. Dada, surrealism, collage and pop-art did not emerge unscathed in relation to IP law. In the US case of Dauman v the Andy Warhol Foundation,[16] Andy Warhol had used a series of images of Jacqueline Kennedy that he had acquired from newspapers and magazines including *A Sorrowing Family Marches Together,* a photograph by Henri Dauman published in the 6 December 1963 edition of *Life* magazine. Dauman did not discover that Warhol had used his photograph until *The New York Times* published an article about the sale of *16 Jackies* at Sotheby's in 1995. He then brought a claim against the Warhol Foundation for the unauthorised use of his copyrighted photograph. Though the images did not compete in the same art markets, the merchandising by the Warhol foundation potentially conflicted with Dauman's rights over his image and the Warhol Foundation settled the case without a trial.[17]

Appropriative works are particularly widely cited in texts dealing with postmodern ideas, and might involve adopting another's imagery into, for example, a collage, or a simulation of another work. The two key questions in law, however, are do the newer works infringe the rights of others and if not, are the appropriative works themselves copyrightable? In the case of Lego (referred to in Chapter 1),[18] the Privy Council determined that for a derivative artwork to enjoy copyright protection itself there must be some element of 'material alteration or embellishment' to justify defining the second work as 'original', a new context probably being insufficient. This leaves such works not just open to litigation for copyright or moral rights infringement but themselves sometimes unprotected in intellectual property law.

Some might argue that both postmodern art and parody are forms of criticism or review which are recognised defences to copyright infringement.[19] However, this defence requires that the author be acknowledged and in parody this would be equivalent to explaining a joke. The US has been quicker to respond to the concept of parody in case law though not always evenly (see Chapter 5).

In addition to potential copyright infringements that might arise in postmodern art or parody, there are also moral rights in a work and the associated reputational rights of the author to consider.[20] Although moral rights cannot be assigned to others, they can be bequeathed in a will or waived.[21] An author (or their beneficiaries) has the right to assert attribution[22] (or 'paternity') and the right to object to derogatory treatment (the right of integrity).[23] Some creative practitioners assert their moral rights by stating that they do so on the work in question and signing it. If they do so, there is often an accompanying remark to the effect that this is done in accordance with the Copyright, Designs and Patents Act 1988.[24]

UK law has not had a defence of parody or spoof so the closest it got was the defence to copyright infringement of 'for the purposes of criticism or review'.[25] A claimant might also sue for 'passing off' (see Chapters 1 and 3) or even false attribution.[26] In the case of Alan Clark v Associated Newspapers,[27] the former MP brought action in respect of a spoof diary that had appeared in the *Evening Standard*. The work was held to infringe the claimant's Section 84(1) rights under the Copyright, Designs and Patents Act 1988; there had been 'false attribution' of authorship. The court held that this could only be neutralised by an express contradiction, rather than the simply naming the true author of the diary as the newspaper had done. The rule from this case might appear to be that if people have been deceived into believing that a work is not a parody, but genuinely that of the claimant, then a case for infringement will succeed. Davies (2011: 104) describes this as the 'moron in a hurry' test. The more subtle a parody, the funnier it generally is, but the more likely it seems that it will fall foul of the law.

The laws relating to parody and postmodernity in art vary throughout European jurisdictions and in the US. Although ultimately ruling against the defendant artist in Gautel v Bettina Reims, the Cour de Cassation in France[28] recognised appropriation as a technique. The appearance of the word 'Paradise' in gold lettering at the doors of an old psychiatric sanatorium was defined as 'original' and this prevented the defendant, Rims, from using a photograph of the lettering in the artwork *New Eve*. In the Swedish case of Max Walter Svanberg v Leif Eriksson,[29] the court found that the reputation of Svanberg had

not suffered as a result of Eriksson's treatment of a reproduction of his work. Parody is also recognised as a defence in Spain, the Netherlands and Belgium, and there is some provision for it in German case law. Australia has introduced a new defence of parody or satire to its Copyright Act.[30] The South African Judge Sachs has aptly summed up the tension between law and parody in a South African Constitutional Court ruling: 'Humour … permits the ambiguities and contradictions of public life to be articulated in non-violent forms … It is an elixir of constitutional health'.[31]

As stated, in English law the defence of 'fair dealing for the purposes of criticism or review' of copyrighted works[32] is problematic to those seeking to defend an infringement action because most parodies do not overtly identify the author of the original work as required by Section 31 of the CDPA. In addition, since parody involves some form of ridicule, UK parodists are exposed to action in the moral right to object to derogatory treatment of a work. A European Directive[33] aimed to harmonise aspects of law relating to intellectual property allowing member states to provide exceptions for the purpose of caricature, parody or pastiche.[34] As this book goes to press, the UK media has reported that this aspect of the Infosoc Directive will be implemented in the UK. These reports arise from a recent CJEU ruling (Deckmyn v Vandersteen 201/13); it is too early to say what effect this will have on UK copyright infringement and parody cases. However The Copyright and Rights in Performances (Quotation and Parody) Regulations 2014 have (on 1st October 2014) introduced a new section to the CDPA (Section 30A) which states that works done for the purposes of caricature, parody or pastiche will fall under 'fair dealing' in respect of copyrighted works. Case law that emerges from now on will be of particular interest to those working in these fields.

While the US approach to the dilution of trademarks restricts the use of parody in many contexts, it is not by any means as potentially restrictive as the approach taken in the UK. In the US, parody potentially falls under the 'fair use' defence available through copyright law[35] as long as it does not diminish the value of the original work, and only if the subject matter infringed is essential to understanding the work parodied.[36] The fair use defence requires the court to consider the purpose and character of the later work (including, for example, whether the infringing work is for profit), the nature of the copyrighted work, the amount and substantiality of the portion used and the effect of the infringing work on the market value of the original work. In a case concerning criticism of L. Ron Hubbard's doctrines (relating to Scientology) and Carol Publishing[37] (not a parody case *per se*), the appellate court determined that an unflattering biography of Hubbard made fair use of quotes from a source work. The fact that the criticism diminished sales of an authorised biography did not, in this instance, undermine the fair use defence. Parody was explicitly recognised as fair use in the case of Campbell v Acuff-Rose,[38] involving a parody of the song *Oh, Pretty Woman* by Roy Orbison, and established that the fact that there is profit to be made by a defendant does not rule out the possibility of the fair use defence.

On the other hand, the US case of Art Rogers v Jeff Koons[39] has generated a significant amount of criticism. Koons argued that his use of Rogers' work (a postcard depicting a man and woman with a 'string of puppies') to produce a sculpture was a parody of society. The sculpture was used in the *Ushering of banality* show at the Sonnabend Gallery, New York, in 1988. The court held that to employ the 'fair use' defence, the work must be a parody of the work copied, not society. According to the judge, 'if an infringement … could be justified as fair use … on the basis of the infringer's claim to a higher or different artistic use … there would be no practicable boundary to the fair use defense'.[40] The intentional use of the work of Art Rogers and the substantial profit made by Koons appears to have significantly impacted on the judgement even though Rogers and Koons did not compete in the same market. Okpaluba remarks of the case that 'it appears from the second circuit's decision that it was more influenced by its distaste for Koons and his art than by any sound legal principle' (2002: 207). The works can be seen at http://cpyrightvisualarts.wordpress. com/2011/12/20/art-rogers-vs-jeff-koons/. Perplexingly, in 2006 a different approach was taken in Andrea Blanch v Jeff Koons[41] where Koons' use of part of Blanch's fashion photograph (*Silk Sandals by Gucci*) in a Koons collage (*Niagara*) to comment on mass media (rather than on Blanch's work) was fair; the use of the word 'transformative' is seen in these types of cases. Koons' work was found to be transformative in relation to the claimant's work, and it was observed that his work did not compete in the same market.

With regards to appropriation without parody, the US court ruled against Richard Prince in Cariou v Prince[42] for his use of torn images from *Yes, Rasta* by Patrick Cariou in Prince's work *Canal Zone*. The district court refused to find *per se* that appropriative art falls under the fair use principles. The Gagosian Gallery, who were in possession of Prince's work, was ordered to deliver-up the work for destruction (or disposition as determined by the plaintiff),[43] as well as photographs of it and unsold exhibition catalogues.[44] This led to a brief for *amici curiae* by the Association of Art Museum Directors, the Metropolitan Museum of Art (MoMA) and the Solomon Guggenheim Foundation, which reversed the finding. An amicus brief is the legal opinion of someone other than the parties in the case; it is not common-place so its history in UK or US law is not detailed here. The US Circuit Court of Appeals in Manhattan found 'fair use' on the grounds that there had been sufficient transformation of the work in question, and that the law imposed no requirement that a work comment on the original work or its author in order to be considered transformative (that is to say that the second work is not a market substitute for the first).[45] This sits at odds with Rogers v Koons, though Cariou v Prince did come later in time.

In the UK, then, there is scope for the development of a distinctive defence of parody in line with either US law or other European civil systems, and since those who are parodied will seldom give permission for the use of their work by those showing it, or them, in a less than favourable light, this issue will not disappear any time soon.

Censorship

According to a 1998 memo from the vice-chancellor of the University of Central England,[46] West Midlands Police seized a book (*Mapplethorpe*) from the university's art and design library. The vice-chancellor was informed that two of the images contained within the book, were, in the view of the Crown Prosecution Service, obscene. Accordingly, the police informed senior staff that if the book was destroyed, no further action would be taken against the university (though the Director of Public Prosecutions (DPP) would still wish to determine whether the publisher would be prosecuted). The book was not destroyed and several months later the DPP confirmed that no further action would be taken.[47]

Historically, English law concerned itself with the control of seditious utterances to protect royalty, the titled and officers of the Crown, from scandal. *De scandalis magnatum* 1275 prohibited 'false News or Tales, whereby discord … may grow between the King and his People, or the Great Men of the Realm'. The King's Council heard cases in secret without a jury; this practice had been abolished by 1641. Given that the practice of secret hearings could be used by those in power to ensure that they held onto it, it did not disappear entirely until the eighteenth century. In 1556, the Stationers' Company was founded in order to license book distributors and printers; licences could be refused and those responsible for published materials were alert to this. Daniel Defoe, writer of *Robinson Crusoe,* was prosecuted in the early eighteenth century for seditious treason in respect of a political pamphlet published anonymously. Defoe was subjected to several days in a pillory (a kind of stocks devised for public humiliation), extortionately fined and imprisoned until the fine was paid. The intention behind the high fine was that Defoe would not be able to pay it but it was discharged by the Earl of Oxford some days later. With regards to the spread of published materials and literacy, Sir William Berkeley (Governor of Virginia during English rule) remarked that 'learning has brought disobedience and heresy' (1640).[48]

The licensing of printers, which had become increasingly unpopular because of its censorial use, came to an end under English law in 1694 and the first copyright legislation was established in 1710, giving publishers and authors fourteen years copyright subsistence. Subsequent attempts to silence dissent or prevent the publication or display of undesirable material have had significantly less effect than the licensing system but are still relevant today.

The most widely known of these is probably the Obscene Publications Act (OPA) 1959 which makes it an offence to publish obscene works.[49] The OPA has its origins in the Hicklin judgement of 1868[50] which concerned itself with the effect of controversial works on the most susceptible members of society. This judgement informed the regulation and definition of 'obscenity' for just under a century, and the wording is echoed in the Obscene Publications Act:[51]

> For the purposes of this Act an article shall be deemed to be obscene if its effect or (where the article comprises two or more distinct items) the effect

of any one of its items is, if taken as a whole, such as to tend to deprave and corrupt persons who are likely, having regard to all relevant circumstances, to read, see or hear the matter contained or embodied in it.

The test of depravity/corruption is for the jury to decide. However, an item cannot be obscene if it tends to deprave only 'a minute lunatic fringe of readers'[52] but if the user is already depraved then the article need only maintain them in that state in order to qualify as 'obscene'. An article 'may be an error of taste'[53] but this need not make it criminal under the OPA.[54] A 1964 amendment to the OPA allows for the prosecution of wholesalers who are wilful or negligent in respect of the obscene materials with which they deal. There can be no conviction for a criminal offence under the OPA if it can be shown that the publication of the article in question 'is justified as being for the public good on the grounds that it is in the interests of science, literature, art or learning, or other objects of general concern'[55] but this defence is only used once it has been determined that the article in question is obscene. The equivalent legislation in Scotland is found in the Civic Government (Scotland) Act 1982. Art academics are generally alert to the sensitive materials they must collate for lectures, particularly those involving photographs of children and the 'public good' defence[56] against liability in relation to obscenity for items which are in the interests of learning, is of particular relevance to them.

The OPA gives the authorities wide powers of seizure, search and arrest (though a warrant must be obtained), and the offence is triable either way (so it can be heard in front of Magistrates or the Crown Court; see Introduction). The OPA permits the testimony/opinion of experts in court.[57] Readers with a particular eye for semantic issues will spot the paradox in Section 1 of the Act that an article must 'tend to deprave and corrupt persons who are likely ... to read, see or hear [it]'; since the jury must see/hear/read it they are compelled to condemn themselves as corrupted if they find that it 'tend[s] to deprave'. The Court must then follow the verdict of a group of persons who have been 'corrupted'.

Imagery has been imported with particular power in the realm of obscenity and more widely in cases where the use of particular pictures has caused offence to religious groups (detailed further below) so it is surprising that the most famous prosecutions for obscenity under the Act have been those involving literature. In the case of R v Penguin Books,[58] D.H. Lawrence's *Lady Chatterley's Lover,* which contains the words 'fuck' and 'cunt', was described as a landmark in 'beastliness' in the opening address by counsel for the prosecution Mervyn Griffith-Jones. Griffith-Jones was criticised for his lack of comprehension of contemporary life, in particular when he asked the jury if the book was of a type that they 'would wish your wife or servants to read'. Expert testimony was used and the literary merit defence was successfully employed; the book was acquitted and sales of the book rose significantly.

Although Article 10 of the ECHR can now be engaged in relation to any apparently opposing statute,[59] the prevention of crime or the protection of morals as given at Article 10(2) provides for necessary and proportionate

restraint in the right to freedom of expression.[60] According to Ormerod, the term 'obscene' now tends to be restricted to sexual interference with animals, rape, sadomasochistic material, torture, dismemberment, graphic mutilation, degrading treatment and fisting (2011: 1058).

Under the Criminal Justice and Immigration Act 2008, the possession of extreme pornographic imagery is an offence triable either way. Unlike offences under the Obscene Publications Act, the images do not have to be likely to deprave or corrupt for liability to be found. Instead, a list of prohibited acts is given in the act (these include pornography involving children and coprophilia). The term 'pornographic' relates to the purpose of inciting sexual arousal[61] but the defendant's intentions to this are immaterial (that is to say liability is *strict*). An 'extreme image' is defined by the statute as 'grossly offensive, disgusting or otherwise of an obscene character',[62] and anything which depicts threat to life, a serious injury to the anus, breast or genitals of a person, interference with a corpse or acts on animals[63] or appears to do so in the mind of a reasonable person will be included here. Classified films are excluded. There are two statutory defences provided by the statute: legitimate reason for possession, where a person did not know what the material was or was sent it unknowingly,[64] and participation in the consensual acts depicted.[65]

The Postal Services Act 2000[66] makes it an offence to send indecent or obscene material through the post. Summary conviction will lead to a fine. Conviction on indictment might lead to a fine or a maximum twelve months' imprisonment. Obscene, for the purposes of the Postal Services Act, is not defined by the Obscene Publications Act but by its 'ordinary meaning'. The Malicious Communications Act 1988 makes it an offence to send a letter or email which is indecent, grossly offensive, threatening or contains false information. The intention of the sender is key to this offence, not the recipient's reaction. The Communications Act 2003[67] makes it an offence to send electronic communication which is indecent, obscene or menacing (again, intention on the part of the defendant is required). A summary conviction for this offence can result is six months' imprisonment (up to twelve months if there is more than one offence) or a fine. The Unsolicited Goods and Services Act 1971[68] makes it an offence to send to someone any unsolicited material which describes sexual technique.

There are other acts and regulations that have been used to control the expression of creative practitioners which may be equally affected by the implementation of Article 10, though some have been repealed already. They are listed here since they bring to the attention of the reader the range of methods that have been used against articles found by someone else to be offensive, and also the use of statutes directed at misbehaviours unrelated to creative practice.

The Vagrancy Act 1824[69] was primarily concerned with begging and sleeping rough but incorporated the offence of 'wilfully exposing to view, in any Street… any obscene Print, Picture, or other indecent Exhibition' which left galleries vulnerable to prosecution. In 1929, the police seized 13 paintings by D.H.

Lawrence that were being shown in a London gallery. The images were banned from public display but shown again in 2003 (though the ban is still technically in force) (Demetriou 2003). The album cover for *Never Mind the Bollocks, Here's the Sex Pistols* was the subject of an unsuccessful prosecution in the 1970s under the Vagrancy Act[70].

The Vagrancy Act was repealed in 1981 through the Indecent Displays (Control) Act 1981[71] which makes it an offence to cause, or permit, the display of offensive material unless the material is in a shop protected by a warning notice, adult clubs where payment is taken and museums/art galleries, as long as the work is only visible from within the premises (classified films also enjoy protection). There have been very few prosecutions under this act but a gallery displaying the work of Marie White was warned to remove a nude sculpture from its window in 2004 and the work was placed behind frosted glass.[72] For this offence, there is a maximum imprisonment of two years; police have no powers of arrest without a warrant but they do have powers of seizure.

The Metropolitan Police Act 1839 extended the powers of the police in the district of London which then included a radius of fifteen miles from Charing Cross,[73] and regulated such activities as smuggling, gunpowder, fairs, the opening hours of public houses, unlicensed theatres, bear-baiting, cock-fighting, gambling, parades, 'furious' driving, the blowing of horns, discharging firearms, drunken or indecent behaviour, knocking on doors wantonly (or ringing a door-bell in the same manner), making slides out of the snow and flying kites,[74] as well as beating a carpet before 8am.[75] The Metropolitan Police Act outlawed the sale or distribution of 'profane, indecent, or obscene books, papers, prints, drawings, painting or representations'.[76] Under this Act, a gallery was unsuccessfully prosecuted in the 1970s for the display of erotic sketches by John Lennon.[77] The London Arts Gallery, New Bond Street (owned by Eugene Schuster) displayed lithographic caricatures of Lennon and Ono engaged in sex

acts. Detective Frederick Luff, who seized eight of the works, compared them to the type of works seen on toilet walls and indeed one of the witnesses for the prosecution referred to the lack of talent evidenced by the works.[78] Since the meaning of the wording of the Metropolitan Police Act 1839 could not be agreed on, the magistrate dismissed the case.[79]

There are still several pieces of legislation and common law that might give a gallery or artist cause to pause before determining what work to show. The Town Police Clauses Act 1847 extended the rights of local councils to regulate public events and, of course, beating a carpet and flying a kite. Furthermore, the act also made it an offence to obstruct the street to the distraction, annoyance or danger of the public.[80] The term 'annoyance' is not defined by the act. The Public Order Act 1936 prohibits the distribution or display of writings/signage/ visible representations which are threatening/abusive/insulting in a public place or a museum, if the intention, or likely outcome, is to provoke a breach of the peace.[81] The term 'insulting' is not defined by the act. A defendant must know that their words or behaviour might provoke a breach,[82] and if the conduct in question is 'reasonable' then the defendant is not liable under the act.[83] The public works of Spencer Tunick, usually involving hundreds of volunteers stripping naked in cities around the world, have seen him arrested in America five times in the interests of 'public decency' but when working in the UK in this way he has attracted little more than media attention.[84]

The various Public Order Acts prohibit treason and disorder, and acts likely to incite these. The Customs Consolidation Act 1876[85] makes it an offense to import indecent, or obscene, prints, paintings, photographs, books, lithographs, engravings and so on. The Post Office Act 1953[86] makes an offence of sending similar materials through the inland postal system. The problem with these acts is that although the threshold for 'indecency' would seem to be lower than that of 'obscene', there appears to be no statutory definition of 'indecency'. HM Revenue and Customs, however, appear to restrict its use to images involving children.[87] Customs and Excise may detain any material of an indecent nature; the 1960s film *Games in Bed* was seized under import regulations. The film in question was one suggesting games to entertain a sick child.

A further catch-all can be found in the common law offence of Outraging Public Decency (in case you should escape prosecution for flying your kite or beating a carpet on a technicality). Again, definition of the terms involved has problematised case law but it seems that a disgusting, or lewd, act or display must be available to be seen in public by two or more persons in order for a prosecution to succeed. In 1988, artist Rick Gibson and gallery owner Peter Sylveire were charged with, and later successfully prosecuted for, outraging public decency after the exhibition of a sculpture made from freeze-dried foetuses (human) at the Young Unknowns Gallery; both defendants were fined.[88] The defendants appealed unsuccessfully to the Court of Appeal (Criminal Division).[89] The offence can also attract a custodial sentence. The defence of 'public interest' is not available on the common law charge of conspiracy to outrage public decency, which is preserved as an offence by the Criminal Law Act 1977.

There is a range of other legislation which may be employed to restrict creative practice under the right circumstances. These include the Official Secrets Acts which make it an offence to retain information obtained as a result of privileged employment, or to communicate or receive it.[90] This also restricts the description of real-life jury deliberations.[91] A *DA-Notice* (a 'Defence Advisory Notice', prior to 1993 referred to as a *D-Notice*) can be issued by the Ministry of Defence, or the Press and Broadcasting Advisory Committee, to discourage publication of material on national security grounds; several were issued during the Wikileaks controversy of 2010.[92] A DA-Notice is usually issued to a news editor and has no legal force; though the issuing of a DA-Notice will be taken into account in the event of any subsequent prosecution, for example, under the Official Secrets Acts.

Children

In 1996, prior to opening an exhibition of Robert Mapplethorpe's work, The Hayward Gallery, London, are reported to have consulted with the Vice Squad over work in a retrospective exhibition and subsequently self-censored two works. One of the self-censored pieces was the much discussed, and widely regarded, photograph *Rosie* which depicts a child of the photographer's friend wearing a dress, without underwear and sitting in a manner which allows her genitalia to be seen.[93] Any one of the statutory or common law offences relating to indecency, obscenity or causing outrage might have been the determining factor in the decision of the gallery but there are specific Acts of Parliament that impact on the use of children in artwork.

The Protection of Children Act 1978[94] and the Children and Young Persons (Harmful Publications) Act 1955 prohibit the taking, distribution or display of indecent photographs of a child under sixteen. These laws were extended in 2009 by the Coroners and Justice Act[95] which made it a criminal offence to *possess* images of imaginary children since the Protection of Children Act 1978 had required direct harm to an actual child and 'intent to display'.[96] The Coroners and Justice Act is concerned with contact with materials that desensitise people to child abuse or reinforce such desires. The offence attracts a maximum sentence of three years.[97] Where a person did not know what the material was, or was sent it unknowingly, defences are available.[98]

Since no statutory definition of 'indecent' exists, an artist or gallery may find themselves subject to action unexpectedly. It is reported that the police visited the Saatchi Gallery in 2001 in connection with the work *I am a Camera* by Tierney Gearon. The exhibition included photographs of the artist's own children unclothed; no prosecution was pursued and the subsequent news reporting confirmed Gearon's reputation as an artist.[99] The photographer Sally Mann was the subject of similar controversy (in terms of the news columns generated) with her 1992 work *Immediate Family*.[100] In the 2011 case of R v Neal,[101] concerning photographs of children available in books by an established photographer, a conviction for possession of indecent photographs of children was quashed.

Film and theatre

The Theatrical Licensing Act 1737 gave the Lord Chamberlain[102] control over theatre. The Lord Chamberlain was given powers to vet all plays prior to performance and could prevent any play from being performed without giving a reason for the decision. The powers of the Lord Chamberlain were restricted by the Theatres Act 1843 whereby the decision to prohibit a play had to be specified and based on matters of public policy or 'decorum'. This act also transferred the powers to license theatres to local authorities.[103] The Theatres Act 1968 makes it an offence to present or direct an obscene performance of a play and this can result in six months' imprisonment on summary conviction or three years on indictment[104] (see the Glossary for a reminder of these terms). The definition of 'obscene' is that given in the Obscene Publications Act[105] so there is a 'public good' defence available.

Cinema was at first regulated through both the Theatres Acts and the Disorderly Houses Act 1751 (an act designed to control the leisure pursuits of the lower classes). Three years subsequent to the opening of the first purpose-built cinema, Parliament passed the Cinematograph Act 1909 which was concerned with safety (cellulose nitrate, of which film was then made, being highly flammable) and regulated for the provision of exits, lighting, projector use and its casing, smoking, film storage and so on. However, this act was also employed to withhold licenses from cinemas showing unacceptable material and to prohibit the showing of films on a Sunday. The first cinema to be taken

to task for violating the latter term of licence was the London Bridge Picture Palace which opened on a Sunday in February 1910. The owner's challenge in the subsequent case was that the Cinematograph Act was concerned with safety, and that London County Council had no right to impose further conditions.[106] The cinema lost the case and this appears to have encouraged other county councils to censor film. Film was already covered by common laws relating to decency but this could only be used after a film had been broadcast, and local authorities were keen to preserve the morality of the underclass who could not be trusted to do this for themselves. A Home Office memo from this period remarked that 'the cinema differs greatly from the theatre: the audience is less intelligent and educated',[107] and the Chief Constable for Edinburgh stated that 'the darkness, combined with the low standard of morality of the individual leads to indecency'.[108]

Local authority control over film screenings left film-makers and cinema owners in commercially vulnerable positions, since the screening of film was subject to the inconsistent whims of individuals. So the *Cinematograph Exhibitors Association* began a trade-sponsored code of voluntary censorship which is now called the British Board of Film Classification (the BBFC). The first president of the BBFC was the Examiner of Plays at the Lord Chamberlain's office. The key goals of the Board at its inception related to the restriction of films which were suggestive of impropriety or immorality, seen to sanction criminal and unpatriotic behaviour and depict insanity, violence, blasphemy or films which were in 'any way repulsive or objectionable to the good taste and better feelings of English audiences'.[109] In its first annual report, the BBFC gave a list of its reasons for denying film classification during 1913 which included indelicate sexual situations, excessive gruesomeness and 'native customs in foreign lands abhorrent to British ideals'.

Films that have fallen foul of the BBFC include *Nosferatu* (directed by Murnau, 1922) which was concurrently being sued by the widow of Bram Stoker for copyright infringement of *Dracula*.[110] Although Mrs Stoker succeeded in legal action, copies of *Nosferatu* have survived. *A Clockwork Orange* was submitted as a screenplay to the BBFC who stated that it would be rejected. The film was shot (as per the screenplay) and passed without cuts.[111] BBFC guidance is 'advisory' and local authorities are free to reject a film that has been classified or to show a film that the BBFC have refused to classify. The 1970s films *The Exorcist, Last Tango in Paris* and *Monty Python's Life of Brian* were all subject to bans by a variety of local authorities, despite having obtained BBFC classifications.[112] Local authority powers, in respect of controlling film screenings, were confirmed in statute by the Cinematography Act 1952 and the Cinema Act 1985. The BBFC is now the recognised authority to license video, DVD, etc. and some games;[113] 1984 was the first year that the BBFC was given powers under statute. The equivalent body to the BBFC in the US is the the Motion Picture Association of America (MPPA) which published its guidance in the form of the Hays Code in 1930.

Film and home-cinema materials are now subject to control under the Obscene Publications Act.[114] *Last Tango in Paris* (directed by Bertolucci 1972)

was the first film to be the subject of a private prosecution under the Obscene Publications Act.[115] Although it had achieved an X-certificate, some authorities had refused to show it, in particular because of the scene involving butter as a lubricant in anal sex. The case failed because it was not until 1977 that the Obscene Publications Act was amended to include film.[116]

The role of religious groups in controlling expression

During the 1990s, a carefully painted sign (white lettering on a black background) was to be found situated above the door of a Christian church on Spring Bank in Hull (north-east England). The sign stated that 'This Anglican parish will play no part in the apostasy of priestesses'. Putting aside the semantic error, it transpired that the church in question did not approve of female vicars. The sign was there to offend anyone who passed the church (whether on the grounds of the misuse of English or that it was sexist) but no violence or civil unrest resulted. On my way to give a lecture in 2014, I noticed that the sign was no longer there.

Institutionalised religion has played more than a peripheral role in the suppression of thought and the expression of independent ideas; though the right of religion to cause offence has only relatively recently been questioned. Criticising a religious doctrine can be fraught with risk. In 2004 film director Theo Van Gogh was shot dead in Amsterdam by Dutch-Moroccan Muslim Mohammed Bouyeri for making the ten-minute film *Submission* (shown on Dutch television) which critiqued the role of women in Islam.[117] In 2005, the Danish newspaper *Fyllands-*

Posten published cartoons of the Muslim prophet Muhammad to accompany an article about self-censorship, leading to violent world-wide protests in 2006.[118] To most viewers these cartoons were rather puerile and the protests gave them a profile they did not deserve. The protection of free speech must be uniform though, and if we protect only material in which we subjectively find value we risk becoming suppressive fanatics ourselves. Cohen remarks of the times prior to acts of terror in the name of Islam: 'If a religion was oppressive or a culture repugnant, one had a duty to offend it … The job of artists, intellectuals and journalists became to satirise and expose' (2012: 4–5).

Probably the most well-known protest by Muslim extremists is that against the publishers and author of *The Satanic Verses*. Of the fatwa issued against Salman Rushdie, *New York Times* book critic Ralph Ellison remarked: 'A death sentence is a rather harsh review' (Ellison 1989: 28). Published in the UK in 1988 by Viking Penguin and, within months, banned in India, Pakistan, Egypt, Saudi Arabia, Bangladesh, Sudan, Sri Lanka, Thailand, Tanzania, Kenya, Indonesia, Singapore, Venezuela and South Africa, the book led Muslims in Bradford and Bolton in 1989 to nail copies to wooden stakes and burn them.[119] On 14 February 1989, the Ayatollah Khomeini issued a fatwa.[120] For the sake of this book, there have been violent attacks on booksellers and publishers, yet there was significant criticism of the author and publisher for making themselves the target of threats. Author Nick Cohen reports the following story of Peter Meyer (Penguin's then-Chief Executive in the US) who received an anonymous phone call: 'Not only would they kill me but they would take my daughter and smash her head against a concrete wall' (Cohen 2012: 44). Meyer stated that the school that his daughter attended had been lobbied by parents demanding her expulsion. '"What would happen", they asked, "if the Iranian assassins went to the school and got the wrong girl"? And Meyer thought, "You think my daughter is the right girl?"' (Cohen 2012: 44). The novelist Hanif Kureishi described the Rushdie affair as one of the 'most significant events in post-war literary history'.[121] Reader of Indian History at Oxford University Faisal Devji remarked 'so few of its Muslim critics had read the novel'.[122] Although a subsequent Iranian government stated that it no longer supported the fatwa, it is hard to gauge the risk that still exists for the author of this work; especially from persons who have never read his work.

The work *Piss Christ* (1987) by Andres Serrano attracted a lot of hatred and controversy, particularly in the US.[123] Modern Christianity tends not to issue death sentences and although threats have been made against galleries and the work itself subject to vandalism, Serrano has not had his private and family life destroyed in the way that Rushdie has. A failure to read or see the article, by those condemning it, is not unique to the Rushdie affair, however, and is common across all religious groups.

In English law, the common law offence of blasphemy (established in the seventeenth century) was abolished in 2008 by the Criminal Justice and Immigration Act. Prior to this, it had been used against religions other than the Church of England (the only religion protected under English law) as well as

atheists and broadcasters. In modern times, denial of the bible was insufficient to warrant a prosecution and material had to be offensive for a successful prosecution to occur. The most well-known case prior to the abolition of this common law offence was probably the case of Mary Whitehouse against *Gay News*. In 1976, *Gay News* (edited by Denis Lemon) published a poem by Professor James Kirkup (*The love that dare not speak its name*). The poem was sexually graphic and concerned the Crucifixion. The indictment initiated by Mary Whitehouse (of the National Viewers' and Listeners' Association, a group interested in safeguarding, in particular, the Christian values of the UK) described the charge as 'blasphemous libel'. The defendants were found guilty; *Gay News* was fined £1,000 and Lemon £500 with a nine-month suspended prison sentence (the sentence was set aside by the Court of Appeal).[124] The bulk of Whitehouse costs were awarded against the defendants; this was raised through public donations (including those made by the Monty Python team) to the Gay News Fighting Fund.[125]

Since the common law of blasphemous libel was developed before that of the concept of *mens rea* (see Chapter 4), the offence in this case was found to be one of *strict liability*. This meant that no specific intent on the part of Lemon was required for him to be found to have committed the offence; he merely had to publish the poem, not intend to blaspheme or to be reckless to the possibility of it.[126] By 2009, the offences of blasphemy, blasphemous libel[127] and the common law crimes of obscene and seditious libel[128] had all been abolished. The Racial and Religious Hatred Act 2006 makes it an offence to use threatening words or behaviour, or display any written material which is threatening[129] but there must be intent on the part of the defendant to incite hatred in relation to a religious or racial group.

Animation

Animations fall under the BBFC for its classifications. In the UK, religious groups generally have less sway with the public than in the US so, to examine the role of the religious right in animation, there is here a brief diversion into US-based controversies in animation. A 1948 interview, for *Night and Day Magazine*, with Walter Lantz, creator of *Woody Woodpecker*, lists acts his character had done which were contrary to public decency and the Hays Code. These included: cruelty to animals, stealing pennies from a blind man's cup, milking a cow and kissing a girl (he was permitted to kiss his own species) (Cohen 2004: 27). Lantz added that in England there was particular difficulty with animating females (of any species) who were considered too sexy for matinee audiences (*ibid.*).

The American Family Association (AFA) has been particularly vocal in respect of animation complaining that one of the towers on the box housing *The Little Mermaid* viedo looked like a phallus,[130] and that a priest became aroused during a wedding in the film. In 1996, Reverend Donald Wildmon (then President of the AFA) complained that Donald Duck using the f-word to a clock in the

Clock Cleaners (Disney 1937).[131] It is unclear why it took almost sixty years before anyone noticed but having watched the cartoon, it is just possible that Donald Duck is saying 'says who?' to the clock rather than 'fuck you'. We must question, though, the objectivity of anyone who claims to understand exactly what Donald Duck is saying. The AFA has also been quick to complain on the occasion that it suspects that animated characters may be homosexual.[132]

In 2013, the Federal Communications Commission (FCC) (a government agency in the US that regulates broadcast media) released a series of complaints it had received about the Fox Network show *The Simpsons* between 2010 and 2013. The feedback included the following remarks: 'the depiction of God as subservient to Satan is blasphemous and revolting to a true Christian believer … The next affront to my faith is hte (*sic.*) depiction of God … giving Satan a cup of coffee'.[133]

Defences

The interests of those seeking to disseminate information is now (post-1998) subject to Article 10 of the ECHR which gives the right to freedom of expression and the right to receive and impart information and ideas without interference. This right may be qualified by restrictions and penalties as prescribed by law 'necessary to a democratic society'.[134] Acts of Parliament that restrict the circulation of information of material often allow for a defence of disclosure being in the 'public interest' (for example, the Fair Dealing defence in the Copyright, Designs and Patents Act 1988).

Restrictions to Article 10 rights that might be legitimate include those that are in the interests of public safety, the prevention of crime, the protection of health or morals (such as the Obscene Publications Act), the protection of the rights of others (such as the Defamation Act – see Chapter 3), preserving the impartiality of the judiciary (such as the Contempt of Court Acts and the Criminal Justice Acts), preventing the disclosure of information divulged in confidence (see Chapter 3) and national security. For example, case law suggests that Article 10 rights would rarely justify the disclosure of materials subject to the Official Secrets Act 1989 Section 1.[135]

The issue of 'public interest' and the balance between Article 8 (the Right to a Private Life – discussed in Chapter 3) and Article 10 was examined in HRH Prince of Wales v Associated Newspapers[136] which was concerned with unpublished diaries circulated by the Prince to other parties. The confidential nature of the circulated diaries had been made clear to the recipients. In this case, the interference with the Prince's Article 8 rights outweighed, for the court, the public interest argument put forward through Article 10, though neither article takes precedence in law.[137] The Human Rights Act references codes that the courts might consider in this balancing act; these include the codes of Ofcom, the BBC or the Press Complaints Commission (replaced by the Independent Press Standards Organisation in 2014).[138] Lady Hale sums up the balancing act as follows: 'Where two Convention rights are in play,

the proportionality of interfering with one has to be balanced against the proportionality of restricting the other ...'.[139]

Where a court is considering granting interim relief (particularly an interim injunction) against someone seeking to use the right to freedom of expression to defend a case, then it must consider the extent to which the information is already, or is about to be, in the public domain.[140] In addition, the Human Rights Act (HRA) 1998[141] introduces a test for determining the availability of interim relief in cases potentially triggering a party's Article 10 rights. To grant *prior restraint*, a court must be satisfied that the public interests at stake (in disclosure of the material) are weak when balanced against the rights of others. The courts, in deciding whether to grant any form of relief, must have 'particular regard' to the convention right of freedom of expression in journalistic, literary and artistic material[142] (though criminal proceedings are exempt from this consideration[143]). It is for the claimant to show that their chances of success at final trial are high and that the defence will probably fail. The defendant's beliefs in their case must be reasonable, and the basis for these genuine, in order to satisfy the court that 'public interest' can be argued.[144] The defence of 'responsible journalism', however, is potentially a strong one.[145]

Lord Steyn summarised the need for justification and proportionality in relation to each article of the convention:

> First, neither article has *as such* precedence over the other. Secondly, where the values under the two articles are in conflict, an intense focus on the comparative importance of the specific rights being claimed in the individual case is necessary. Thirdly, the justifications for interfering with or restricting each right must be taken into account. Finally, the proportionality test must be applied to each. For convenience I will call this the ultimate balancing test.[146]

Penalties imposed must not be excessive when public interest defences fail. In the case of Tolstoy Miloslavsky v United Kingdom,[147] the Strasbourg Court held that libel damages (defamation is covered in Chapter 3) had been too high and were a disproportionate interference with Article 10 rights. The role of the European Court of Human Rights is not to usurp national courts in relation to findings of fact but to evaluate whether they have determined the law correctly in relation to the Convention.

The conduct of the claimant may be a determining factor in looking at balancing Article 10 rights against the rights of others and statute. However, the concept of 'morality' and public interest is problematic. For example, the sexual conduct of a party might be unusual to many but this does not entitle other parties to put such information in the public domain. In the case of Mosley v News Group Newspapers, this was summarised as: 'the private conduct of adults is essentially no one else's business'.[148]

Immunities and exemptions

Privilege

Some parties have immunity from prosecution due to privilege; for example, proceedings of Parliament or the courts. Both of these are 'absolute' privileges which give immunity from prosecution for anything done in the course of such proceedings. Parliamentary privilege[149] allows parliamentarians to speak freely without fear of action; for example, for slander (see *defamation*) or contempt of court. Privilege does not exist in the same form in the devolved administrations of Scotland and Wales: it is a Westminster protection. Members of the House of Commons and the House of Lords are regulated by the use of parliamentary language (see Introduction), and there is a Parliamentary Committee on Standards and Privileges to investigate the conduct of members of these houses. There has been much criticism of the self-regulatory nature of Parliament.

Comedian and activist Mark Thomas employed parliamentary privilege through giving evidence to a quadripartite parliamentary select committee in 2006 in order to place information about the arms industry in the public domain without exposing himself to civil action from the firms involved.[150] MP John Hemming used parliamentary privilege to expose the footballer who was the subject of a controversial 'super-injunction' (see Chapter 3) in May 2011.[151]

Data Protection Act (DPA) 1998 exemptions

The Data Protection Act was implemented to regulate how information about people is processed and stored. It is likely that photographs can be construed as 'information' under this act. However, Section 32 provides certain media exemptions to the normal rules that regulate access and control of data (detailed in Chapter 3);[152] with regards to rights of subject access;[153] the right to prevent the possession of data likely to cause distress;[154] and the right to have information rectified,[155] if data is retained for 'special purposes'[156] as defined by the DPA. Exemptions are devised to afford protection against litigation for the processing of information where there is intention to publish (journalistic, artistic or literary material), if the controller of that information believes it to be in the public interest and reasonably believes that compliance with the DPA is incompatible with that 'special purpose' then these exemptions apply. In Campbell v *The Mirror*,[157] (see Chapter 3) this defence was used to 'put the record straight' as to whether the claimant had ever possessed Class A drugs,[158] even where there was a reasonable belief that the claimant would not consent to the disclosure/processing of 'sensitive' information that the newspaper had in its possession and which the DPA encompasses.[159] There is a further Statutory Instrument in place[160] which permits a defence to prosecution: if the sensitive data is of substantial public interest; in connection with defined wrong-doings; for 'special purpose'; with a view to publication; and which the controller of the data reasonably believes to be in the public interest. 'Wrong-doings' are defined as unlawful acts, dishonesty, malpractice, serious improper conduct or mismanagement.[161]

Whistleblowing

Disclosures made in the public interest are protected acts. Provision for this protection for employees can be found in law regulating the employee/ employer relationship[162] and the Public Interest Disclosure Act 1998 (PIDA).[163] A disclosure used to be protected if made in good faith, to an appropriate party and if the subject matter related to misconduct that risked justice, health or the environment.[164] Recent legislation has removed the 'good faith' requirement[165] while the rest of the provisions remain largely the same. Disclosure to the general public in these circumstances is a last resort that needs justification.[166] The idea that those that speak out against certain types of injustice have only themselves to blame is disappointingly pervasive.

Notes

1 Glyn v Weston Feature Film Co. [1916] 1 Ch 261.
2 A-G v Guardian (No. 2) [1990] 1 AC 109.
3 Official Secrets Act 1989 Section 1.
4 Copyright, Designs and Patents Act 1988 Section 1(1).
5 CDPA 1988 Ch III.
6 Pro Sieben Media A-G v Carlton UK Television Ltd [1998] FSR, 188.
7 CDPA 1988 Section 30(1).
8 *ibid.* Section 30(2).
9 CDPA 1988 Section 30(3).
10 Beloff v Pressdram Ltd [1973] 1 All ER 241, 263.
11 CDPA 1988 Section 30(1).
12 *ibid.* Section 171(3).
13 Hyde Park Residence v Yelland [2001] Ch 143, para 64.
14 Gartside v Outram (1856) 26 LJ Ch 113.
15 Lion Laboratories v Evans [1985] QB 526.
16 Dauman v the Andy Warhol Foundation for the Visual Arts Inc 1997 WL 337488.
17 *Photographer sues Andy Warhol estate over Kennedy Photo* New York Times 8 December 1996 http://www.nytimes.com/1996/12/08/nyregion/photographer-sues-andy-warhol-estate-over-kennedy-photo.html & http://ncac.org/resource/dauman-v-the-andy-warhol-foundation/.
18 Interlego v Tyco [1988] 3 All ER 949, 970.
19 CDPA 1988 Section 30(1).
20 *ibid.* Section 94.
21 *ibid.* Section 87.
22 *ibid.* Section 77.
23 *ibid.* Section 80.
24 *ibid.* Sections 77–78.
25 *ibid.* Section 30.
26 *ibid.* Section 84.
27 Alan Clark v Associated Newspapers Ltd (High Court Chancery Division) [1998] 1 All ER 959.
28 Gautel v Bettina Reims 2008 the Cour de Cassation/French Supreme Court [2009] D266.
29 Max Walter Svanberg v Leif Eriksson (1979) EIPR D-93 [France].
30 Australian Copyright Amendment Act (Cth) 2006 Section 141A.

31 Laugh it off Promotions CC v South African Breweries International (Finance) BV t/a Sabmark International & Another (CCT42/04 [2005] ZACC 7, 2006(1) SA 144(CC), 2005 (8) BCLR 743 (CC) 27 May 2005 [South Africa].

32 CDPA 1988 Section 30(1).

33 EU Directive 2001/29.

34 *ibid.* Article 5(3)K.

35 US Copyright Revision Act 1976 Section 107.

36 Fisher v Dees 794, F 2d 432 (9th Cir 1986), *215* [US].

37 New Era Publications International ApS v Carol Publishing Group 904 F 2d 152 (2d Cir 1990) [US].

38 Campbell v Acuff-Rose Music Inc 510 US 569 (Sup Ct) 1994 [US].

39 Rogers v Koons 960 F 2d 301 (2d Cir), 506 US 934 938 (1992) [US].

40 Rogers v Koons 960 F 2d 301, 310 (2d Cir 1992) [US].

41 Blanch v Jeff Koons, the Solomon R Guggenheim Foundation and Deutsche Bank AG, (Defendants Appellees) United States Court of Appeals, Second Circuit Docket No 05-6433-CV, 467 F 3d 244 2nd Cir 2006 [US].

42 Cariou v Prince 08 CV 11327 (SDNY March 18 2011) [US].

43 The word 'plaintiff' is still used in American law.

44 *ibid.*

45 Cariou v Prince April 25, 2013 11–1197-cv, 12 [US].

46 20 March 1998 Memo from Dr Peter Knight, Vice-Chancellor of the University of Central England, Birmingham to Diana Warwick, Chief Executive Committee of Vice-Chancellors and Principals of the Universities of the United Kingdom.

47 http://en.wikipedia.org/wiki/Robert_Mapplethorpe.

48 http://quotes.liberty-tree.ca/quote_blog/William.Berkeley.Quote.8EF4.

49 Under the Obscene Publications Act 1959 Section 1(3), the term 'publish' encompasses distribution, circulation, sales, loans, gifts or offers to do any of these.

50 Regina v Hicklin (1868) LR 2 QB 360.

51 Obscene Publications Act 1959 Section 1.

52 DPP v Whyte [1972] 3 All ER 12, para 169.

53 R v Martin Secker Warburg [1954] 2 All ER 683; [1954] 1 WLR 1138.

54 *ibid.*

55 OPA 1959 Section 4(1) as also amended by Criminal Law Act 1977.

56 *ibid.*

57 *ibid.* Section 4(2).

58 R v Penguin Books [1961] Crim LR 176.

59 Human Rights Act 1998.

60 R v Perrin [2002] EWCA Crim 747.

61 Criminal Justice and Immigration Act 2008 Section 63(3).

62 *ibid.* Section 63.

63 *ibid.* Section 63(7).

64 *ibid.*

65 *ibid.* Section 66.

66 Postal Services Act 2000 Section 85.

67 Communications Act 2003 Section 127.

68 Unsolicited goods and Services Act 1971 Section 4.

69 Vagrancy Act 1824 as amended 1838.

70 http://en.wikipedia.org/wiki/Indecent_Displays_(Control)_Act_1981.

71 The Vagrancy Act was repealed in Scotland in 1982 by the Civic Government (Scotland) Act 1982.

72 http://news.bbc.co.uk/1/hi/england/london/3894553.stm.

73 Metropolitan Police Act 1839 Section 2.

74 *ibid.* Section 54.

75 *ibid.* Section 60.

76 *ibid.* Section 54(12).
77 http://news.bbc.co.uk/1/hi/entertainment/3561607.stm.
78 http://www.theguardian.com/uk/2001/jan/26/freedomofinformation.thebeatles.
79 The various Metropolitan Police Acts were amended in respect of Section 54 by the Indecent Displays (Control) Act 1981.
80 Town Police Clauses Act 1847 Section 28.
81 Public Order Act 1936 Section 5.
82 *ibid.* Section 6(3).
83 *ibid.* Section 5(3)(c).
84 http://www.thetimes.co.uk/tto/arts/visualarts/article2540001.ece.
85 Customs Consolidation Act 1876 Section 42.
86 Post Office Act 1953 Section 11.
87 http://customs.hmrc.gov.uk/channelsPortalWebApp/channelsPortalWebApp.
 portal?_nfpb=true&_pageLabel=pageExcise_ShowContent&propertyType=docu
 ment&featurearticle=true&id=HMCE_PROD_010644.
88 R v Gibson & Sylveire [1990] Crim LR 738, 91 Cr App Rep 341, 155 JP 126; Criminal Justice Act 1988 Section 160.
89 *ibid.*
90 Official Secrets Acts 1911 Section 5 and Contempt of Court Act 1981.
91 Contempt of Court Act 1981 Section 8.
92 http://en.wikipedia.org/wiki/DA-Notice.
93 http://www.independent.co.uk/arts-entertainment/hayward-censors-mapplethorpe-nude-of-girl-five-1362646.html.
94 Protection of Children Act 1978 Section 1(1).
95 Coroners and Justice Act 2009 Sections 62–67.
96 Criminal Justice Act 1988 Section 160.
97 Coroners and Justice Act 2009 Section 66.
98 *ibid.* Section 64.
99 http://news.bbc.co.uk/1/hi/entertainment/1215944.stm.
100 http://sallymann.com/selected-works/family-pictures.
101 R v Neal [2011] EWCA Crim 461.
102 A historical position association with the royal household.
103 Theatres Act 1968 repealed these acts.
104 Theatres Act 1968 Section 2.
105 Obscene Publications Act 1959 Section 1(1).
106 LCC v Bermondsey Bioscope Co Ltd [1911] 1 KB 445.
107 Hand-written memo from the Home Office 14 August 1917 PRO-HO 45/10955.
108 Cinema Commission Enquiry 1917.
109 Screen Violence and Film Censorship (nd) *Home Office Research Study*, Number 40: 2.
110 http://en.wikipedia.org/wiki/Nosferatu.
111 http://www.bbfc.co.uk/case-studies/clockwork-orange.
112 http://en.wikipedia.org/wiki/British_Board_of_Film_Classification.
113 Video Recordings Acts 1984, 2010.
114 A-G Reference (No 5) 1980 [1981] 1 WCR 88, CA.
115 http://www.screenonline.org.uk/film/id/591898.
116 Amendment through the Criminal Law Act 1977 Section 53(6) to Obscene Publications Act 1959 Section 4(1A).
117 http://en.wikipedia.org/wiki/Theo_van_Gogh_(film_director).
118 http://en.wikipedia.org/wiki/Jyllands-Posten_Muhammad_cartoons_controversy.
119 http://en.wikipedia.org/wiki/The_Satanic_Verses_controversy.
120 *ibid.*
121 http://www.theguardian.com/books/2012/sep/14/looking-at-salman-rushdies-satanic-verses.

122 *ibid.*
123 http://en.wikipedia.org/wiki/Piss_Christ.
124 Whitehouse v Lemon [1979] 2 WLR 281; Whitehouse v Gay News [1979] AC 617 HL.
125 http://en.wikipedia.org/wiki/Whitehouse_v_Lemon.
126 R v Lemon [1979] AC 617; R v Gay News Ltd [1979] 1 All ER 89.
127 Criminal Justice and Immigration Act 2008 Section 79.
128 Coroners and Justice Act 2009 Section 73.
129 Racial and Religious Hatred Act 2006 Section 29B.
130 http://www.awn.com/animationworld/was-walt-disney-saint-evil-sinner-or-devil-incarnate-truth-about-some-those-nasty.
131 http://www.awn.com/animationworld/was-walt-disney-saint-evil-sinner-or-devil-incarnate-truth-about-some-those-nasty.
132 *ibid.*
133 http://www.uproxx.com/tv/2013/10/fcc-released-bunch-simpsons-related-indecency-complaints-pretty-great/.
134 European Convention on Human Rights Article 10(2).
135 R v Shayler [2003] 1 AC 247.
136 HRH Prince of Wales v Associated Newspapers [2006] EWCA Civ 1776; [2007] 3 WLR 222, [2008] Ch 57.
137 A v B [2003] QB 195.
138 Human Rights Act Section 12(4)(b).
139 Campbell v Mirror Group Newspapers [2004] 2 AC 457 HL, para 140.
140 A v B [2003] QB 195.
141 Human Rights Act 1998 Section 12(1).
142 HRA 1998 Section 12(4).
143 *ibid.* Section 12(5).
144 Terry v Persons Unknown [2010] EMLR 400.
145 *obiter* Mosley v News Group Newspapers Ltd [2008] EMLR 20.
146 Re S (A Child) [2005] a AC 593, para 17.
147 Tolstoy Miloslavsky v United Kingdom Application 18139/91 (1995) 20 EHRR 442.
148 Mosley v News Group Newspapers Ltd [2008] EWCH 1777 QB; [2008] EMLR 20, para 128.
149 Article IX Bill of Rights 1689.
150 http://www.publications.parliament.uk/pa/cm200506/cmselect/cmquad/uc873-i/uc87302.htm.
151 *ibid.*
152 See also Data Protection (processing of sensitive personal data) Order 2000, SI 2000/417, Paragraph 6(1) Schedule 2 DPA and Section 35(2).
153 Data Protection Act 1998 Section 7.
154 DPA 1998 Sections 10.
155 *ibid.* Sections 14(1)-(3).
156 Special purposes are defined at DPA 1998 Section 3.
157 Campbell v Mirror Group Newspapers Ltd [2004] 2 AC 457.
158 DPA 1998 Section 32(1)(b).
159 *ibid.* Section 32(1)(c).
160 Data Protection (processing of sensitive personal data) Order 2000, SI Order 2000/417, Article 2, Paragraph 3.
161 SI 2000/417 Article 2 Paragraphs 3(1)(b) and 3(2).
162 Employment Rights Act 1996 Part 1VA Sections 43 A-L.
163 Public Interest Disclosure Act 1998 Section 103A.
164 Employment Rights Act 1996 Part 1VA Section 43C-H.
165 Enterprise and Regulatory Reform Act 2013 Section 18 removing Employment Rights Act 1996 Sections 43C-43H.
166 Employment Rights Act 1996 Part 1VA Section 43G(3)(a)

Bibliography

Barnes, J. (2011) Data protection, in M. Warby, N. Moreham and I. Christie, eds. *The law of privacy and the media (Tugendhat and Christie)*, 2nd edn. Oxford: Oxford University Press, 271–318.

Barro, R. and Sala-i-Martin, X. (1995) *Economic growth*, Cambridge MA: MIT Press.

Bate, S. and Hirst, D. (2011) Copyright, moral rights and the right to one's image, in M. Warby, N. Moreham and I. Christie, eds. *The law of privacy and the media (Tugendhat and Christie)*, 2nd edn. Oxford: Oxford University Press, 393–430.

Boldrin, M. and Levine, D.K. (2008) *Against intellectual monopoly*, Cambridge: Cambridge University Press.

Cohen, K.F. (2004) *Forbidden animation: censored cartoons and blacklisted animators in America*, Jefferson, NC: McFarland & Co Inc.

Cohen, N. (2012) *You can't read this book,* London: Fourth Estate.

Davies, G. (2011) *Copyright law for writers, editors and publishers*, London: A&C Black Publishers Ltd.

Demetriou, D. (2003) Obscene art of DH Lawrence goes on show after 70-year ban, *The Independent* 4 December 2003.

Dubin, S. (1992) *Arresting images: impolitic art and uncivil actions*, London and New York: Routledge.

Ellison, R. (1989) Words for Salman Rushdie, *New York Times Book Review* 12 March: 28.

Glass, L. (2006) The ends of obscenity, *Critical Inquiry*, 32(2): 341–361.

Greenburg, L.A. (1992) The art of appropriation: puppies, piracy and post-modernism, *Cardozo Arts and Entertainment Law Journal*, 11(1): 20–21.

Hyde, L. (2012) *Common as air: revolution art and ownership*, London: Union Books.

Lessig, L. (2004) *Free culture*, New York: Penguin Press.

McCutcheon, J. (2008) The new defence of parody or satire under Australian Copyright Law, *Intellectual Property Quarterly*, Issue 2: 163–192.

Okpaluba, J. (2002) Appropriate art: fair use or foul, in D. McClean and K. Schubert *Dear Images: art, copyright and culture*, New York: Institute of Contemporary Arts, 197–224.

Ormerod, D. (2011) *Smith and Hogan's criminal law,* 13th edn, Oxford: Oxford University Press.

Petley, J. (2012) *Censorship: a beginner's guide*, London: One World.

3 The use and misuse of information

Introduction

There is a variety of sensitive subject matter and activities over which a party might seek control: the distribution of false or injurious material; the release of private information; unwarranted intrusion (physical or otherwise); the determination of how the image associated with a personality is used (publicity rights); and trade secrets. The concept of privacy is a difficult one to define but colloquially we might refer to the protection of our reputation or dignity; the preservation of physical integrity or mental health; the right to develop our relationships unfettered or even a right to be alone. The right to be left alone might seem too imprecise to be worthy of legal rules but as Cohen remarks, it is important to 'recognise that the full truth about an individual's life cannot be made public without crushing his or her autonomy. Under the pressure of exposure ... He would become suspicious, fretful, harassed ...' (2012: 22).

In order to understand the legal tools available to someone who wants to protect information about themselves, it is necessary to examine the following principles: contract, breach of confidence, passing off, personality rights, privacy, defamation and data protection; often a combination of these converge in just one case. In addition, much of the case law that develops around breach of confidence concerns itself with commercial information but is employed to protect information of a personal and intimate quality. Furthermore, since passing off as a legal tool arises in intellectual property cases, there will also be a return to some of these ideas to illustrate their connection to 'personality rights' (which do not formally exist under English law). There is an attempt here to create a logical and linear narrative around these themes but too much logic will not reflect the state of the law in this field.

This chapter is aimed at practitioners whose work either creates content about others or whose work relies on information about others. Photographers, particularly those involved with editorial, documentary or press work, writers of non-fiction and film-makers will find this particularly useful. These readers are reminded of the use of model and interview release forms for all work involving human participants and the difficulties that the use of these, in advance of activities, can overcome.

Contract

A grasp of the basic principles of contract is integral to understanding much of what follows here (and is important more widely). The law of contract in England and Wales is primarily determined not by statute, but by case law. For a contract to be found to exist there must be an offer and an acceptance of it. The offer of a willingness to contract on specified terms need not be in writing[1] and it can even by implied by conduct, previous dealings or custom and practice without any words confirming it precisely.[2] However, something in writing relating to the contract will always be important evidentially. The fall of a hammer in an auction is an indication of the binding acceptance of an offer.[3] An offer, even one made unilaterally,[4] can be revoked at any time before it is accepted[5] as long as this is communicated to the *offerees* by reasonable means.[6] Means of communication might include e-methods, the post, telephone, in person and so on. Once performance of a contract has begun, an offer cannot be revoked.

A contract requires *consideration* which is the profit, or benefit, that accrues to one party at the forbearance, or detriment, of the other party;[7] without this, it is not a contract. The terms of a contract can be express or implied (overtly stated or inferred through circumstance). If the terms are written down then extrinsic evidence of oral variation to a written document will be less useful for the parties in the event of a dispute between them and the written agreement will generally prevail. There are a few exceptions to this rule; for example, in Smith v Wilson,[8] the Parol Evidence Rule developed and '1,000 rabbits' was held to mean '1,200 rabbits'. Implied terms arise from custom and practice and also from previous dealings between the parties.[9] Implied terms can also arise from a legal obligation relating to a product or service which must be of satisfactory quality[10] and 'fit for purpose'.[11]

Acceptance of a contract can also be inferred from conduct and generally comes into effect when the acceptance is received/understood by the *offeror*.[12] The means by which an offer may be accepted can be specified within the offer itself and then only this method will suffice as a method of acceptance. If the method for acceptance is not specified then any reasonable means will be sufficient.[13] Conditional assent (with new terms attached) does not constitute a legal acceptance, and a counter-offer voids the original offer.[14] However, a request for further information does not constitute a counter-offer.[15]

A breach of the terms of a contract will be breach of contract entitling the offended party to damages (financial) or *rescission* ('unmaking' of a contract), if this is practical. Otherwise, both parties must discharge their liabilities under the contract within a reasonable time unless a date and time is specified, in which case late *performance* will be a breach of contract.[16] In such circumstances, the contract can be *repudiated* by the victim of late completion (a repudiation is a refusal to perform the duties under the contract).

In the case of a breach of contract, the courts will look at the intention of the parties[17] and the consequences of the breach to either party.[18] If there is a

breach of a major term then the victim of this breach can treat the contract as still operative (but only by an express or unequivocal act)[19] or as terminated.[20] Ordinarily the courts would analyse whether the late completion or other breach was sufficiently serious to be 'repudiatory'. If it is, then the other party has a choice: to 'affirm' the contract (carry on with it and limit rights to damages for the breach), or to 'accept' the *repudiatory breach* (treat the contract as at an end and sue for damages for the breach and losses caused by the termination of the contract). In an 1888 case involving a photographer, who had been commissioned to take a photograph and subsequently put the image on a Christmas card for sale, was successfully sued for breach of contract;[21] as the law has changed in the twentieth and twenty-first centuries, more rights of action would be available to a claimant under these circumstances. This case pre-dates the Copyright, Designs and Patents Acts 1988 which prohibits the author of such commissioned photographic work from displaying it publicly without permission (see Chapter 1).

If a contract becomes impossible to perform (not merely more onerous) then either of the parties might argue that *frustration* of contract has occurred. This must be an extraneous event without fault of either party and outside their control.[22] If one of the parties foresaw the event that made the contract impossible then this will go against them and against the finding of frustration.[23]

If there has been misrepresentation by, or to, one of the parties, or there is any evidence of duress or illegality, then a contract may be *void* or *invalid*. Where there is misrepresentation by one party to another as to some aspect of the matter contracted over then the contract will be voidable at the point that this is discovered. Fraudulent misrepresentation (where there is absence of honest belief in the party making a representation) has always been actionable under common law. Negligent misrepresentation (now covered by the Misrepresentation Act 1967[24]) will also affect a contract's status, particularly against the party who has been wilfully negligent. Wholly innocent misrepresentations, however, require the party who committed the misrepresentation to show that they had reasonable grounds for their belief in what they said. Where there is misrepresentation, the remedy might be rescission (setting aside of the contract by application to the court) or notification to the other party of repudiation; this terminates the contract *ab initio* (as if it were never made). Remedy might alternatively be achieved through damages if the (mis)representation was fraudulent or negligent (to restore the claimant to the position they would have been in had there been no misrepresentation). In the case of Leaf v International Galleries, Leaf thought he had purchased a work by Constable, only finding out some years later when he tried to sell it that he had not. International Galleries were innocent of any deliberate misrepresentation so rescission of contract was not available to the claimant.[25]

A contract formed when one of the parties was under duress or undue influence will be voidable and illegal. Duress might take the form of physical or economic pressure or threat. If there is no special relationship between the parties, the claimant must show the influence involved before undue influence

might be found. If there is a special relationship (such as a familial one or where one party was vulnerable and there was particular advantage to the other party) then there is a rebuttable presumption of undue influence (meaning that a defendant must show that there was no undue influence). The remedies for duress and undue influence include rescission.

A court may find a contract to be illegal or void if it is made so by statute, public policy or particularly if it is 'immoral'. In the 1866 case of Pearce v Brooks,[26] Ms Brooks, after some weeks of using an ornamental carriage supplied by Mr Pearce under a hire-purchase agreement, returned it before completing all the payments. There was a penalty payment due under such circumstances and Pearce sought damages for 'wear and tear' as also permitted in the contract. Brooks argued that, since Pearce knew the nature of the work she would be conducting in the carriage, the contract was unenforceable. The court found that as Pearce knew that Brooks had entered the hire-purchase agreement in order to 'ply her illicit trade' he had no claim against since the contract had been made for immoral purposes.

If a contract is illegal then neither party may sue, but if it is void there may be some recovery of monies. If there has been a mistake by both parties (common mistake), a mutual mistake or mistake as to the existence of subject matter or its ownership, then a contract might be found to be void.

The Unfair Contract Terms Act 1977 overrules some older case law for contract; for example, where an individual is trading with a business, the courts are obliged to apply a test of reasonableness as to the terms and performance of a contract with regards to limitation or exclusion of liability clauses.

The relative strength of the bargaining parties has always been of some relevance in the determination of cases involving contracts. You might want to refer here to Schroeder v Macaulay[27] in which the House of Lords determined that a contract limiting a songwriter's ability to write for other publishers was unlawful as it constituted a 'restraint of trade'. Their finding (Lord Reid again) was influenced partly by the inequality of the contract in question.

Remedies for breach of contract

Action for breach of contract must generally be brought within six years of the breach.[28] Damages for a breach of contract include *restitution* (based on what a party should have gained) and *compensation* (which is concerned with awarding what a party lost). Equitable remedy (see Introduction) or specific performance will not be awarded: if some form of damages would be adequate; if constant supervision would be required to ensure specific performance; or if the contract is for some form of personal service. In the case of Warner v Nelson,[29] the actress Bette Davies was prevented from taking other acting work for the duration of her contract with Warner but the judge restricted the injunction to her acting work rather than preventing her from working entirely; nor was she compelled to work as an actress for Warner. In Lumley v Wagner,[30] the court stated that while it had no power to compel Wagner to sing for Lumley under her contract, it could restrain her from singing for anyone else while the contract was in place; presumably singing in private was excluded since it would be impossible to control.

Why contract is important here

The explanation of contract given so far might convince the reader to be cautious in contracting with others, and to ensure that rights and duties under the contract are clear. However, there is further reason to understand contracts and that is where the actions of one creative practitioner interfere with the rights of another. In Douglas v *Hello!*,[31] an unauthorised paparazzo had obtained images of a celebrity wedding for *Hello!* magazine. An exclusive contract between the claimants and *OK!* magazine had been created of which the subject matter was the wedding photographs. That the information (in this case photographs) had been commodified in this way did not prevent it from being protected as 'private' information (dealt with in further detail below). The case, though much publicised as about privacy, raises many other issues concerning the rights of personalities to control the commercial use of their image ('publicity rights') (also examined below).

Warby, Speker and Hirst refer to Douglas v *Hello!* as a 'hybrid' case (2011: 163), and it has been described by Bate and Hirst as 'the principal stimulus to the development of a right of publicity in England and Wales' (2011: 425). The hybridity of the case is underlined by a further claim against *Hello!* by *OK!* because the latter had the exclusive rights to use the materials in question. The judgement of the House of Lords in Douglas gave rights to an exclusive

licensee (in this case *OK!*) against a third-party (*Hello!*) to sue on interference with their rights.[32] A pre-publication injunction against *Hello!* was refused in this case. Since it is interweaved around many emerging principles, this case will be returned to several times throughout this chapter.

Control over personality and reputation: trademarks, passing off, copyright, defamation, privacy

The reader will be alert already to the somewhat disparate areas of law being brought together here but since there have been some clear signals in recent case law that quasi-personality rights are emerging, this field of law is likely to develop. However, currently there is no direct right of personality so celebrities whose images have been used to promote goods and services without their authorisation have limited protection. The causes of action used include trademark infringement, passing off, copyright, breach of confidence and defamation. The copyright in photographs usually belongs to the photographer which can create further problems for celebrities trying to control their image (though often a contract will be in place restricting a studio photographer).

Trademark infringement

Since 1994, the Trade Marks Act has permitted personalities to apply to register their names as a mark.[33] Potentially, images of an individual, their name or their signature might be protected through registration. The party making an

application for the specified mark would have to stipulate the class of goods associated with the mark as well as showing that it is capable of being graphically represented and distinguishing the goods/services in question from other traders[34] (outlined in Chapter 1). Case law suggests that none of this has been straightforward when it comes to celebrity trademarking under English law.[35] If a celebrity mark is registered successfully, it will be infringed when a consumer would be, or is, deceived or confused as to the personality associated with the goods or service.

Passing off

Though referred to also in Chapter 1, the concept of passing off is important to understanding how information about a person could be exploited as a commodity, and how the subject of that information might achieve control over it. The background to this offence is the tort of deceit/misrepresentation, where traders lead a consumer to believe that they offer the goods or services of, or are associated with, another party whose goodwill they therefore exploit. Reverse passing off refers to a state of affairs where the defendant suggests that they are actually the source of the claimant's goods. Passing off action can also be used in relation to trademarks that are unregistrable or unregistered. Much case law was generated that developed rules around passing off but in 1979, the House of Lords in Advocaat v Townend[36] issued a judgement which summarised the approach to be used. A staged test for passing off was devised as follows: there must be misrepresentation; made by a trader in the course of trade; to prospective or actual customers; which was calculated to, or foreseeably likely to; injure the reputation or goodwill of another trader/business; and which causes damage to the business of the other party on whose reputation they have relied. In a later case of Jif Lemon v Borden,[37] this approach was distilled slightly into tests relating to reputation (the existence of customer goodwill); deception (misrepresentation); and foreseeable damage. In the Jif Lemon case, the House of Lords restrained the use of a plastic container shaped liked a lemon by the defendant. Since a lemon shape cannot be construed as a trademark, action had to be for passing off.

For a trader to have deceitfully traded on the reputation/goodwill of another, there must be more than confusion in the mind of a potential consumer. The trader must be involved in a commercial activity of the type with which the goodwill is associated, and there must be some form of deception or misrepresentation. Deception can be express or implied, through words or action, as long as these are likely to lead a potential consumer to believe that the goods or services are connected to the claimant. A claimant's case is strengthened by a defendant's conscious attempts to mislead, cause confusion or commit fraud, though a successful passing off case does not demand a particular state of mind in the defendant. For evidence of confusion in the minds of a more than trivial number of potential consumers, the courts may consider actual, expert or survey evidence and the characteristics of the market-

place (whether, for example, the consumer is likely to closely scrutinise the goods or services in question). In the US case of *odor eaters* and *odour eaters*,[38] the court awarded an injunction against the defendant from using names that were phonetically identical.

The damage caused to the trader whose goodwill has been exploited might be the diversion of profit they have suffered as a result of the passing off activities of the defendant. It might also include the loss of potential trade in a commercial or geographical area in which the trader intends to trade as well as damage/dilution to their reputation. Loss of licensing revenue (or royalties) might also be considered. The 1970s case of Lyngstrad v Annabas[39] found that potential consumers would not believe that the defendant had been approved by Abba to produce T-shirts on which their image was printed. It was therefore found that there had been no misrepresentation but a response, by the defendant, to the demand for goods. This type of defence seems less likely to succeed since the case of Rihanna v Topshop[40] discussed in Chapter 1.

In English law, there is a contrast between a lack of personality rights in real people and character merchandising in relation to fictional characters. Not for the first time readers will be aware that there is significantly more law available for use by imaginary characters than for persons who exist in the flesh form. In Mirage v Counter-Feat Clothing,[41] the tort of passing off was found in relation to trading by the defendant in *Teenage Mutant Ninja Turtles* clothing since the defendant had made it appear that there was permission to use the claimant's drawings. Copyright action would also have been possible here[42] whereby the owner of a character could protect the image under the category of 'artistic work'.[43]

Copyright

Bate and Hirst (2011: 430) put forward the view that privacy interests may arise in copyright materials[44] since the owner of copyright controls their reproduction, publication and commercial use.[45] In Pro Sieben v Carlton TV,[46] the court stated the need to balance the rights of a copyright owner against public interests.[47] The fact that a work is unpublished need not preclude the possibility of the defence of fair dealing[48] (see Chapter 2) to a copyright infringement claim but the copyright owner may well cite the fact that it is unpublished as evidence of its private or restricted nature. The Court of Appeal in Ashdown v Sunday Telegraph[49] observed the power of Article 10 ECHR (Right to Freedom of Expression) in this respect: 'There will be occasions when it is in the public interest not merely that information should be published, but that the public should be told the very words used by the person, notwithstanding that the author enjoys copyright in them'.[50] The public interest defence in the CDPA[51] can give effect to the right to freedom of expression though, in this case, the court held for Ashdown finding that the newspaper had been motivated by commercial rather than public interests. The decision of the court was influenced by the proportion of material that the

newspaper had used from confidential notes by Mr Ashdown, made during the course of meetings in Downing Street while he was an MP. The volume of material used went beyond that required to demonstrate the veracity of the story.

The copyright acts protect privacy in certain documents and prohibit their unauthorised publication. In Williams v Settle,[52] punitive damages were awarded under the Copyright Act 1956 where there had been unauthorised publication of wedding photographs sold to a newspaper to illustrate a story about the murder of the bride's father (which had not taken place at the time of the wedding). The privacy of the subject of an image, in certain cases, usurps ownership of copyright by a photographer.[53] This principle is clarified in the CDPA 1988 which creates a privacy right lasting for the duration of copyright in images commissioned for private use. The images arising from such privately commissioned work may not be exhibited, shown or communicated to the public without the authorisation of the subjects[54].

Breach of confidence

While there are no property rights in ideas, there is some legal provision to prevent others from using or disclosing ideas and materials if they have specified obligations. Prior to the implementation of the Human Rights Act 1998, breach of confidence was one of a few tools available under English law for regulating the use of private or sensitive information. Developments in consumer law, common law and equity gave rise to a cause action which covers a range of information types (personal, commercial, trade secrets and so on). So where no contract exists on which to sue, the conduct of the parties involved in the exchange of information, and the 'good conscience' a court might impose on them, can give rise to a duty of confidence.[55]

Breach of confidence is based on the obligation that might arise in a person to whom an idea, material or information is disclosed (often before it is made tangible, making it ineligible for IP protection). The person to whom the material was disclosed can be prevented from publicising or exploiting it through action for breach of confidence. The nineteenth-century case of Prince Albert v Strange[56] prevented the publication of etchings of the royal family (or a description of them) that had been 'improperly obtained' (by the defendant's contact with the 'light-fingered printer'). Until relatively recently, this cause of action had been concerned mainly with commercial information though a duty of confidence may also be imposed by statute.[57] In addition, the CPR[58] and Criminal Procedure and Investigations Act 1996[59] protect information compulsorily disclosed in court proceedings. Information can also be protected on direction from the court.[60] The Sexual Offences (Amendment) Act 1976[61] provides anonymity for victims of rape and the Sexual Offences (Amendment) Act 1992[62] provides the same for victims of other sexual offences: buggery, indecent assault, incest, procurement and, since 2004 (as amended), voyeurism and indecent exposure.

In the UK, the conditions for demonstrating breach of confidence were outlined in Coco v Clark[63] which concerned a moped engine. For a 'quality of confidence'[64] to be found, a claimant must show: that the information is capable of being protected (that it is of a type which qualifies for protection determined by factors such as its accessibility and its sensitivity); that the defendant owes the claimant a duty to keep the information confidential (that a reasonable man would know that 'the information was imparted in circumstances importing an obligation of confidence'[65]); and that the defendant used the information in a way that breached the duty imposed (that there was misuse of the information under the 'conscience test'[66]). In the case of Coco v Clark, the claimant could not obtain an injunction prior to full trial to prevent manufacture of the item, and instead the court required a deposit into a joint account, by the defendant, of royalties relating to the sale of the contested item.

For an obligation of confidentiality to arise, there had to be a direct relationship between parties which gave rise to a duty (some provision is made for third parties – see below). This might be through a contract term or the type of relationship in question, such as is the case with an employer and employee. For example, in the case of Shelley Films Ltd v Rex Features,[67] photographs of costumes and make-up taken by a set-photographer on the closed set of *Frankenstein* were found to contain information of commercial value which was confidential and protected. The obligation will arise where either party has ensured a Non-Disclosure Agreement (NDA) is in place prior to activities likely to lead to a party obtaining sensitive information; however, in many instances, the sight of an NDA might deter one party from engaging with the other.

To establish a duty of confidence, the relationship between claimant and defendant had be shown to place an obligation on one of the parties to act

for the benefit of the other. Sometimes the manner in which information is communicated will impose the duty, or a reasonable express statement to that effect, or it could be inferred from the circumstances of the exchange of information. The duty is indefinite in duration, though it can be ended by circumstance (the death of the person who has imparted the information or that the information entered the public domain lawfully by other means).

Third parties who come into contact with confidential information will also have an obligation of confidence in relation to the disclosure of information. This includes anyone who is aware that information is confidential or those who are *grossly negligent* to the fact and parties acting in 'bad faith'.[68] Carelessness or naivety will probably not lead to a finding of liability in a third party innocently receiving information.[69]

The position under English law has been that a claimant must come to a case with *clean hands*: in Lennon v News Group,[70] John Lennon was unable to restrain publication of his former wife's account of their marriage, because he had himself discussed the issues publicly.

In the past, the fact that there was no relationship between claimant and defendant presented significant problems. The case of Douglas v *Hello!*[71] examined the manner in which information was obtained, and established that it was not necessary for it to have been disclosed during the course of a particular relationship for a duty of confidentiality to arise. Ultimately, this case succeeded because of the quality of the commercial material over which the claimants had control. It was in Douglas v *Hello!* that the House of Lords distinguished 'misuse of private information' as a form of breach of confidence; the need for 'confidence' will be amplified in cases where there is a closer relationship between the parties.[72]

In order for information to be 'capable of being protected', the claimant must identify information of a sensitive nature.[73] Information that is already in the public domain is generally not protected, though it might be known by several parties and still not, in the view of the court, be in the public domain. Oddly, previously public information can become 'secret' again in law.[74] Once information is unlawfully widely available, however, the courts cannot restrain it further as was the case with the *Spycatcher*[75] case discussed in Chapter 2; though the person in whom confidence was placed may still be sued and will not own copyright.

Defences to action for breach of confidence include that of justification in the public interest. This defence is particularly bolstered by Article 10 ECHR. Information that might be in the public interest includes reporting of crime, fraud or other misconduct (particularly in public office). According to Lady Hale, Article 10 protection for 'most vapid tittle-tattle'[76] brings the act of balancing convention rights under somewhat of a cloud (discussed further below).

Other defences to breach of confidence actions include that the material is in the public domain, and that restriction of the use of information is an unlawful restraint of trade. As with copyright, 'immoral' ideas or materials

are not protected through breach of confidence. Traditionally, falsity of the information could not give rise to action for breach of confidentiality. However, more recently the Strasbourg Court has recognised that false information may engage a claimant's right to a private life, through the preservation of reputation as enabled by the ECHR.

Demonstrating 'consent' of the claimant may give rise to a defence. A defendant can argue it is inequitable for a claimant to complain about a particular act (such as if the claimant themselves had put the information in the public domain), and that they are *estopped* from making a claim. The defence that the claimant consented to whatever was done[77] requires affirmative action, rather than passivity, on the part of the claimant.[78] The burden of proof is on the defendant to show evidence of this. If written consent was given by the claimant then even this might not be sufficient since the act complained of might not be within the scope the consent given,[79] or the consent may not have been properly 'informed'.[80] Consent can be implied by conduct or words spoken, and can be revoked where it was given gratuitously but also, depending on the circumstances, if money was paid.

Before the implementation of the Agreement on Trade-Related aspects of Intellectual Property Rights (TRIPS) 1994, there was no international regulation for dealing with breaches of confidence. TRIPS now requires that its member states make provision for those who control certain categories of protected information, and for unfair competition practices.[81] Such legal instruments are intended to prevent the disclosure or use of information and control the acquisition of information where there has been dishonesty. In the UK, there is no unfair competition law as such, though the concepts of dishonestly creating confusion as to the origins of goods/services and/or misleading the public is encapsulated clearly in passing off.

Reputation; malicious falsehood and defamation

> 'If you've nothing to hide, you have nothing to fear' say authoritarians. But everyone has something to hide, and if there isn't a dirty secret, there is always something that your enemies can twist to make you look dirty.
>
> (Cohen 2012: 22)

The Universal Declaration of Human Rights 1948 (to which the UK is a signatory) refers to protections against 'attacks on … honour or reputation'.[82] Similarly, the International Covenant on Civil and Political Rights[83] places emphasis on protections against interference in private life, home and reputation. The UK is also a party to this Covenant but does not provide its citizens with the right of individual petition to the UN Human Rights Committee. The concept of 'honour' means that actions for privacy, confidentiality and defamation may overlap. The Strasbourg Court has noted[84] that there is a relationship among these actions since the right to 'reputation' forms part of the right to a private life (ECHR Article 8 – discussed below). Parkes identifies the overlap as follows:

If defamation is necessary to protect the reputation that a person has in the minds of *right-thinking* members of society generally, then privacy can be said to be necessary to protect the reputation a person has in the minds of *wrong-thinking* members of society.

(original emphasis; 2011: 325)

Defamation law protects information that is sensitive and false; emerging privacy protections safeguard against information that is sensitive but true.

Malicious (injurious) falsehood

Malicious falsehood lies between the torts of passing off (above) and defamation (below). To succeed in action for this, the claimant must show that the defendant maliciously made false statements about the claimant's goods or services which were calculated to cause damage, and which caused financial loss to the claimant. The term 'malice' is defined as 'spiteful or improper motive'.[85] The aim of malicious falsehood law is to safeguard against pecuniary damage that might be incurred if products or business are falsely represented. If the statements made turn out to be true then no action is possible, even if the remarks are not in the public interest. The burden is on the claimant to prove the falsity of the statement made by the defendant (the opposite is true in defamation where the burden is on the defendant to show the comment is true).

Libel and slander

In February 1982, a high court jury in the UK awarded damages of a half-penny, in respect of a defamation action, to dentist, Kenneth Watson.[86] Watson had complained that a photograph of him aboard his yacht in northern France was printed in a magazine with the caption 'Marina Thief' alongside an article about an unknown quay-side thief operating in France (Frederick 1985: 505). The contemptuous damages awarded in this case seem to indicate a disregard for the impact of directing an audience to read an image in a certain way. Photographs are coming to be recognised now as worthy of special consideration, rather than humble substitutes for words.

The history of defamation goes back to 1275 in English law, and its background is found in seditious libel (imposing penalties for unfavourable talk about the monarch and, later, government officials).[87] Prior to 1792, a judge alone decided whether there had been a libel and the truth of a statement was no defence. The Fox Libel Act 1792 introduced juries into the decision-making process as to whether a statement was libellous, and in 1843 the Libel Act (Lord Campbell's Act) introduced truth as a permissible defence against seditious libel action.

Defamation (covering libel and slander) is a *tort* (see Chapter 4) but also recognised under the Defamation Act 1952. It is only available after the wrongful act has been committed, whereas 'privacy' actions can seek to prevent the distribution of information prior to its disclosure to the public. Such prior

restraint is generally not available in defamation cases if the defendant confirms that they will attempt to justify the disclosure as fair comment or qualified privilege (see below).[88] Occasionally, where there is overlap with other causes of action, such as a breach of confidentiality, prior restraint may occur.[89]

In contrast to action for malicious falsehood, it is for the defendant to show that a remark is true but, in common with malicious falsehood, the truth need not be in the public interest for the defence to apply.[90] Words are construed to be defamatory if 'they tend to lower the claimant in the estimation of right thinking members of society generally, or if they are likely to affect the claimant adversely in the estimate of reasonable people' (Parkes 2011: 319). Any words that expose a claimant to 'hatred, ridicule or contempt' (Parkes 2011: 319) can be defamatory. Defamation does not require a relationship between the parties.

The *McLibel* trial of the 1990s confirmed the preference for large businesses to take their action for defamation to the English courts. A group called The London Greenpeace had distributed a pamphlet containing a number of allegations against McDonalds, who issued proceedings for libel. In 1997, part of the case went against the defendants (who had had to represent themselves in court), and they were ordered to pay £60,000 to McDonalds.[91] Although the judge rejected the pamphlet's claim that McDonalds were accountable for the use of lethal poisons to destroy the rainforest, he upheld the claim that the food supplier 'pretended to a positive nutritional benefit which their food did not match', that their advertising exploited children and that the company paid low wages.[92] It had been one of the longest cases in English legal history, and it was not until 2005 that the Strasbourg Court ruled that the lack of legal aid available

in such circumstances denied the defendants the right to a fair trial (as set out in Article 6 of the European Convention on Human Rights).[93]

In recognition of Article 10 ECHR (the right to freedom of expression), there has been a move towards the exclusion of inconsequential remarks from action for defamation, and claimants must now rely on information that would/has had a significant, adverse effect on how they are perceived by others. However, one of the problems with litigation for defamation is that since truth is a defence, a claimant can be subjected to intrusive questioning and forced to disclose evidence that they may find humiliating. Defamation can take the form of libel (the written or broadcast word) or slander (the spoken word). Since action for slander is rare, only libel is detailed here. It is a myth that prefacing a defamatory remark with words such as 'allegedly' or 'in my opinion' will always neutralise the remark.

Libel

In 1877, John Ruskin published a review of the work of James Whistler which was less than favourable: 'I have seen, and heard, much of cockney impudence before now; but never expected to hear a coxcomb[94] ask two hundred guineas for flinging a pot of paint in the public's face'[95]. Ruskin suffered mental ill-health and was unable to appear at the subsequent libel trial (November 1878). Whistler was asked by counsel for the defence if he thought the time he had spent in creating the work *Nocturne in Black and Gold* was worth the 200 guineas he asked for it (a nineteenth-century brief might well be accused of hubris for such a question), to which Whistler replied, 'No, I ask it for the knowledge I have gained in the work of a lifetime'. Whistler succeeded in action for defamation but was awarded damages of one farthing.[96] The case led to the bankruptcy of Whistler.

For a libel to be found there must be a published, wrongful statement likely to give rise to injury to a reputation. The criteria for demonstrating libel are that: the statement made must be defamatory (injurious); communicated, published or broadcast to one person (other than the victim) who must see or hear it; the victim must be identified (or readily identifiable); and there must be an element of fault on the part of the perpetrator (who must either know the statement to be false, accompanied by actual malice or neglectful of whether the statement is true or not; referred to as a negligent misstatement). If this last element of fault is not shown (but all others are) then the claimant is permitted to show proof of monetary loss to obtain damages. The time limit for action in libel is one year[97] though where there is good cause for delay to action, a court may extend this time limit.[98]

Defences

Aside from the justification in the truth of the comment made, the Defamation Act 1996[99] provides a defence of innocent dissemination of false and injurious comment. The Defamation Act also permits a potential defendant to offer to

amend a misstatement to avoid litigation.[100] In addition, a defendant may plead that their words were honest or fair comments made in good faith, without malice, on a matter of public interest.

Available to some is the defence of privilege. This was divided into absolute privilege (comments made in Parliament by members of the House during proceedings and the subsequent transcript in *Hansard*) (see Chapter 2), and qualified privilege (public interests defence). Those working in news have sometimes enjoyed 'qualified privilege', meaning that if the publisher of the information acted responsibly in respect of publication of material in the public interest that could be defamatory and cannot be shown to be true, but which was honestly held opinion, they will have a defence. It is for the defendant to show that they took steps to ensure the accuracy of their words. This was called the Reynolds defence[101] until 2013 when the new Defamation Act[102] abolished the common-law defence of qualified privilege and replaced it with publication of matters in the public interest.[103] The new Defamation Act requires claimants to show probable, or actual, harm to succeed in a case, and applies to events on or after 1st January 2014. Privilege as a defence has been found not disproportionate to the right to a private life.[104]

A private life

In the 1991 case of Kaye v *Sunday Sport*,[105] a then widely-known actor (for his work in the BBC series *'Allo 'Allo!*) suffered serious injuries in a car crash. He attempted to restrain publication of photographs of these which had been obtained by deception (a journalist had entered the hospital by dishonest means). The court observed that the case was a 'graphic illustration'[106] of the need for Parliament to consider statutory provision for the protection of privacy. The only thing the court could do for the claimant in this case was ensure that the paper did not present Kaye as having consented to the story.

Until 1998, privacy protections were hard to secure under English law. Other European jurisdictions did provide protection for private information; for example, disclosure of personal information is regulated through Article 9 of the French Civil Code. In 1950, photographer Robert Doisneau released his best-known work *Le baiser de l'hôtel de ville* (referred to as *the Kiss*): a photograph of a couple kissing in Paris. Jean-Louis and Denise Lavergne believed that they were the subject of Doisneau's image and took court action in 1992. Under French law, not only are there rights to privacy but individuals own the rights to their likeness. It was during the course of this action that Doisneau was compelled to reveal that he had asked two people he had seen kissing to repeat the activity for the purposes of a photograph and the actual subjects evidenced that this was how the image was staged. Doisneau succeeded in defending himself against the claimants but the action significantly damaged the myth behind the image that had persisted until then (Follain 2005).

Although legal commentators had widely discussed the possibility of a tort for the invasion of privacy in English law, this was rejected in Wainwright v

Home Office.[107] To preserve their privacy, claimants had relied on the laws of passing off, breach of confidence and defamation to control the circulation of information about themselves. For example, the 1930s case of Tolley v Fry[108] made use of defamation law to protect an amateur golfer who did not endorse the goods of the defendant, but was seen in an advertisement to have their chocolate in his back pocket; the harm suffered being potentially that Tolley could lose his status as an amateur and be expelled from his club. Defamation is of limited use since it requires the claimant to show actual damage to reputation resulting from the untruth (which was found to be the case in Tolley).

The Human Rights Act 1998 transposed the Convention for the Protection of Human Rights and Fundamental Freedoms formulated by the Council of Europe in 1950 into English law. Article 8(1) of the convention gives protection against interference in private life but this right is not absolute since Article 8(2) allows interference with the right if it can be justified in accordance with lawful, legitimate aims which have been proportionately secured and which are necessary in a democratic society. There is no property right included in Article 8 of the European Convention on Human Rights; this means that private information is not classified as a form of property. This right is often referred to as a right to privacy but there will be much case law to come generated by the grey margins of defining a 'private life' (as set out in the convention) and privacy. The Convention had granted the right of individual petition across Europe to the Strasbourg Court in 1966[109] but these rights only became directly enforceable in the English courts subsequent to 1998.

A significant case prior to this change in law is that of Peck[110] who, in 1996, was filmed attempting suicide (cutting his wrists with a kitchen knife after learning his girlfriend was terminally ill) in an area covered by Brent County Council CCTV. The tape was later sold to the BBC and screened. Peck's rights to privacy were negligible under English law and he is to be applauded for having endured a lengthy series of court cases in order to establish a principle that many of us might have assumed to be so obvious as to already be in place. It was not until 2003 that the Strasbourg Court established the inadequacy of English law in protecting the privacy of individuals.[111] The Strasbourg court has even held that low damages may not sufficiently compensate a violation of Article 8 rights.[112] It is extremely difficult to compensate someone for a loss of privacy; monies are awarded but what has been lost can never be restored.

Chapter 2 put emphasis on the right to freedom of expression introduced into English law by the Human Rights Act 1998[113] and how the courts have engaged it in relation to other rights. A significant 'other right' in this respect is the right to a private life.[114] In 2003 Sara Cox was one of the first celebrities to successfully sue a tabloid newspaper (*The People*) using Article 8 and was awarded £50,000 in damages plus costs[115] (the newspaper had published photographs of the claimant while she was on honeymoon and in a private place). In the case of Theakston v the *Sunday People*,[116] the *Sunday People* attempted to publish a story relating to a visit by the claimant to a brothel. The claimant argued for his Article 8 rights, stating that the brothel was private and the story was not in the public

interest. The newspaper argued that as an employee of the BBC, the claimant's conduct was of public concern. The court determined that a verbal description of the claimant's activities could be published since the claimant had himself put details of his sex-life in the public domain but photographs of the events in question, which were described as 'peculiarly humiliating',[117] could not. The court also underlined the principle that the right to seek rectification of false information must be available to those who are so entitled.[118]

In 2002 the Court of Appeal indicated that a duty of confidence in private information will arise:

> … whenever the party subject to the duty is in a situation where he either knows or ought to know that the other person can reasonably expect his privacy to be protected.[119]

One of the key consequences of Article 8 in English law then has been that there are now obligations on the recipients of private information where there is no actual relationship between the parties (as would be required in traditional actions for Breach of Confidence).

One of the key cases in this field has been Campbell v the *Mirror*[120] which scrutinised the concept of 'misuse of private information'. In order for a case to be successfully pursued under Article 8, the House of Lords outlined the following criteria: whether the claimant has a reasonable expectation of privacy; whether fresh publication of subject matters that retain a private character (but which are known among many) constitutes a fresh intrusion of privacy; whether a public figure in a public place can claim that a photograph of them should be kept private; and what effect the circumstances in which the information was disclosed would have on the outcome of a case. According to the House of Lords in Campbell, there is a 'reasonable expectation of privacy'[121] in information that relates to health, personal relationships, sexuality, sex and finance. Article 8 and Article 10 have equal weight[122] so, with regards to the claimant's use of regulated substances, which had been denied by the claimant previously, the newspaper was permitted to 'set the record straight' but publication of a photograph of the claimant leaving/entering a Narcotics Anonymous meeting was an infringement of the claimant's rights. The House of Lords made this determination through defining privacy 'as an aspect of human autonomy and dignity', as well as the preservation of 'well-being'.[123] In Campbell, the House of Lords recognised that the preservation of well-being might include someone struggling with a narcotics addiction, details of their course of treatment and pictures of them leaving the place of treatment. Anything which might deter a party from participating in a legitimate recovery programme would engage a claimant's Article 8 rights. Lady Hale succinctly summarises that trivial health matters might not engage Article 8 as follows:

> The privacy interest in the fact that a public figure has a cold or a broken leg is unlikely to be strong enough to justify restricting the press's freedom to report it. What harm could it possibly do?[124]

Contrary to these principles though, the European Court of Human Rights has begun to recognise that trivial information might enjoy some protection. The case of von Hannover concerned the right of Princess Caroline of Monaco to go about private business without intrusion and saw the Strasbourg Court overrule the German Federal Constitutional Court, holding that photographs of the princess taken in Germany that were not taken in the course of her public duties violated her Article 8 rights.[125] The case influences English law since Section 2 of the Human Rights Act 1998 requires that the courts pay attention to Strasbourg jurisprudence, including its opinion as well as its judgements. It seems that the court hold photographs as particularly powerful in respect of their potential to intrude on a private life.

In the case of Murray v *Express* Newspapers,[126] the Court of Appeal evaluated what level of intrusion a claimant might have to endure before Article 8 was engaged. The issues discussed included the nature of the activities in which a claimant is engaged (whether in the course of public duties or recreation); the place in which the claimant is found when there is an alleged intrusion; the nature and purpose of the intrusion; whether the defendant is aware of the lack of consent; and the effect that the intrusion has on the claimant. The case highlighted the tensions between the rulings of the House of Lords in John v Associated Newspapers,[127] where the publication of a picture of Elton John wearing a baseball cap near his home was found to not infringe his Article 8 rights, and the von Hannover case of 2005.

Also explored in Murray v *Express* Newspapers was the degree of privacy that would be appropriate for a child (the case concerned the child of J.K. Rowling). The rights of the child were upheld and there was no need to demonstrate that the child had suffered harm. The press set out standards relating to the children of celebrities in the 1990s. The former Press Complaints Commission's Code of Conduct included guidance on this; however, it became clear during the UK Leveson enquiry[128] that the Code of Conduct was not adhered to in this respect (and in many other respects).

Those involved in criminal activity as children may also expect protection of their anonymity under the law,[129] particularly where there is risk of public disorder or danger to safety. There are various regulations that protect the identity of children in the courts and other proceedings.[130]

The position in Scotland has been different in the approach to privacy. The principle of *actio injuriarum*, more common in jurisdictions relying on civil law, developed in Scotland to preserve the dignity, reputation and physical integrity of a person. While reputation might fall under action for defamation, the concept of dignity or physical integrity is limited in English law; unless the perpetrator strays into the territory of physical assault. In Scotland, in the 1936 case of Robertson v Keith,[131] the court determined that a chief constable's surveillance of a home was potentially an 'invasion of liberty' since it gave rise to 'suspicion in the public mind'. More recent Scottish case caw has, however, relied on Article 8 of the ECHR.[132]

In Ireland, privacy is protected through the Press Council and Press Ombudsman System which give effect to Article 8 through the Irish Human

Rights Act 2003 (which transposed the ECHR into Irish law). Certain rights, however, were already guaranteed in the Irish Constitution.[133] Developing case law under the constitution has provided for phone-tapping and marital privacy, though these personal rights have been balanced against public interest and common good defences. Freedom of Expression is also guaranteed under the Irish Constitution.[134]

As this book goes to press, the European Court of Justice answered questions referred to it by the National High Court in Spain (*Audiencia Nacional*) on what the press have referred to as the 'right to be forgotten'. Although the internet may contain lawful and accurate material, it is the responsibility of search engines to comply with EU rules for the processing of personal data. In this case, Google were compelled to remove data on an individual.[135] Since the right to freedom of expression must be balanced against privacy rights, it is unlikely that the matter will be settled with this case, and the ruling places an unusual burden on the respondent here. The case should not be interpreted as giving individuals the right to control all information about themselves, and search engines do not have to comply with all removal requests since they might refer a request to the information commissioner in the relevant European member state to obtain guidance on weighing public interest against the rights of the individual seeking to enact their privacy rights.

The absence of personality rights

In the US, according to Coombe (1992) the tort of 'appropriation of personality' has been developed and the right of publicity is recognised as a property right (see Chapter 5). With recent expansions in passing off, trademark law and breach of confidence actions, it might seem logical to extend English law to provide protection for personality rights. It has already been determined in a European Court that the holders of personality rights may sue in member states that have laws to protect these (such as France and Germany) if an infringement was by way of the internet.[136]

Black (2011) identifies three possible approaches to how publicity rights might be achieved in English law: publicity as a form of property (which could therefore survive the death of the personality and be transferred to another); publicity as a subset of personality rights existent in civil code jurisdictions (which could not be transferred to another on death); or the creation of a tort of appropriation of personality.

'Image Rights' are recognised on Guernsey[137] through the establishment of a 'registered personality' and images associated with, or registered against, that personality.[138] This right is recognised as a property right.[139] While this might seem to represent progress for some (though not in English law), according to Adrian (2013) it may expand rights over fictional characters. Adrian points out that this image right means 'Disney … [is] allowed to sue people for using Mickey Mouse in social satire' (2013: 401). Since Mickey Mouse cannot die, the Guernsey Image Rights Ordinance could lead to Disney controlling the use

of Mickey Mouse in perpetuity. Intellectual property rights were intended to provide sufficient incentive to ensure the continued advancement of intellectual and creative endeavour, not to facilitate a permanent monopoly over the use of information.

Publicity rights relate to the commercial interests of a personality, and the Douglas v *Hello!* case (discussed throughout this chapter) certainly edged towards a recognition of market interests. Personality rights largely sit in contrast to privacy rights, infringement of which requires distress to the claimant. Since English law contains no free-standing right of personality or publicity, there has been reliance on copyright, trademark infringement, passing off, breach of confidence, privacy, defamation and also data protection law.

The Data Protection Act (DPA) 1998

The Data Protection Act 1998 (DPA) implemented the UK's obligation under a European Union Directive[140] concerning the protection of individuals in respect of the processing of personal data and came into force in 2000. The DPA requires that information obtained for specified, lawful purposes must be processed fairly and accurately for no longer than is necessary. Only information that is relevant (rather than excessive) to the specified purpose can be processed, and it must be kept secure. The case of Cox v the *Mirror*[141] discussed above relied, to a degree, on both the common law duty of confidence and the DPA to secure the rights of the subjects of photographs taken in a private place. In some circumstances, the DPA can be an alternative to action for breach of confidence. In Campbell,[142] the Court of Appeal confirmed that publication would fall under the category of 'processing ... personal data' which is limited by the Data Protection Act. The act provides a definition of the term 'process' which includes 'disclosure of information or data by transmission, dissemination or otherwise making available'.[143]

The Data Protection Act regulates both computer and manual storage systems as well as 'unstructured' data,[144] and imposes a duty on those who control data to comply with the regulations relating to data handling.[145] The DPA specifies eight categories of 'sensitive personal data' which are subject to additional control. The law requires express rather than implied consent in relation to the use and processing of sensitive information.[146] Infringements in relation to sensitive data can give rise to compensation for distress alone (meaning that the claimant need not show financial damage). Subjects have rights of access, rectification, destruction and compensation for misuse of data. Processing must be fair and necessary in order to be lawful: this requires the consent of the subject.[147]

There are criminal offences created by the Data Protection Act; obtaining or disclosing personal data without the consent of the data controller[148] and selling data obtained unlawfully (either knowingly or recklessly).[149] If an act is done to prevent/detect crime, is authorised by law, the person obtaining the information had a reasonable belief that there was a right to do the act in question and the

activities done were justified in the public interest, then criminal liability will not arise.[150] Liability, however, is *strict* (meaning that no particular state of mind, or intent, is required of the defendant).[151]

Any person has the right to obtain information in possession of a public authority under the Freedom of Information Act (FOI).[152] The Act exempts from this provision personal data (as defined in the DPA) and the disclosure of information that would breach the confidence of another body.[153]

Protecting journalistic materials

There are several tools that can protect the materials of a journalist or similar researcher from others. Article 10(1) ECHR, as outlined, provides that individuals are free to receive or impart information without interference which potentially offers protection to journalistic sources. An order for disclosure of such materials, or the naming of a source, that is not necessary or proportionate might be incompatible with Article 10. Prior to the Human Rights Act 1998, a journalist might be ordered to disclose the identity of a source[154] or, if they refused to do so, be imprisoned for contempt of court. Under the Contempt of Court Act 1981,[155] no court may order a disclosure of a source, nor can a person by guilty of contempt for refusal, relating to a publication or broadcast for which that person is responsible, unless such an order is in the legitimate interests of justice, national security or the prevention of crime. Subsequent to 1981, then, orders for disclosure were no longer discretionary, and the court had to be convinced that they were necessary and proportionate on the balance of probabilities.

The Police and Criminal Evidence Act (PACE) 1984 and other Acts of Parliament[156] contain provisions relating to search/seizure and also journalistic materials. PACE contains a list of excluded materials which includes 'journalistic material in confidence'.[157] Journalistic materials are also protected under the Freedom of Information Act,[158] and the Data Protection Act[159] confers some exceptions for legitimate media personnel. Internet service providers have some protection in relation to controlled information which shields them against damages and other pecuniary remedy (but not injunctive relief), as long as they have no knowledge of, or control over, the information displayed. Once a service provider has notice that the information should be removed, they must take action.[160]

Remedies for misuse of information

For all the regulations that control the use of personal information, there are a number of defences including that the information is in the public domain, that there has been informed consent, that the information is in the public interest, that the defendant has privilege (a form of immunity) or lawful authority, that there has been no negligence, or that the intrusion is incidental to some form of reporting. The most important defence post-1998 will be that of freedom of

expression discussed in Chapter 2. If all these defences fail, however, and an infringement is found then a range of remedies are available.

Prior restraint

As observed by the Strasbourg Court, the 'news is a perishable commodity',[161] and in many cases an award for damages to the claimant will be sufficient to rectify the issue. Equally though, where a claimant wishes to legitimately keep information secret, a final injunction will be too late. Article 13 of the European Convention on Human Rights states that there must be an effective remedy to the infringement of any right set out in the convention. The Parliamentary Assembly of the Council of Europe passed a resolution in 1998[162] in which it recognised the importance of emergency judicial proceedings in relation to information about to be disclosed. The Human Rights Act[163] and the Senior Courts Act[164] make it possible for a court to grant injunction where it is 'just and equitable' to do so. However, Article 12(3) of the ECHR imposes a duty on the claimant to show that the defendant intends publication of information of a quality engaging their right to a private life, and that the claim is likely to succeed. There must be a serious issue to be tested at a full hearing before a court will consider granting any interim relief that might impinge on the defendant's right to freedom of expression.

In the case of normal injunctions, sought on an interim basis, the claimant and defendant will be named in the judgement. In recent years, however, claimants have requested what have been referred to as super-injunctions; these restrict not only the subject matter which is the cause of action, but also the names of the parties involved. *Contra mundum* injunctions (made against the defendant and the rest of the world) are peculiar since there are many legal jurisdictions in which English law carries no weight.[165] The circulation of information over the internet makes such injunctions impossible to enforce and significantly weakens the law that regulates the control of information discussed here. With regards to the emergence of new technologies, Davies remarks 'it is no longer possible to keep secrets secret by judicial order alone' (Davies 2011:83).

Prior restraint is rare in defamation and malicious falsehood cases unless the defence cannot succeed at trial.[166] In breach of confidence and privacy cases, the issue is more complex and prior restraint more likely. This means that a claimant (or rather their legal representative) might cynically plead their case on the basis of the likelihood of certain classes of action succeeding in order to obtain an injunction. For example, public interest cannot be advanced as a defence if the information is false but a claimant, instead of taking action for defamation, may take action for 'misuse of private information' to obtain an injunction. In the case of defamation, a reputation can often be restored in the event of successful action; privacy once lost cannot be cured.

For cases involving copyright infringement, once a claimant shows the subsistence and ownership of copyright, there is greater likelihood of obtaining interim relief if there is a threat of infringement, imminent damage caused by this, and the public interest defence can be brought into sufficient doubt at the interim hearing.

Civil Procedure Rules[167] (CPR) provide protection for materials that a claimant may not wish to disclose at an interim hearing since these might confirm something about which a defendant is speculating. The CPR specify that such information can only be used for the purpose of the legal proceedings (and not further disseminated). In addition, applications can be made for a hearing in private where information being heard in the course of public legal proceedings[168] might render the claimant's case pointless.[169] Files may also be sealed to 'non-parties'.[170] The Contempt of Court Act[171] may also be used to prohibit the publication of information used in court or tribunal proceedings.

Damages

Damages are available in breach of confidence infringements and in privacy for injury to feelings and/or psychological injury. In the case of passing off and intellectual property claims, the courts must attempt to put the successful claimant in the position that they would have been in had it not been for the wrongful act. Account for profits is sometimes available and more likely to arise in breach of confidence and copyright claims where the wrong-doer has financially benefitted from the unlawful act.

With regards to non-pecuniary losses (such as distress and loss of dignity), the Data Protection Act[172] permits compensation for emotional distress and the CDPA[173] allows for the manner in which the infringement was done to be considered in the element of injury to the claimant's feelings. Other factors in these cases will be the scale of the intrusion, how the information was obtained and what the defendant knew of the harm that might be caused. In the case of Mosley v News Group Newspapers,[174] the use of photographs attracted damages of £60,000 which is one of the highest for this type of case. In Campbell, the award for injury to feeling in relation to the photograph of the claimant leaving/arriving at Narcotics Anonymous was a more conservative £2,500.

In some cases, aggravated damages may be available (where there has been deliberate and persistent disclosure, or where the conduct of the defendant during legal proceedings was inflammatory). In Campbell, a further award of £1,000 was given in recognition of the publication of articles in the defendant newspaper during litigation. Exemplary damages are rare and are only available where the offence is flagrant or where the actual compensation is insufficient. A sense of outrage will increase the probability of this. In Mosley, they were ruled not to be available in cases involving misuse of private information.[175]

Delivery-up or destruction of materials or property is also possible but unusual. This was done in the case of the etchings in Prince Albert v Strange.[176]

Time limits

The Limitation Act 1980, and the principles of equity (see Introduction), set the following limits for legal action to be taken: six years for infringements relating to the Data Protection Act, contract, breach of confidence and other torts, and a limit of one year for defamation.

Notes

1 Brogden v Metropolitan Railway (1876–1877) LR 2 App Cas 666.
2 Hillas & Co Ltd v Arcos Ltd [1932] UKHL 2; (1932) 147 LT 503 (HL).
3 Payne v Cave (1789) 3 TR 148.
4 Carlill v Carbolic Smoke Ball Company [1892] EWCA Civ 1.
5 Payne v Cave (1789) 3 TR 148.
6 Byrne & Co v Leon Van Tien Hoven {1880] 5 CPD 344.
7 Currie v Misa (1875) LR 10 Ex 153; (1875–1876) LR 1 App Cas 554.
8 Smith v Wilson (1832) 110 ER 226.
9 British Crane Hire Corporation v Ipswich Plant Hire [1975] QB 303.
10 Sale of Goods Act 1979 Sections 14(2)-(3).
11 *ibid.* Section 14(3); see also Sale of Goods Act 1995 Sections 12–15 & Section 48(A) (3) (terms); Sale and Supply of Goods Act 1994 Sections 13–15 (terms); Sale and Supply of Goods to Consumer Regulations 2002 (terms).
12 Entores Ltd v Miles Far East Corporation [1955] EWCA Civ 3.
13 Tinn v Hoffman (1873) 29 LT 271.
14 Hyde v Wrench [1840] EWHC Ch J90.
15 Stevenson v McLean [1880] 5 QBD 346.
16 United Scientific Holdings Ltd v Burnley Borough Council [1978] AC 904.

17 Bannerman v White (1861) CBNS 844.

18 Reardon Smith Line Ltd v Yngvar Hansen-Tangen & Sanco SS & Co Ltd [1976] 1 WLR 989.

19 Vitol SA v Norelf Ltd [1996] AC 800; [1996] 3 WLR 105; [1996] 3 All ER 193.

20 Johnson v Agnew [1980] AC 367.

21 Pollard v Photographic Co (1888) 40 Ch Div 345.

22 Tsakiroglou & Company Ltd v Noblee & Thorl [1962] AC 93.

23 Walton Harvey Ltd v Walker & Homfrays [1931] 1 Ch 274; see also Law Reform (Frustrated Contracts) Act 1943 Section 1(2)&(3); Sale of Goods Act 1979 Sections 7, 30(1), & 51 (covering frustration).

24 Misrepresentation Act 1967 Section 2(1).

25 Leaf v International Galleries [1950] 2 KB 86.

26 Pearce & Anor v Brooks (1866) LR 1 Ex 213.

27 Schroeder v Macaulay [1974] 1 WLR 1308.

28 Limitation Act 1980.

29 Warner Brothers v Nelson [1937] 1 KB 209.

30 Lumley v Wagner [1852] EWHC Ch J96.

31 Douglas v *Hello!* [2006] QB 125.

32 Douglas v *Hello!* [2008] 1 AC 1.

33 Guidance given in Nichols Plc v Registrar of Trademarks Case C-404/02.

34 Trade Marks Act 1994 Section 1.

35 Executrices of the Estate of Diana, Princess of Wales' Application [2001] ETMR 25.

36 Advocaat (TM) (Erven Warnink Besloven Vennootschan) v J Townend & Sons Ltd [1979] AC 731.

37 Jif Lemon (TM) Reckitt & Colman v Borden [1990] 1 All ER 873.

38 Combes Inc v Scholl Inc US Federal District Court 453 F Supp (1979) 961 [US].

39 Lyngstrad v Annabas Products [1977] FSR 62.

40 Fenty v Arcadia Group Brands Ltd [2013] EWHC 2310.

41 Mirage Studios v Counter-Feat Clothing Co Ltd [1991] FSR 145 (Ch).

42 Copyright, Designs and Patents Act 1988 Section 1(1)(a).

43 CDPA 1988 Sections 17–18.

44 *ibid.* Section 1(1).

45 *ibid.* Sections 2(1) & 16.

46 Pro Sieben Media A-G v Carlton UK Television Ltd [1999] 1 WLR 605; [1998] FSR 188.

47 CDPA 1988 Section 171(3).

48 *ibid.* Section 30.

49 Ashdown v Telegraph Group Ltd [2001] EMLR 44.

50 *ibid.* para 43.

51 CDPA 1988 Section 171(3).

52 Williams v Settle [1960] 1 WLR 1072.

53 Hellewell v Chief Constable of Derbyshire [1995] 1 WLR 804.

54 CDPA 1988 Section 85(1).

55 Seager v Copydex Ltd [1967] 1 WLR 923, CA 931.

56 Prince Albert v Strange (1849) 2 De Gex & Sm 652; 64 ER 293; (1849) 1 Mac & G25, 41 ER 1171 CA.

57 For example under the Official Secrets Act 1911 and the Abortion Act 1967.

58 Civil Procedure Rules 1998 (CPR) r31.22, r32.12, 234.12.

59 Criminal Procedure and Investigations Act 1996 Sections 17–18.

60 CPR 1998 r18.2.

61 Sexual Offences (Amendment) Act 1976 Section 4(1)(a).

62 Sexual Offences (Amendment) Act 1992 Section 1.

63 Coco v A N Clark (Engineers) Ltd [1969] RPC 41.

64　See also Saltman Engineering Co Ltd v Campbell Engineering Co Ltd (1948) 65 RPC 203.
65　Coco v A N Clark (Engineers) Ltd [1969] RPC 41, para. 48.
66　*ibid*. para. 67.
67　Shelley Films Ltd v Rex Features Ltd [1994] EMLR 134.
68　Stephens v Avery [1988] 1 Ch 449, 454.
69　Thomas v Pearce [2000] FSR 718.
70　Lennon v News Group Newspapers Ltd [1978] FSR 573.
71　Douglas v *Hello!* [2006] QB 125.
72　McKennitt v Ash [2008] 1 QB 73.
73　Thomas v Mould [1968] QB 913.
74　Sharing Chemicals v Falkman [1982] QB 1.
75　Attorney General v Observer Ltd [1990] 1 AC 109.
76　Jameel (Mohammed) v Wall Street Journal (Europe) [2007] 1 AC 359, para. 147.
77　Established in Smith v Baker [1891] AC 325, 360.
78　Re Organ Retention Group Litigation [2005] QB 506.
79　Stone v South East Coast Strategic Health Authority & ors [2007] UK HRR 137.
80　Re Organ Retention Group Litigation [2005] QB 506.
81　TRIPS 1994 Article 39; Paris Convention Article 10*bis*.
82　Universal Declaration of Human Rights 1948 Article 12.
83　International Covenant on Civil and Political Rights Article 17.
84　Cumpana & Mazare v Romania Application 3348/96 (2005) 41 EHRR 14.
85　Herbage v Pressdram Ltd [1984] 1 WLR 1160.
86　Watson v IPC Transport press Ltd, reported by *The Daily Telegraph* 18 February 1982.
87　*de scandalis magnatum* 1275.
88　Bonnard v Perryman [1891] 2 Ch 269, 284.
89　Francome v Mirror Group Newspapers Ltd [1984] 1 WLR 892, 899.
90　Fraser v Evans [1969] 1 QB 349.
91　McDonalds v Steel & Morris [1997] EWHC QB 366.
92　http://news.bbc.co.uk/1/hi/uk/4266741.stm and http://en.wikipedia.org/wiki/McLibel_case.
93　*ibid*.
94　A vain man.
95　*Fors Clavigera* No 79, June 1877.
96　Whistler v Ruskin Queen's Bench, High Court 25–26 November 1878.
97　Defamation Act 1996.
98　Limitation Act 1980 Section 32.
99　Defamation Act 1996 Section 1.
100　*ibid*. Section 2.
101　Reynolds v Times Newspapers Ltd [2001] 2 AC 127.
102　Defamation Act 2013 Section 4(6).
103　*ibid*. Section 4(5).
104　A v United Kingdom Application 35373/97 (2002) 36 EHRR 917.
105　Kaye v Robertson [1991] FSR 62.
106　*ibid*.
107　Wainwright v Home Office [2001] EWCA Civ 2081; [2002] QB 1334; [2003] UKHL 53; [2004] 2 AC 406.
108　Tolley v J S Fry & Sons Ltd [1930] 1 KB 467, 478; [1931] AC 333.
109　Convention for the Protection of Human rights and Fundamental Freedoms Article 34 (1966).
110　R v Brentwood BC *ex p* Peck (1998) EMLR 697.
111　Peck v United Kingdom (2003) 36 EHRR 41.
112　Armoniene v Lithuania Application 36939/02 (2009) 48 EHHR 53.
113　ECHR Article 10.

114 ECHR Article 8.
115 Cox v MGN [2006] EWHC 1235 QB.
116 Theakston v MGN [2002] EWHC 137 QB.
117 Theakston v MGN Ltd [2002] EMLR 398.
118 *ibid.*
119 A v B&C [2002] EWCA Civ 337.
120 Campbell v Mirror Group Newspapers Ltd [2004] 2 AC 457.
121 *ibid.* para. 21.
122 A v B [2003] QB 195.
123 Campbell v Mirror Group Newspapers Ltd [2004] 2 AC 457, para. 12.
124 Campbell v Mirror Group Newspapers Ltd [2004] 2 AC 457, para. 157.
125 von Hannover v Germany Application 59320/00 [2005] 40 EHRR 1.
126 Murray v Express Newspapers Plc [2008] EWCA Civ 446; [2009] 1 Ch 481 CA.
127 John v Associated Newspaper [2006] EMLR 722.
128 http://www.levesoninquiry.org.uk/.
129 Venables & Thompson v News Group Newspapers Ltd [2001] Fam 430.
130 These include Children and Young Persons Act 1933 Section 39, Section 49 (as amended); Administration of Justice Act 1960 Section 12(1) (which protects children in civil proceedings); Magistrates' Courts Act 1980 Section 71; Children Act 1989 Section 97(2); and Youth Justice and Criminal Evidence Act 1999 Section 44 which affords anonymity to children accused of a crime.
131 Robertson v Keith (1936 SC 29) [Scotland].
132 X v British Broadcasting Corporation (2005) SLT 796.
133 Irish Constitution Article 40.3.1 *Bunreacht na heireann.*
134 *ibid.* Article 40.6.1(i).
135 Google Spain SL, Google Inc. v Agencia Española de Protección de Datos, Mario Costeja González C-131/12 May 2014.
136 Oliver Martinez v MGN Ltd (C-509/09 and C-161/10) [2012] EMLR 12.
137 Bailiwick of Guernsey Ordinance (IRO).
138 *ibid.* Section 5(1).
139 *ibid.* Section 2(1).
140 EU Directive 95/46/EC.
141 Cox v MGN Ltd [2006] EWHC 1235 QB.
142 Campbell v Mirror Group Newspapers [2004] 2 AC 457.
143 Data Protection Act 1998 Section 1(1).
144 DPA 1998 as amended by the Freedom of Information Act 2000.
145 DPA 1998 Section 4(4).
146 *ibid.* Schedule 3, para. 1.
147 *ibid.* Schedules 2–3.
148 *ibid.* Section 55(1).
149 *ibid.* Sections 55(4)-(5).
150 *ibid.* Section 55(2).
151 *ibid.* Section 4.
152 Freedom of Information Act 2000 (FOI) Section 1.
153 FOI 2000 Section 41.
154 British Steel Corporation v Granada TV [1981] AC 1096.
155 Contempt of Court Act 1981 Section 10.
156 Police and Criminal Evidence Act 1984 (PACE) Part II; Terrorism Acts 2000, 2006; Regulation of Investigatory Powers Act 2000; Serious Organised Crime and Police Act 2005; Financial Services and Markets Act 2000; Police Act 1997; Criminal Justice Act 1987; Official Secrets Acts 1911, 1989; and Security Service Act 1996.
157 PACE 1984 Section 11.
158 Freedom of Information Act 2000.
159 DPA 1998 Section 32.

160 E-Commerce Directive 2000, Directive EC 2000/31/EC.
161 Observer & Guardian v UK Application 13585/88 (1991) 14 EHRR 153, 191.
162 Parliamentary Assembly of the Council of Europe 1998 Resolution 1165, para. 14.
163 Human Rights Act 1998 Section 6.
164 Senior Courts Act 1981 Section 37.
165 Venables & Thompson v News Group Newspapers Ltd [2001] Fam 430.
166 Bonnard v Perryman [1891] 2 Ch 269, CA.
167 Civil Procedure Rules 1998 (CPR) r32.12(1).
168 CPR 1998 r39.2(1).
169 *ibid.* r39.2(3)(a)-(d) & (g).
170 *ibid.* r5.4C.
171 Contempt of Court Act 1981 Section 11.
172 DPA 1998 Section 13.
173 CDPA 1988 Section 97(2).
174 Mosley v News Group Newspapers Ltd [2008] EMLR 20.
175 *ibid.*
176 Prince Albert v Strange (1849) 2 De Gex & Sm 652, 716; 64 ER 293.

Bibliography

Adrian, A. (2013) Mickey Mouse wants to live forever: Guernsey's Image Rights Ordinance will make that possible, *European Intellectual Property Review*, 37(7): 397–401.

Barnes, J. (2011) Data protection, in M. Warby, N. Moreham and I. Christie, eds. *The law of privacy and the media (Tugendhat and Christie)*, 2nd edn. Oxford: Oxford University Press, 271–318.

Bate, S. and Hirst, D. (2011) Copyright, moral rights and the right to one's image, in M. Warby, N. Moreham and I. Christie, eds. *The law of privacy and the media (Tugendhat and Christie)*, 2nd edn. Oxford: Oxford University Press, 393–430.

Beverley-Smith, H. (2002) *The commercial appropriation of personality*, Cambridge: Cambridge University Press.

Black, G. (2011) *Publicity rights and image: exploitation and legal control*, Oxford & Portland, OR: Hart Publishing.

Cohen, N. (2012) *You can't read this book,* London: Fourth Estate.

Coombe, R.J. (1992) Author/izing the celebrity: publicity rights, postmodern politics and unauthorized genders, *Cardozo Arts and Entertainment Law Journal,* 10: 365.

Davies, G. (2011) *Copyright law for writers, editors and publishers*, London: A&C Black Publishers Ltd.

Follain, J. (2005) It started with a kiss, *Sunday Times* 6 November.

Frederick, P. (1985) *Carter-Ruck on libel and slander*, 3rd edn, London: Butterworths.

Gurry, F. (1984) *Breach of confidence*, Oxford: Clarendon Press.

Parkes, H.J. (2011) Privacy, defamation and false facts, in M. Warby, N. Moreham and I. Christie, eds. *The law of privacy and the media (Tugendhat and Christie)*, 2nd edn. Oxford: Oxford University Press, 319–352.

Wadlow, C. (2004) *The law of passing off*, 3rd edn. London: Sweet & Maxwell.

Warby, M., Speker, A. and Hirst, D. (2011) Breach of confidence, in M. Warby, N. Moreham and I. Christie, eds. *The law of privacy and the media (Tugendhat and Christie)*, 2nd edn. Oxford: Oxford University Press, 163–222

4 (Un)commissioned art

Tortious and criminal liability

Introduction

In Chapter 2, reference was made to the role of transgression in developing the reputation of individual artists and collectivised art movements. If artists or art movements do not generate attention from the public then commercial success can be a remote aspiration. Henri Gervex's work, *Rolla*, was excluded from the *Salon* in the spring of 1878 because the work was deemed to be immoral. The painting depicts the aftermath of the character Rolla's sexual encounter with Marie (a young prostitute); the girl sleeps prostrate and Rolla (in the poem by Alfred de Musset) will imminently take his own life with poison. The nudity itself may not have been particularly contentious but the disposition of the teenage prostitute, the post-coital signifiers, the garter and the corset cast to the floor, were a scandal. The picture was exhibited elsewhere and attracted significant crowds.[1] Even the challenge put to the dominant pictorial styles of the period attracted criticism. There will be many artworks, however, considered to be so scandalous that the powers that existed around them ensured they were not preserved for us to see at all.

Existing on the fringes, as many renowned artists have, brings the individual into conflict with the dominant ethics of the society in which they exist; a person travels on to private land to paint a wall and they may already be guilty of trespass and criminal damage (unless they were commissioned to paint the wall). The feature that protects them most from civil action may well be that they do not have the financial resources to pay for the damage, but this will not protect them from criminal prosecution.

Criminal acts are largely regulated by statute but case law developed the concept of torts to deal with a range of activities on which one person could sue another rather than expect the state to prosecute their case. There is some cross-over though: assault appears as both a tort and a crime in legal textbooks.

This chapter looks at tort and criminal acts and the ways in which artists might come into contact with these causes of action. It will be of particular use to curators, artists creating work in, or for, public spaces and site-specific work, as well as photographers or film-makers working in public, and artists exhibiting installation work (whether commissioned to do so or not).

Tort

In 2009, the city of Manchester was forced to dismantle the work *B of the Bang* by Thomas Heatherwick (commissioned in celebration of the 2002 Commonwealth Games) due to problems with its structural integrity. The structure was one of the tallest in UK public art history and was designed to lean. Construction of the work had overrun by 2005 and, even before the unveiling of the work, a tip of one of the 2.1 metre spikes had detached and fallen to the ground. A few weeks later, a second spike was removed after it became loose; public rights of way nearby had to be closed temporarily. Legal action for breach of contract (see Chapter 3) and *negligence* was begun in 2007 by Manchester City Council against the makers of the sculpture (Thomas Heatherwick Studios Ltd and the subcontractors) resulting in a reported out-of-court settlement of £1.7 million. This case should alert all those who display art in public to the importance of Public Liability Insurance. If you cannot afford to be sued, you definitely need it. In July 2012, what remained of the sculpture was sold as scrap for £17,000.[2]

A tort is a civil wrong and allows the courts to allocate financial responsibility to a party responsible for some form of damage. Sometimes the legal action will be for tort alone, and sometimes it will be in combination with breach of contract or other causes of action, depending on the nature of the relationship between the parties. A tort generally requires a wilful act or negligence on the part of the defendant (though some, such as trespass, are actionable 'without fault' – discussed further below). Most tort case law has concerned itself with how the courts establish whether a party has been negligent and in order to do this courts will look to establish a duty of care, a breach of that duty, causation and damage. It is not difficult to envisage that falling debris (in the form of a large metal spike) might cause damage to property or people, and that the City of Manchester owed a duty of care to its residents and visitors.

In order to establish that the defendant owes a duty of care to the claimant, the court must find that there is sufficient proximity between the parties for such a duty to arise.[3] This proximity is referred to as the neighbour principle and does not require a contract or a close relationship but simply that the defendant 'ought reasonably to have them [the claimant] in contemplation'[4] at the time they did the act that caused damage. A contract, however, will more quickly establish the proximity required for tortious liability to be found. The principle of proximity was established in a case called Donoghue v Stevenson,[5] a case so well-known to law students as to scarcely appear on exam papers. The events leading up to the case involved someone finding a decomposing snail (or slug) in a bottle of ginger-beer, which had been bought for them (so there was no 'contract') and becoming ill as a consequence. The case went all the way to the House of Lords (originating under Scots law); so many lawyers and only one snail. Proximity existed in the case of the Heatherwick sculpture both through that created by the contract but also through the placement of the work in a location to which the public had frequent access. In Donoghue v

Stevenson though, there was no contract (purchase) between the injured party and the manufacturer of ginger-beer, and the principle of 'proximity' had yet to be established; hence its long trip to the House of Lords.

As well as establishing that a duty is owed by the defendant to a claimant, the court must be satisfied that it was foreseeable that damage would be caused by the defendant's act, or failure to act; in other words, that the defendant could 'reasonably foresee [that their conduct] would be likely to injure [the neighbour]'.[6] Case law subsequent to Donoghue v Stevenson has established that it must be fair, just or reasonable to impose a duty of care on the defendant.[7]

To find a breach of the duty of care, the court must apply the 'reasonable man' (person) test[8] in assessing whether the defendant exposed the claimant to an unreasonable level of risk[9] and the practicality of reducing that risk.[10] The risk of falling debris in Manchester was an unreasonable level of risk and the practical solution to the risk of spiking residents and visitors was to take down the sculpture after temporarily fettering access of the public to the area (which was itself an infringement (necessary) of the public's right to access the land).

For tortious liability to be found, the act, or omission to act, of the defendant must have caused the damage. This test is widely referred to as the 'but for' test;[11] 'but for the acts/omission of the defendant would the damage have occurred'? and was the action (or inaction) of the defendant the material cause of damage.[12] A defendant cannot be accountable for novel, intervening acts (*novus actus interveniens*) that caused the damage. In the 1953 case of Behrens v Bertram Mills Circus,[13] the claimants' daughter (Santa) had a dog (Simba, a Pomeranian breed) which antagonized a circus elephant called Bullu (the 'lead' elephant) who chased the dog on her way to (or from) the circus ring at London Olympia for a twice-daily performance (the path being shared with

camels who also performed). Since Bullu was the lead elephant, a number of the other five elephants (all Burmese) followed, knocking over the adjacent booth which collapsed on the claimants (a husband and wife), frightening the husband and injuring his wife, during a performance with colleagues (Mrs Behrens had difficulty playing either the saxophone or accordion subsequent to the event. Simba did not make it). Nothing in this series of events 'broke the chain'. Notwithstanding that it was the claimant's dog at the circus against the rules of the defendant who caused the events to unfold (despite being tied up at the ticket booth with its lead), Bullu's owner was held liable in tort (it was his responsibility to control the elephants, and the presence of a dog was not so unusual as to break the chain of causation). The judge remarked that 'an elephant coming over the top of a booth would be a terrifying thing even for an ordinary man' (the claimant and co-performers were exhibited by the circus as persons of restricted growth)[14] but held that the behaviour of the elephant, under the circumstances suffering from fright, was 'excusable'. I can find no indication of what happened to the cat that performed with Mr and Mrs Behrens.[15]

Finally, for a claimant to succeed in action for tortious liability, the damage caused by the defendant must be of the type that might arise from the risk that the defendant took,[16] and not so remote that it could not have been foreseen. Someone who commits a civil wrong unfairly, causing harm to another, is called, in law, the *tortfeasor*. Aside from recovery of damages for physical injury, a claimant may also recover damages for psychological damage[17] or 'shock'.[18]

The case of Heatherwick's falling spikes created problems not just for the artist but also for Manchester City Council who were the legal occupiers of the land in question, and liable for damage caused by the defective structure.

Occupiers' liability

In addition to the normal responsibilities assigned for negligence through case law, the owners, or controllers, of land/property owe a duty of care to any visitor to their premises even, in many circumstances, to a trespasser. This is regulated through the Occupier's Liability Acts 1957, 1984, and requires the lawful occupier of property to consider 'all persons who might reasonably be expected to be affected by defects'.[19] Warning signs do not automatically absolve the controller of the land from liability for negligent acts.[20]

Defences in tort

There are some defences to tortious liability. These include *ex turpi causa non oritur actio*: a doctrine which means that a plaintiff undertaking an illegal act cannot sue in tort (or contract). This is a complete defence, even if the defendant was negligent.[21] This approach is summarised by the judge in National Coal Board v England:[22] 'If two burglars, A and B, agree to open a safe by means of explosives, and A so negligently handles the explosive charge as to injure B, B might find some difficulty in maintaining an action for negligence against A'. Although the defence is described as 'complete', it is uncertain how far it extends, and UK cases involving the shooting of unlawful intruders to property have confirmed its limits[23] since a disproportionate response to a threat will not engage *ex turpi*. In the case of Lane v Holloway,[24] the defendant had referred to the claimant's wife as a 'monkey-faced tart' and instructed her to 'shut up'. The claimant, an elderly man, punched the defendant (a much younger man) but the defendant's resultant attack (causing serious harm) was found to be disproportionate and so he was not able to argue *ex turpi*. Self-defence, defence of another, defence of property or the prevention of crime can all be used as defences in tort but only if reasonable force is used.[25]

A further defence in tort is *volenti non fit injuria,* meaning that voluntary consent (express or implied) to an act that might cause injury negates liability for such an injury. Again, this is described as a complete defence. However, consent to the act done is not necessarily consent to the injury involved. This defence has been used successfully to the injury of trespassers where the Occupiers Liability Act 1984 might have given rise to liability[26] but not where the voluntary acts of a claimant were in bravery to save others.[27] In American law, this defence is referred to as 'assumption of risk'. A partial defence to action in tort is that of contributory negligence; once liability is found, the burden of proof is on the defendant to show that the claimant did not take reasonable care and contributed to the damage caused. A rare example of this defence being successful in full is Morris v Murray[28] where a passenger voluntarily got into a plane with a pilot whom he knew to be drunk, and was held to have voluntarily accepted the risk.

In the nature reserve of Kullaberg near the town of Arild, Skåne County (southern Sweden) there is an installation constructed of 75 tonnes of driftwood.

The work is called *Nimis* and was begun in 1980 by artist Lars Vilks; it sits alongside another piece by the same artist (*Arx*) which is made of stone. The sculptures sit among steep shorelines and are hard to reach. On discovery, Vilks was ordered to remove the labyrinthine works which are a very popular tourist destination, despite the fact that the work is not signposted or marked on maps; though there are some yellow *N*s painted near the site. The works present a risk of injury to those who climb among them but have not been removed, and every year they become more popular with visitors.

Intrusion

Under English law, both common law and equity have protected lawful occupiers of land against trespass. The intrusions discussed here are those that may be tied to causes of action such as breach of confidence or the 'misuse of private information'. Some intrusions do not, by themselves, give rise to legal action: photographing someone against their will, but in a public place, is not generally a cause of action in law (though the resultant images might engage a legal action). In the event that a private citizen was observed on private land from a public place, there was in the past no cause of action, even where there was intentional infliction of emotional harm and the publication of images as a result. The Sexual Offences Act 2003 did, however, legislate for the prohibition of sexually motivated voyeurism.[29] A successful prosecution under this act can lead to a fine or imprisonment of up to six months on *summary conviction* (or two years on *indictment*). The offence involves observing for the purposes of sexual gratification, without consent, a person doing a private act (or the operation/installation of equipment to enable or record this). A private act is any act done where there is a reasonable expectation of privacy[30] particularly

where the genitals, buttocks or breasts are exposed or where the individual is in their underwear, using a lavatory or performing a sexual act.[31]

The lack of consent to being photographed can be a self-censoring factor for some photographers with a particularly strong moral compass but for those who lack this, actionable forms of intrusions include trespass, nuisance and harassment. Subsequent to the Human Rights Act 1998 and the Cox[32] case (see Chapter 3), the right to a private life under Article 8 ECHR has given rise to further remedy for such activities.

Trespass

Trespass involves intentionally (or negligently) entering (or remaining on), or allowing (or causing) materials to intrude, on land in possession of another. Trespass involving the retrieval of trivial property (such as a kite – see Chapter 2) will generally not give rise to action.

Journalists may approach the door of a subject but where the occupier of land has made it clear that consent is not given for their presence, they must leave. However, a landowner has no right to confiscate equipment. There is no need for the occupier of the land to show proof of financial loss in order to succeed in action for trespass. (In Scotland, damages are only recoverable for trespass if actual damage is caused.) Only the occupier of the land has the right to action for trespass: invited visitors to land or property do not have their own right of action.[33] In addition, information collected as a result of trespass will not always be subject to an injunction.[34] Trespass to goods is also a possible cause of action (such as accessing private information)[35] but damages are generally only available when there has been actual damage to the goods, so this action is limited in its scope here.

Photography for commercial purposes is prohibited in Parliament Square and Trafalgar Square, London, without permission from the Mayor's Office.[36] It is a criminal offence to trespass onto certain types of property; for example, railways, aerodromes and military installations. Under the Official Secrets Act 1911, it is an offence to take a photograph in a 'prohibited place' or one 'useful to an enemy'.[37] It is a tort and also a criminal offence to obstruct free passage on the highway (including roads, footpaths and so on)[38] or to wilfully obstruct a police officer in the execution of their duties,[39] making photojournalism quite difficult in some circumstances.

Nuisance

The tort of 'nuisance' (which is an interference with the right to quiet enjoyment of property) has been available for several hundred years; both privately between individuals[40] and publicly where there is an act unwarranted in law (or the omission of a legal duty), causing damage or inconvenience to the public in the exercise of rights common to all (such as through obstruction or wilful damage). To take action for nuisance, the activities involved have had to

be persistent and the protection, in private nuisance, applied solely to the legal, or equitable, occupier of land (not those using the property with permission of the land owner).

Any harmful or noxious activity that results in damage might give rise to a cause of action for nuisance but negligence, for this action, is insufficient for liability to be found (unlike tort). Responsibility for creating a nuisance is assessed through foreseeability and reasonableness on the part of the defendant so the court would look at: motive; social utility of an activity said to cause a nuisance; thoughtlessness on the part of the defendant; knowingly coming to a nuisance on the part of the claimant; the duration of the nuisance; and so on. Remedies for nuisance include injunction and damages. A defence to nuisance can be contributory negligence (see above) or the malicious acts of a third party (creating the nuisance in relation to the defendant's land), though the defendant must have taken reasonable precautions, against the malicious acts of others, to escape liability. Potentially nuisance actions are possible against street artists and street performers who might also be liable for obstruction.

Prior to 1997, no tort of harassment had been developed in the English courts. Consequently, those suffering in this respect relied on nuisance and the tort of the intentional infliction of emotional distress;[41] intentional here does not mean 'malicious' but rather that the harm suffered was foreseeable.

Protection from Harassment Act 1997

Actions that have been found to constitute harassment include: making false allegations about a person;[42] video-taping without permission and rummaging through bins;[43] constant telephone calls;[44] and the publication of information that incited racism.[45] The conduct of some press photographers and journalists may engage action for harassment.

The Protection from Harassment Act 1997 was introduced to provide protection to those who were subject to 'stalking' (the Act does not contain a definition of harassment) which previously had little redress under English law. Unlike private nuisance and trespass, it does not require the person taking action to be the lawful or equitable occupier of the land in question. The Protection from Harassment Act covers both criminal and civil liabilities and provides a range of remedies. The act prevents a person from undertaking a course of conduct which that person knows (or ought to know[46]) amounts to harassment.[47] To be actionable, the harassment must occur on at least two occasions.[48] In addition, the action must be aimed at the claimant, calculated to cause distress and be oppressive or unreasonable.[49]

A person can be fined or imprisoned for up to six months for harassment.[50] Where there has been fear of violence then a prison term of up to five years may be imposed.[51] A restraining order may be taken against someone if the action persists.[52] As well as criminal remedy, a civil claim can also be brought[53] for damages (psychological or financial[54]) and restraint by injunction.[55]

Defences are available in the statute. These include 'reasonableness'[56] and action that is necessary and proportionate in the prevention or detection of crime.[57] Since the Human Rights Act 1998 came into effect, the courts may also have to consider a defendant's Article 10 rights to freedom of expression (see Chapter 2), although in circumstances of intrusive harassment the right to a private life (Article 8) may also be engaged.

According to Christie and Wolanski, with regard to physically intrusive conduct, 'English law still lags behind other states and European norms' (2011: 5); so prying, no matter how offensively done, will continue to create difficulties for those affected by it. In March 2014, singer Harry Styles obtained an injunction against four photographers under the Protection from Harassment Act.[58]

Criminal acts

Throughout this book, there has been reference to activities actionable in the civil courts and those that are subject to criminal prosecution, and some activities can lead to either civil or criminal legal action (harassment, for example, falls under both umbrellas). There are certain prohibited acts though that are nearly always the subject of only criminal action. The threshold for proving a crime is 'beyond reasonable doubt', unlike in civil cases where the threshold is on the 'balance of probabilities' (more likely than not).

Guilty act/guilty mind

Traditionally, to be found liable for a crime in English legal systems, the defendant must have voluntarily done the act prohibited by the statute in question and have the state of mind required of that statute. In legal study, these two components are divided into *actus reus* (guilty act) and *mens rea* (guilty mind).

The *actus reus* requires a (usually) voluntary act (bodily movement) which results in an activity prohibited by law (or rarely an omission to act when the defendant should have). The activity must both in fact, and in law, cause the prohibited conduct, but it need not be only cause of it.

The *mens rea* of a crime is the element of fault or state of mind required for the crime in question. The *mens rea* varies from crime to crime. The *mens rea* required for most offences is intentional or reckless action (knowing the risk, but taking the action). The key principle for intent is set out in the murder case of Woollin[59] and states that an intended consequence is either a desired outcome, or a virtual certainty, arising from the defendant's actions, and that the defendant knew this. Many crimes require the defendant to intend to do the act that produces the forbidden consequences and where such a result is virtually certain ('maliciously'). Some crimes require 'wilful blindness' or 'recklessness'; where the defendant consciously takes a risk and is aware of it, though their aim was not necessarily the crime itself (through this risk-taking, a form of intention is inferred). Other crimes require negligence (unjustified risk-taking where there is constructive knowledge of the risk or an absence of suspicion of the risk

where it should have been). Statutes relating to certain crimes require only *strict liability* which the courts sometimes infer from reading the Act of Parliament; terms like 'no-negligence' indicate that liability is strict. Strict liability means that the state of mind of the claimant is not relevant; that there is no *mens rea* (or negligence requirement) with respect to at least one element of the *actus reus*. Driving without insurance is an example of a strict liability offence.

The concept of intention in crime is difficult to firmly define. Knowledge, desire or foresight of the end result will enable inferences to be drawn but confusion arose and persists through case law (nearly all of them murder cases).[60] Some cases have relied on a 'very high degree of probability [that damage would be caused]',[61] while other cases have determined that foresight cannot be equivalent to intent and that the outcome has to be a 'virtual certainty'[62] for intention to be found.

There are various defences available to those accused of a crime. These include self-defence which, if found, leads to an acquittal for a murder charge. Self-defence cannot reduce murder to manslaughter since the defendant is required to intend to deliver lawful force (even if the defendant is mistaken as to the circumstances), and use this proportionately to the perceived threat. Other defences include insanity (involving a defect of reason, from disease of the mind, such that the defendant did not know the nature or quality of the act done or that it was wrong: the M'Naghten rules[63]). A defendant might also plead diminished responsibility (an abnormality of the mind through specified cause, causing a substantial impairment to reason, but this is only available to convert murder to manslaughter) or an honest mistake which prevented the defendant from having the required *mens rea*. Provocation leading to the loss of self-control in a reasonable person is only a defence to murder; while duress (where the will of the defendant is overcome by another) cannot be used as a defence to murder or attempted murder, or to reduce a murder charge to manslaughter. If duress is used as a defence to other crimes then the defendant must have envisaged that the harm they would suffer might be death or grievous bodily harm (to themselves or to someone for whom they feel responsible) and the threat of this must be imminent. The defence of necessity has not generally been available to murder since it relies on the defendant committing a criminal act to avoid more serious harm; though not necessarily an emergency. The act done, for necessity to be used as a defence, must be necessary and proportionate to the harm perceived, and any mistakes made as regard to the perception of harm must be reasonable.

Criminal Justice and Police Act 2001

As well as the Protection from Harassment Act 1997, English law provides protection from harassment in the 'home' under the Criminal Justice and Police Act 2001.[64] This offence requires intention to cause distress (or that the defendant ought to know that distress might occur) and distress to be experienced by the victim. It is intended to cover circumstances involving the presence of persons

outside a building (this need not be a residence), and potentially provides some protection from media scrums or 'door-stepping'. According to Christie and Wolanski, these activities 'may fall foul of Section 42 of the Criminal Justice and Police Act 2001... if carried on in contravention of a police requirement to desist' (2011: 17). Intentionally causing distress in these circumstances is punishable by a fine, a restraining order or a prison term[65] of no more than fifty-one weeks,[66] and the police are permitted to take steps to prevent it from occurring[67]. Civil remedy is also available in the form of injunction or damages.[68]

Public Order Act 1986

The Public Order Act prohibits the use of threatening/abusive/insulting words or behaviour within hearing or sight of the victim.[69] It requires intention to behave in this manner (or that the defendant ought to know that the conduct is threatening/abusive/insulting).[70] The defence of 'reasonableness' is available[71] as it is in the Protection from Harassment Act. The Public Order Act has been brought into some disrepute by action in 2012 with the prosecution of someone who had said 'Excuse me, do you realise your horse is gay?' to a police officer.[72] It was less controversially applied in relation to the surreptitious video-recording of persons in changing rooms.[73]

The Counter-Terrorism Act 2008

Under the Counter-Terrorism Act, a person commits an offence if they attempt to elicit information about an individual who is, or has been, a member of Her Majesty's forces, a member of the intelligence services or a police constable, if that information is likely to be of a kind useful in terrorism.[74] 'Information' can include photographs and electronic data.[75] A person convicted of this offence on indictment can be imprisoned for up to ten years and, on summary conviction, for up to six months by a magistrate (twelve months if there is more than one offence).[76] It is, however, a defence for a person so-charged to show that they had reasonable excuse for their action.[77] It is the introduction of this type of law that has led the police to make some rather unusual arrests and confiscations in relation to photographers and their equipment. Photographer Phil Smith was subject to stop and search, and ordered to delete photographs he had taken during a public event (Geoghegan 2008). I have been unable to determine any statute in this field that permits the police to delete photographs belonging to another.

Photography in court

Filming and photography is prohibited in courts and court buildings, as is the publication of materials derived from this offence;[78] such an activity can lead to imprisonment. Consequently, there has been a high demand for court artists but there are actually very few of these in the UK. I have only been able to find

three; Priscilla Coleman, Elizabeth Cook and Julia Quenzler. In 2013, cameras were permitted into the Court of Appeal and these artists will be alert to the possibility that their careers may be shortened by the introduction of similar technologies into other courts. They will be missed by many. Court artists are not permitted to sketch in court, only to take notes, leave the court and work from memory to short deadlines.[79]

Interference or misuse of communication services

Under the Regulation of Investigatory Powers Act (RIPA), it is an offence to intercept (without lawful authority) any communications in the public postal service or the telecommunications system.[80] The 'telecommunications system' is broadly defined[81] but there must be interference with a system rather than the mere taping of a voice from a telephone.[82] The Telecommunications Act 1984 protects from disclosure the content of transmitted messages over telecommunications systems.[83] There are criminal sanctions for breach of a duty of non-disclosure, and this also covers those who receive information as a result of unlawful interference with telecommunications. The Wireless Telegraphy Act 1949,[84] the Interception of Communications Act 1985 and the Regulation of Investigatory Powers Act 2000 also make the use of 'wire-taps' illegal, or other improper acquisition of information.[85] In addition, the European Court of Human Rights has held that phone-tapping of private conversations infringes Article 8 (the right to a private life).[86]

Conspiracy to commit misconduct in public office

A common law offence of conspiracy to commit misconduct in public office applies to those who supply confidential information to a party not authorised to receive it, or who solicit others to commit such misconduct.[87] Following the sixteen-month Leveson inquiry into press conduct in the UK (2012), there were several criminal prosecutions which, in 2014, led to some senior employees of the UK Press being found guilty of, for example, 'conspiracy to intercept voicemail'.

Graffiti

It might be hard to foresee a scenario in which a street artist asserts copyright, since this would require self-identification, but there is an additional problem which is that the Copyright, Designs and Patents Act 1988 exempts work situated in a public place from a range of infringement actions (see Chapter 1). Furthermore, according to the *ex turpi* principle (see above), no legal claim can be founded on an act of illegality, so for most graffiti artists copyright is not an issue worthy of much exploration. In his 2005 book *Wall and Piece*, Banksy's remarks on the copyright notice page at the start of the book: 'Against his better judgement, Banksy has asserted his rights under the Copyright Designs and Patents Act 1988 to be identified as the author of this work' (2005: np).

Graffiti can be seen in the ruins of Pompeii, and there is evidence that it has a far longer history than this. The wall-writing of Pompeii has been used to further understanding of the development of colloquial language and its everyday use.[88] Graffiti is attributed to a range of motives: the marking of gang territory, political dissent, the assertion of a particular tag and economic inequality. It is legislated against through the offences of criminal damage and trespass, and is widely associated with other anti-social activities such as drug-taking, underage drinking and the theft of paint. Graffiti challenges both authority and ownership (since the defacement of property may undermine its value). It represents a struggle over control of the urban landscape as well as over aesthetics since it is no longer gallery owners and art critics who determine what constitutes art. The artist Banksy summarises his approach as follows:

> The people who run our cities don't understand graffiti because they think nothing has the right to exist unless it make a profit … The people who truly deface our neighbourhoods are the companies that scrawl giant slogans across buildings and buses … they started the fight and the wall is the weapon of choice to hit them back.
>
> (Banksy 2005: 6)

The practicalities of producing such graffiti works usurp traditional aesthetics and techniques which Stewart describes as a 'triumph over the constraints of materials and surface' (1994: 226). Graffiti enjoys its own language: tags, pieces (a complex and planned work), throw-ups (something between a tag and a piece), toys and masters (novices and old-hands) and piecebooks (sketchbooks). According to Ferrell, it is a form of 'public art outside political or corporate control, and by its presence reclaims public space from city planners, corporate developers, and their aesthetic of authority' (1993: 185). It is constituted as a problem in need of purging but it is also sold as a commodity. Graffiti artist Harald Naegeli (of Zurich, Switzerland) was arrested in 1979 and convicted of intent to cause damage (serving his sentence in 1984) but in 1987 one of his Zurich works was restored and cleared of other graffiti.[89]

The act of graffiti-ing is illegal in most jurisdictions and is often a dangerous pursuit: the artist Ozone, renowned for 'dogging'[90] the work of Banksy at Old Street Tube Station, was killed attempting to spray-paint a train (Wade 2008: 7). There is an imbalance in how we regulate and discuss graffiti. In 2009, several UK newspapers remonstrated that a Banksy mural had been damaged by paintballers on Park Street, Bristol.[91] A local councillor described the city's disappointment, and the council undertook to pay for the removal of the offending paint (it is believed that the paint in question had not been applied by Banksy).

According to a BBC report, the presence of Banksy works on a house in Bristol significantly increases its market value, describing them as Banksy works with a house 'thrown in for free'.[92] The paradox of this type of graffiti is that while criminal law requires that it reduces the value of property in order to secure a conviction, the reality is that this is not always the case.

The bottom of Park Street, Bristol © Banksy, Bristol, 2006

Criminal Damage Act 1971

On 10 March 1914, Mary Raleigh Richardson, then a suffragette protesting the recent arrest of Mrs Emmeline Pankhurst, entered the National Gallery, London, and slashed the *Rokeby Venus* with an axe, earning her the historical label Mary 'Slasher' Richardson.[93] She was arrested several times, on occasion also for arson.

The *actus reus* for criminal damage is destroying or damaging property belonging to another without lawful excuse. The mental state (*mens rea*) required for liability to be found is intention to cause the damage, being reckless to the causation of damage or that it was reasonably foreseeable that damage would occur.[94] It is not enough that the accused intends to do the act which caused the damage; they must intend, or be reckless to, the damage that occurred. In Avon & Somerset Police v Shimmen, a martial arts expert claimed that he could karate-kick a shop window without breaking it. He broke it and was held to have been 'reckless'.[95] If the defendant is under a

reasonable misapprehension that they own the property, they will lack the intention required.

The definition of property is given in the act[96] and includes tangible property (land or personal). The definition differs slightly from the definition of property given in the Theft Act 1968 (see below) because there are things that cannot be damaged in law but which can be stolen (such as some plants). The property that is damaged must 'belong to another'[97] which means that another party must have legal custody, control, a proprietary or equitable right over it.

Liability under the statute includes permanent or temporary harm to the value of the property or its usefulness, and covers damage done with water-soluble materials.[98] The requirement for liability to be found would appear to be that the owner is put to inconvenience/expense to restore the property in question[99] or if the property suffers a reduction in value. The maximum imprisonment, following trial on indictment, is ten years[100] except where the act committed is arson.[101] The accused has a defence available which is a justifiable belief in consent to the act done.

The Act also concerns itself with the possession of an item with intent to destroy or damage property without lawful excuse.[102] There is no defence of 'aesthetic value' (Edwards 2009: 345) but a defendant might argue that if a property is already derelict, they did not foresee the possibility of further 'damage' under the act. However, since a High Court decision in Seray-Wurie in 2012,[103] it seems that the defendant's awareness of the possibility of damage is less relevant and damages are, judged objectively.[104]

Antisocial Behaviour Act 2003

The Antisocial Behaviour Act 2003 gathered together existing provisions, making graffiti (among other things) an offence.[105] Graffiti is defined as painting, writing, soiling, marking and other defacing by whatever means.[106] The law permits a 'defacement removal notice' to be served by an authorised officer or local authority upon the person responsible for the surface (the person who owns, leases, occupies, controls, operates or maintains it) in the event that the defacement is detrimental to the amenity, or the area, or is offensive.

With regards to graffiti, the courts appear to be favouring the use of ASBOs (anti-social behaviour orders) introduced under the Crime and Disorder Act 1998. ASBOs are orders that restrict the behaviour of a person found to have engaged in anti-social behaviour. An ASBO might be used where a person had engaged in conduct likely to cause harm, harassment, alarm or distress to others. Anti-social behaviour can include being rude, begging, urinating in public, dogging (here I mean exhibitionism/public sex rather than painting over the work of another graffiti artist), fare evasion, littering, noise, loitering and spitting. In R v Brzezinski,[107] the court expressed its view on the use of ASBOs in relation to graffiti:

> Graffiti … is certainly capable in appropriate circumstances of being alarming … [and] can be intimidating as well as capable of blighting the environment. In any event, it may well be such as to be likely to cause distress …[108]

Of the notions of distress that the courts apparently associate with graffiti, Banksy comments: 'They say graffiti frightens people and is symbolic of

the decline in society, but graffiti is only dangerous to three types of people; politicians, advertising executives and graffiti writers' (Banksy 2005: 6). The use of ASBOs has been widely criticised, and they are currently under threat of abolishment in favour of community-based social controls. They appear to criminalise being annoying which leads to a lack of equity between the makers and breakers of rules, as Becker remarks:

> Most scientific research and speculation on deviance concerns itself with the people who break the rules rather than with those who make and enforce them. If we are to achieve a full understanding of deviant behaviour, we must get these two foci of inquiry into balance.
>
> (1963: 163)

The works of Christo (wrapping up public structures and buildings in assorted materials), making no claim beyond the superficial aesthetic, may have been intensely 'annoying' to some but, as privately and publicly commissioned works, did not invite legal action since the rule-makers determined the lawfulness of their presence. It is important to recognise though that ASBOs have been well-used in the case of a party deliberately setting out to make the lives of others miserable.

Yarn bombing or guerrilla knitting, a more recent urban art, is considered to be non-permanent. However, since non-permanence is no defence to accusations of criminal damage or the imposition of an ASBO, there is no reason that the creators of parking-meter cosies should not receive the same treatment under the law as graffiti artists have done. It appears to have been driven by the same motivation to reclaim public spaces and kniffiti artists also use knitting names or tags. I can find no instances of prosecutions in relation to yarn bombing. Since not all Acts of Parliament define plants as property, guerrilla gardening does not currently appear to qualify as criminal damage; though it could, under the current provisions, result in the issue of an ASBO. Planting flowers on anything that qualifies as a highway might result in a prosecution under the Highways Act 1980, so urban gardeners should proceed with caution.

Theft

In 2008, street artist Cartrain (then 16), made a collage which included Hirst's diamond-encrusted skull (*For the love of god*), itself the subject of an accusation by artist John Lekay, that Hirst had stolen the idea from him (Wade 2008: 1). One of Cartrain's collages showed the skull in a shopping basket with some carrots. Cartrain used the online gallery 100artworks.com (website no longer active) to sell his work (for less than £100 each). He was instructed by DACS on behalf of Hirst[109] to remove the works from sale and deliver them up, along with any profit he had made.[110] Subsequent to this, in 2009, Cartrain removed some pencils from Hirst's *Pharmacy* at the Tate Britain, London. The piece was estimated to be worth around £500,000; it is unclear what it was worth without

the pencils but they were described as 'rare'.[111] Cartrain made posters stating that the pencils would be restored to the gallery when his delivered-up work from the previous action was returned to him, intimating that a failure to comply would result in the pencils being sharpened. Cartrain was arrested but then released without charge,[112] having described the pencils as 'borrowed'.

The Theft Acts 1968, 1978, 1996

The act required for a successful prosecution of theft (*actus reus*) is that the defendant appropriates[113] property[114] belonging to another.[115] The *mens rea* required is that the defendant does so dishonestly,[116] by the ordinary standards of reasonable and honest people,[117] with intent to permanently deprive.[118] Evidence that an item is 'borrowed' cannot result in a conviction for theft. An ASBO can also be used in relation to acts of theft; in the case of R v West,[119] an ASBO was applied when ancient coins were removed from a heritage site in preference to prosecution under the Theft Acts.

In 2006, thieves used an angle grinder to cut out a section of wall in Gloucester Gardens, Paddington, and attempted to sell it on eBay for £20,000; the wall contained a work purported to be that of Banksy and was later removed from sale.[120] The work *Slave labour* (depicting a child making Union Jack bunting) was described as having disappeared in 'mysterious circumstances' from Wood Green, London (Luscombe 2013: 7), only to reappear a couple of weeks later in a Miami gallery for auction. The gallery insisted that the property was lawfully owned and that the sale would be legal (Luscombe 2013: 7).

Faking art objects

Under the Forgery and Counterfeiting Act 1981, a person is guilty of forgery through the making of 'a false instrument',[121] with the intention of 'inducing someone to accept it as genuine'.[122] The term 'instrument' includes 'any document, whether of a formal or informal character'[123] (encompassing documents in electronic form). On summary conviction, a person might be fined or subject to a term of imprisonment not exceeding twelve months (if there is more than one offence) or both fine and imprisonment. On indictment, a conviction can lead to imprisonment of up to ten years.[124] This act also makes an offence of possessing such work (knowingly) and covers postage stamps, cheques, cheque cards, credit cards, passports, certificates of birth, death, marriage or adoption and share certificates.[125] The Fraud Act 2006 captures fraud by false representation,[126] fraud by failure to disclose[127] and fraud by abuse of position.[128] An offence under this act can lead to imprisonment of twelve months on summary conviction (if there is more than one offence), or a fine and ten years on indictment. In common law, conspiracy to defraud has also been available to prosecute such offences.

Prosecutions for art forgery are rare (since they require an attempt to profit from the forgery which can be hard to evidence). Tom Keating, an art restorer, claimed to have faked several hundred paintings during his lifetime (he died in 1984). He was not motivated solely by profit but by a gallery system he perceived to be awash with critics and dealers making money at the expense of both collectors and artists. He left clues in many of his derivative works to indicate their provenance as not Rembrandt, Gainsborough, Renoir and so on. He was arrested in 1977 and accused of 'conspiracy to defraud' but charges were later dropped. His work is now highly collectable.[129]

Stop, search and arrest

Section 44 of the Terrorism Act 2000 gave the police powers to stop and search anyone for articles useful to terrorism, regardless of whether they had grounds for suspecting this. This has been ruled as unlawful by the Strasbourg Court as, with regards to the absence of grounds for suspecting a search to be necessary, it fails to safeguard the liberty of citizens,[130] and the provision was repealed in 2012. Stop and search powers persist under other English statutes; the most widely used is the Police and Criminal Evidence Act 1984 (PACE).

There are eight codes of practice in PACE; these relate to powers of stop and search, arrest, detention, questioning, entering and searching premises and so on. If a police officer who is not in uniform wishes to stop and search you, they must show you a warrant card. Any police officer may stop you and ask you what you are doing but they are only permitted to search you if they have reasonable grounds for suspecting that you are carrying illegal drugs, a weapon, stolen property or something that can be used to commit a crime. You can only be stopped and searched without reasonable grounds if a senior police officer

has authorised this. The police officer must tell you what they expect to find and the reason they expect to find it. They must also tell you which police station they are from and your right to have a record of the search. The officer may ask you to remove your hat, coat and gloves. If they ask you to remove more than this they must be of the same gender and take you out of the view of the public.[131]

If you are arrested, the police officer must identify themselves to you as a member of the police, tell you why you are being arrested and of what crime you are suspected. You can be hand-cuffed or otherwise restrained by reasonable force if this proves necessary. The custody officer at a police station must explain your rights to you. These include the rights: to seek legal advice from the duty solicitor or your own solicitor; to tell someone where you are; to receive medical assistance if this is required; to see the 'code of practice'; to see written rules for food, drink and toilet breaks; and to use an interpreter. If arrested, you may be searched and your possessions kept for you. You do not have to speak in response to questions but there may be legal consequences to this should a case go to court. The police can make you wait for up to thirty-six hours if you have asked for legal advice (longer if you are suspected of an act related to terrorism). You can be held for twenty-hour hours before being charged, and the police can apply to extend this for up to thirty-six to ninety-six hours if you are suspected of a serious crime. You can be held for fourteen days without charge if you have been arrested under one of the terrorism acts. The police are permitted to photograph you and take fingerprints and DNA. In order to take dental impressions, blood or urine, the police need both your permission and the consent of a senior officer (except in the case of an arrest for drink-driving which permits the police to obtain blood or urine). If you are not charged, you have the right to have your information removed from the police database.

A senior police officer is now permitted to issue a formal reprimand ('caution') following an admission of guilt or a conditional caution if there is sufficient evidence to charge a suspect of an offence, and the suspect agrees to it.[132] A conditional caution may involve reparative, rehabilitative or restrictive conditions. Alternatively, information may be passed to the prosecuting authorities and a suspect may be charged and subject to bail (which can be conditional or unconditional) or custody. The Crown Prosecution Service, led by the Director of Public Prosecutions, generally determines whether a criminal case proceeds to court.

Notes

1 http://en.wikipedia.org/wiki/Henri_Gervex.
2 http://en.wikipedia.org/wiki/B_of_the_Bang.
3 Donoghue v Stevenson [1932] UKHL 100.
4 *ibid.* paras 40–44.
5 *ibid.*
6 *ibid.* paras 40–44.

7 Caparo Industries plc v Dickman [1990] 2 WLR 358 (HL).
8 Blyth v Birmingham Waterworks Company (1856) 11 Ex Ch 781.
9 Paris v Stepney Borough Council [1951] AC 367.
10 Smith v Littlewoods [1987] UKHL 18.
11 Cork v Kirby MacLean Ltd [1952] 2 All ER 402.
12 Bonnington Castings Ltd v Wardlaw [1956] AC 613.
13 Behrens v Bertram Mills Circus (1957) 2 WLR 404.
14 *ibid.*
15 http://h2o.law.harvard.edu/cases/4042.
16 Smith v Leech Brain [1962] 2 QB 405.
17 Dulieu v White [1901] 2 KB 669; Hambrook v Stokes [1925] 1 KB 141.
18 This is not 'shock' in a medical/physical sense but a historical legal description of alarm or mental distress.
19 Clarke v Taff-Ely BC (1980) 10 HLR 47.
20 Glasgow Corporation v Taylor [1922] 1 AC 448.
21 Holman v Johnson (1775) 1 Cowp 341.
22 National Coal Board v England [1954] AC 403.
23 Revill v Newbery [1996] 1 All ER 291.
24 Lane v Holloway [1968] 1 QB 379.
25 Criminal Justice and Immigration Act 2008 Section 76.
26 Ratcliff v McConnell [1997] EWCA Civ 2679.
27 Baker v TE Hopkins & Sons Ltd [1959] 3 All ER 225.
28 Morris v Murray [1991] 2 QB 6 CA.
29 Sexual Offences Act 2003 Section 67.
30 *ibid.* Section 68.
31 *ibid.* Section 67(3).
32 Cox v MGN Ltd [2006] EWHC 1235 QB.
33 Kaye v Robertson [1991] FSR 62 CA.
34 Service Corporation International Plc v Channel Four Television Companies [1999] EMLR 83, HC 90.
35 Torts (Interference with Goods) Act 1977.
36 Trafalgar Square and Parliament Square Garden (Amendment No 1) Byelaws 2002 Greater London Authority Act 1999, Section 385(1).
37 Official Secrets Act 1911 Section 1(1)(c).
38 Highways Act 1980.
39 Police Act 1964 Section 51 & Police Act 1996 Section 89.
40 Christie v Davey (1893) 1 Ch 316.
41 Wilkinson v Downton [1897] 2 QB 57.
42 Howlett v Holding [2006] EWHC 41 QB.
43 King v DPP [2000] All ER (D) 840.
44 DPP v Hardy [2008] EWHC 2874.
45 Thomas v News Group Newspapers Ltd [2001] EWCA Civ 1233; [2002] EMLR 4.
46 Protection from Harassment Act 1997 Section 1(2).
47 *ibid.* Section 1.
48 *ibid.* Section 7.
49 Green v DB Group Services (UK) Ltd [2006] EWHC 1898 QB.
50 Protection from Harassment Act 1997 Section 2.
51 *ibid.* Section 4.
52 *ibid.* Section 5.
53 *ibid.* Section 1(1).
54 *ibid.* Section 3(2).
55 *ibid.* Section 3(3).
56 *ibid.* Section 1(3)(c).
57 *ibid.* Section 1(3)(a).

58 http://www.completemusicupdate.com/article/harry-styles-gains-permanent-injunction-against-four-photographers/.
59 R v Woollin [1998] 3 WLR 382 (HL).
60 R v Maloney [1985] 1 AC 905; R v Hyam [1975] AC 55; R v Hancock & Shankland [1986] 1 AC 455.
61 R v Mohan [1976] QB 1; R v Pearman [1984] 80 Cr App R 226.
62 R v Woollin [1998] 3 WLR 382.
63 M'Naghten's case (1843) All ER Rep 229.
64 Criminal Justice and Police Act 2001 Section 42 (or 42A).
65 *ibid.* Sections 2 & 4–5.
66 *ibid.* Section 42A(5).
67 *ibid.* Section 42(7).
68 *ibid.* Section 3.
69 Public Order Act 1986 Section 5(1).
70 *ibid.* Section 6(4).
71 *ibid.* Section 5(3)(c).
72 R v Brown [2012] EWCA Crim 1152; http://www.theguardian.com/world/2006/jan/18/gayrights.politics and http://news.bbc.co.uk/1/hi/england/oxfordshire/4606022.stm.
73 Vigon v DPP [1997] EWHC Admin 947; (1998) 162 JPR 115.
74 Terrorism Act 2000 Section 58A(1) as amended by the Counter-Terrorism Act 2008 Section 76.
75 Terrorism Act 2003.
76 Terrorism Act 2000 Section 58A(3) as amended by the Counter-Terrorism Act 2008 Section 76.
77 Terrorism Act 2000 Section 58A(2) as amended by the Counter-Terrorism Act 2008 Section 76.
78 Criminal Justice Act 1925 Section 41.
79 http://www.independent.co.uk/arts-entertainment/art/features/court-artists-quick-on-the-draw-9091848.html.
80 Regulation of Investigatory Powers Act 2000 (RIPA) Sections 1(1)-1(2).
81 RIPA 2000 Section 2(1).
82 *ibid.* Section 2(7).
83 Telecommunications Act 1984 Section 45.
84 Wireless Telegraphy Act 1949 Section 5.
85 Ashburton v Pape [1913] 2 Ch 469.
86 Halford v UK Application 20605/92 (1997) 24 EHRR 523.
87 Attorney General's Reference (No 2 of 2002) [2005] 1 AC 167.
88 See for example Helen H. Tanzer *The common people of Pompeii: a study of the graffiti*, Baltimore: John Hopkins University Press 1939.
89 http://en.wikipedia.org/wiki/Harald_Naegeli.
90 The act of painting over the work of another graffiti artist.
91 Famous Banksy mural defaced by paintballers, *Daily Mail*, 23 June 2009 http://www.dailymail.co.uk/news/article-1194976/Council-vows-restore-Banksy-mural-defaced-paintballers.html.
92 http://news.bbc.co.uk/1/hi/england/bristol/6598379.stm http://www.theguardian.com/artanddesign/2014/feb/25/banksy-new-orleans-residents-steal-wall-umbrella-girl.
93 http://www.hastingspress.co.uk/history/mary.htm.
94 Criminal Damage Act 1971 Section 1(1).
95 Avon & Somerset Police v Shimmen (1987) Cr App R 7.
96 *ibid.* Section 10(1).
97 *ibid.* Section 10(2).
98 Hardman v Chief Constable of Avon & Somerset Constabulary [1986] Crim LR 330.

99 Roe v Kingerlee [1986] Crim LR 735.
100 Criminal Damage Act 1971 Section 4(1).
101 *ibid.* Sections 1(3) & 4(1).
102 *ibid.* Section 3.
103 Seray-Wurie v DPP [2012] EWHC 208.
104 Thank you to Ian Edwards for bringing this case to my attention.
105 The Antisocial Behaviour Act brought together the London County Council (General Powers) Act 1954 Section 20(1) relating to defacement of the streets, the Criminal Damage Act 1971 Section 1(1) and the Highways Act Sections 131–132.
106 Antisocial Behaviour Act 2003 Section 48(12).
107 R v Brzezinski [2012] EWCA Crim 198.
108 *ibid.* para 26.
109 http://www.telegraph.co.uk/culture/art/4609976/Artists-flout-copyright-law-to-attack-Damien-Hirst.html.
110 *Private Eye* 1224, 28 November–11 December 2008.
111 http://www.telegraph.co.uk/culture/art/art-news/6135963/Teenage-artist-arrested-for-stealing-pencils-from-Damien-Hirst.html.
112 http://sabotagetimes.com/people/cartrain-vs-damien-hirst-the-pop-art-war/#.
113 Theft Act 1968 Section 3.
114 *ibid.* Section 4.
115 *ibid.* Section 5.
116 R v Ghosh (1982) 75 CR App R 154.
117 Theft Act 1978 Section 2.
118 *ibid.* Section 6.
119 R v West [2013] EWCA Crim 1309.
120 http://www.bbc.co.uk/london/content/articles/2007/01/26/banksy_graffiti_feature.shtml.
121 Forgery and Counterfeiting Act 1981 Section 1.
122 *ibid.*
123 *ibid.* Section 8.
124 *ibid.* Section 6.
125 *ibid.* Section 5.
126 Fraud Act 2006 Section 2.
127 *ibid.* Section 3.
128 *ibid.* Section 4.
129 http://www.theguardian.com/money/2005/jul/02/alternativeinvestment.jobsandmoney.
130 Gillan v UK (2010) 50 EHRR 45.
131 http://www.yourrights.org.uk/.
132 Criminal Justice Act 2003.

Bibliography

Banksy (2005) *Wall and Piece*, London: Random House.

Becker, H.S. (1963) *Outsiders: studies in the sociology of deviance*, New York: Free Press.

Card, R. (2012) *Card, Cross and Jones: criminal law*, 20th edn. Oxford: Oxford University Press.

Christie, I. and Wolanski, I. (2011) Context and background, in M. Warby, N. Moreham and I. Christie, eds. *The law of privacy and the media (Tugendhat and Christie)*, 2nd edn. Oxford: Oxford University Press:,3–58.

Edwards, I. (2009) Banky's Graffiti: a not-so-simple case of criminal damage? *Journal of Criminal Law* 73(4): 345–361.

Ferrell, J. (1993) *Crimes of style: urban graffiti and the politics of criminality*, New York and London: Garland Publishers.

Geoghegan, T. (2008) Innocent photographer or terrorist, *BBC News website* Thursday 17 April.

Herring, J. (2013) *Criminal Law*, 8th edn. Basingstoke: Palgrave Macmillan.

Jones, M.A. (2002) *Textbook on Torts*, 8th edn. Oxford: Oxford University Press.

Luscombe, R. (2013) 'Controversial US auction of Banksy mural is halted just moments before sale begins', *The Observer*, 24 February: 7.

Martin, J. and Storey, T. (2013) *Unlocking criminal law,* 4th edn. London: Routledge.

Stewart, S. (1994) *Crimes of writing: problems in the containment of representation,* Durham and London: Duke University Press.

Wade, A. (2008) 'Graffiti moves mainstream', *The Guardian (supplement) Media Law* Monday 10 March: 7.

5 US law

In 2014, a vase by the Chinese artist Ai Weiwei at the Pérez Art Museum, Miami, was smashed by another artist, Maximo Caminero, who was charged with criminal mischief and faced five years' imprisonment if convicted. The artist's intention was to draw attention to the lack of exhibition space for local artists rather than to echo Weiwei's interferences with ancient vases. The vase in question, though painted over in bright green by Weiwei, dated from the Han dynasty which Caminero had not known. The main difference between the two acts would appear to be that Weiwei owned the vase before he altered it and knew the subject matter he was changing, while Caminero knew he was damaging the vase, he did not own it and did not know its provenance (Madigan 2014).

Introduction

Legal cases from the US have appeared frequently throughout this book. They set no precedents in the UK but provide some interesting insight into developing law in a vibrant art market. The American art scene is competitive and the consequent volume of case law significant.

American law is determined mostly by a common law system except for the State of Louisiana which follows a Napoleonic or Civil code (a little like French law). As has been the case with English law, the law of equity has merged with common law (particularly with regards to injunction and specific remedy). The US has a written constitution which stands above ordinary law; this sets it apart from English law which is somewhat quirky in its lack of a written constitution. Constitutional law is difficult to change and requires a two-thirds vote by each *House of Congress*, and ratification by three-quarters of the US states. The US legal system is like English law in the way that power is separated into the tripartite structure through its two separate bodies of congress, its executive and its judiciary. However, there are some important differences as well as those dictated by its constitution. The term 'judicial review', for example, refers to the process by which the Supreme Court has declared acts of congress and state laws to be contrary to the Constitution, with powers to null and void these.

There were relatively early amendments to the constitution through Articles listed in the Bill of Rights 1789; these amendments were intended to limit the

powers of government. The First Amendment includes the rights to freedom of speech, the press, assembly and petition. During the same period of history, the UK's lack of constitution often failed to limit the power of the monarch; for example, the crime of seditious libel allowed the Crown to prosecute its critics in secret, even if what they said was true.

The US codifies law in similar ways to the English legal system (through the transfer of case law into legislation and statute). The courts are always obliged to test the law against the Constitution. The US Congress is made up of the House of Representatives and the Senate. Once both houses pass a bill, it is sent to the President for signature. If the President does not sign a bill, a majority of two-thirds in both houses can override their decision. Unlike English law, however, in addition to the national legislature (Congress), each US state has its own legislature which passes state laws.

The Federal Courts, led by the Supreme Court, hear questions of Federal (US-wide) Jurisdiction. The US district Courts are the main trial courts of the US system. There are ninety-four District Courts (and other specialised tribunals and courts dealing with, for example, tax matters). Above the District Courts are the two Courts of Appeal. These are the Court of Appeals for the Federal Circuit and the Court of Appeals (twelve circuits – divided by geographical area). The Supreme Court is situated above the Courts of Appeal and has both original and appellate jurisdiction.

The state court systems operate through the following structure: Courts of Limited Jurisdiction (that hear cases relating to individual state laws), Courts of General Jurisdiction, Intermediate Appellate Courts and the Court of Last Resort (each State Supreme Court). Criminal cases are instigated by federal or state prosecutors (depending on which law applies) and plea-bargaining (not officially part of the English legal system) is practised. Civil cases (as in English law) pit one party's legal representative against the other party's legal representative in an adversarial way.

Art in America

In contrast to the UK, US law has determined its definition of art through legal action involving its customs authorities. This was early to evolve in the US since it established the criteria for ascertaining whether something was free from import duty. The focus of the US Customs authorities has been on the appearance of the object, who produced it, its purpose and whether it exists in 'editioned' form in contrast to limitless multiples. Traditionally nothing that was 'practical' (and this has included a stained glass window) could be 'art' which originally had to possess a 'representational' quality (Duboff 1993: 1). Non-representational art has been the subject of legal (and intellectual) controversy during the twentieth century when such movements were establishing themselves.[1] The case of Brancusi's *L'Oiseau d'or*[2] concerned a bronze sculpture which Edward Steichen (photographer and artist) sought to import to the US free of import duty. A US Customs official determined that import duty was

payable since it was not art, had a 'utilitarian' function and did not look like a bird; the problem with the sculpture was that it was not figurative but abstract. Steichen appealed the decision and *L'Oiseau d'or* was held to be an original work of art rather than an object with a practical function. There was not a serious question over whether the sculpture performed a practical ('utilitarian') function except that the customs official in question had categorised it as a 'kitchen utensil' (Giry 2002).

Copyright law – process and rights

In 1992, Disney demanded the removal of the Dennis Oppenheim sculpture, *Virus*, from Colorado Place, Santa Monica. The work included representations of Mickey Mouse and Donald Duck.[3] An image of the sculpture can be seen at http://www.acegallery.net/artwork.php?pageNum_ACE=36&Artist=32. The artist was subsequently prohibited from selling the work but allowed to exhibit it.[4]

The US Constitution grants Congress power to promote progress by securing to authors and inventors exclusive rights to their writings or discoveries.[5] This power is conferred 'to promote the progress of science and the useful arts, by securing for limited times to authors and inventors the exclusive right to their respective writings and discoveries'.[6] Straight away you will notice that the term 'science' is not qualified by an adjective but that only 'useful' arts are protected; if an object is useful though, import tax would be payable and the object would not be art. In the US, copyright protection is available to those foreign works for

which copyright subsists in other jurisdictions ('reciprocal protection').[7] With regards to copyright, the key points of note for those familiar with English law are that the term fair use (US) and fair dealing (UK) are not applied in the same way. In addition, the measure of originality is tougher in the US.

Prior to the Copyright Revision Act 1976, many intellectual property rights passed to the purchaser of an object (unless there was evidence stating otherwise) but this position was reversed by the 1976 Act. This separation of the object from the intangible rights associated with it is key to the development of modern copyright regulations in the US. There is an exception to this in the 1976 Act, however, which is similar to those provisions made in English law; the work of an employee creating copyrightable objects within the course of their employment ('work for hire' as it is referred to in the US) is owned by the employer (copyright in this type of work lasts for seventy-five years from the date of publication or 100 years from the date of creation). The commissioner of work owns copyright only if this is agreed in writing by the independent contractor.[8]

In 1989, the US became a party to the Berne Convention and implemented its provisions with the Berne Convention Implementation Act 1988. Some years later, the duration of copyright was extended by twenty years to life plus seventy years. Copyright in anonymous, or pseudonymous works, lasts for seventy-five years from the date of publication or 100 years from the date of creation (whichever is the shorter). If the author's name is revealed after publication then normal copyright duration exists (life plus seventy years). There are no longer renewal requirements for copyrighted works.[9] The argument against the Copyright Term Extension Act 1998, that the US Constitution concerns itself with promoting literary products and not 'rent-seeking', and that life plus seventy years was excessive to this constitutional objective, was argued unsuccessfully in the case of Eldred v Ashcroft.[10]

To qualify for protection under Copyright law, the work in question must comply with the formalities of the Copyright Revision Act 1976.[11] Copyright can subsist '… in original works of authorship fixed in any tangible medium of expression'.[12] Similar to the position in the UK, 'original' is not synonymous with 'novel', and a work does not have to be 'unique' as long as it is independently created and required some creativity. The threshold for originality is, however, higher in the US than it is in the UK; the phrase used in the Copyright Revision Act is 'original works of authorship',[13] creating particular problems for photographs (see below).

As under English law, protection is for the expression of the ideas rather than the idea itself[14] so the work must be fixed in a sufficiently stable state so that it can be perceived, reproduced or communicated.[15] Works that are eligible for copyright protection include literary, musical (including the words), dramatic (including the music), choreographic, architectural, pictorial, graphic and sculptural works as well as motion pictures, sound-recordings and other audio-visual pieces; this list is not exhaustive and the courts are free to recognize items not explicitly specified in the act. Aesthetic features of artistic craftsmanship that

are capable of existing independently from the object are protected but those features for which utility is the 'intrinsic function'[16] are not. Authors of written factual works have narrower protection than those of fiction, requiring almost word-for-word copying for an infringement to be found. Titles, names, short phrases, slogans and speeches are generally not protected through copyright, though some of these can be protected through unfair competition laws, passing off or trademarks.

The rights that a copyright owner has include control over, and prohibition of, the reproduction, performance, preparation of derivative works, display or distribution (by sale, rental, lease, loan and so on) of protected works.[17] A copyright owner may (in writing) assign, transfer, bequeath or license any one or more of this 'bundle of rights', and the transferee, assignee, exclusive licensee or owner has the right to take action in the event of infringement.[18] A non-exclusive license can be granted orally or through conduct.

Failure to comply with formal registration requirements is no longer fatal to the subsistence of copyright in the US since it implemented the Berne Convention. Registration, however, has its advantages during litigation since Congress has declared that an infringer who relied in good faith on the omission of a copyright notice from the register would not be liable for damages. If a work is registered within three months of publication then as a *plaintiff*,[19] copyright owners are entitled to all the remedies available for infringement. If the owner of copyright waits longer than this, then the entitlement is to injunctive relief and actual damages (rather than the statutory damages available with quick registration).[20]

To register their copyright, the proprietor must complete an application (Circular 21), pay a registration fee and deposit copies of the work at the Copyright Office, Library of Congress[21] (one copy if the work is unpublished and two if it is published). The register of copyright has flexibility on the administrative requirements of registration.[22] When a work is 'published' under this procedure, the act requires a copyright notice on the work with the name of the owner of copyright and the year of its first publication.[23] The Buenos Aires Convention 1910 (to which the US was a signatory) gave rise to a notice now seen commonly on work originating in the US: 'All rights reserved'. As well as federal law, state courts have recognised 'common law copyright' which are those rights recognised without the formalities of the 1976 Act at Section 301. Federal law permits protection in individual states for works that fall outside the scope of federal protection, and even for an extension of the rights conferred on intellectual property owners.

Originality

While the test for originality under English law is not particularly high, there is a requirement of creativity for this test to be met in the US. The case of Feist Publications[24] set the bar for this in which it was stated that the 'sweat of the brow' was not evidence of the 'creative spark' required for copyright to subsist.

Consequently, the standard of originality required for photographs to benefit from copyright protection has been the cause of much legal discussion, latterly in relation to the status of photographs that depict other artefacts (often themselves protected by copyright). The US district court made use of the English case of Graves (which had determined that a photograph of a copyrighted work enjoyed copyright protection) in its deliberations for Bridgeman Art Library[25] but denied copyright protection to picture-library photographs of museum artefacts. The copyright on the things photographed had expired and therefore they were in the public domain, so when the defendant copied the photographs of these objects onto a CD-ROM there had been no infringement of copyright. The Southern District Court of New York, in a summary judgement, held that the photographs were not original and consequently no copyright subsisted. The plaintiff moved for reconsideration of the case, and an *amicus* brief was filed, since the court had ignored the US register of Copyright's issuance of a certificate for one of the transparencies. The judge re-considered the case and looked at the Copyright clause in the US Constitution.[26] The judge found that 'slavish copying,'[27] while requiring technical skill, did not qualify for copyright protection referencing the case of Feist Publications (above) in regard to the 'sweat of the brow' as insufficient. The judge added that registration with the US Registry was only *prima facie* evidence of valid copyright.

Whether 'characters' are copyrightable has been the cause of a significant volume of litigation in the US. The 1954 case of Warner Brothers v Columbia Broadcasting[28] suggested that literary characters would rarely be protected; the case involved use of Dashiell Hammett's 'Sam Spade'. However, a 1978 case suggests that, if a character is delineated sufficiently, it could be copyrightable.[29]

Copyright infringements

An infringer is anyone who uses the exclusive rights of the copyright owner[30] without written consent. Written clearance gives 'permission' or affirmation/ license to use a work for a specific purpose. A contract for the use of intellectual property should state the parameters of its use.

The plaintiff must establish that they own copyright and that the defendant has violated one of their exclusive rights. The registration certificate is useful here, but as you will recall from the case of Bridgeman Art Gallery (above), it is not determinative. Since direct evidence of copying is difficult to obtain, evidence of this is normally indirect by demonstrating that the defendant had the opportunity to access the work and by showing 'substantial similarity'. If this is shown then the defendant has the burden of establishing that they created the work independently, or by coincidence. The court may infer copying and, if the similarity is particularly strong, it may do so in the absence of proof that there was access to the plaintiff's work. There is a two-step process for establishing similarity in subject matter. The first is a test for extrinsic similarity (such as the subject matter) and expert evidence is admissible (the 'objective test'). The second test is of the work's intrinsic similarity (the 'subjective test')

which requires the court to assess whether a lay-observer would recognise the two works as similar. Before trial, a copyright owner can apply for injunctive relief (such as the impounding of articles which might infringe copyright).

If the work of the defendant is found to infringe the rights of the plaintiff then the court may grant permanent injunction against it.[31] The court might do this by ordering destruction of the infringing items or the means of making these. The court may also award monetary damages[32] and these might take the form of the actual damages suffered by the copyright owner, the additional profits made by the defendant or 'statutory damages'.[33] If the calculation is done on the basis of the profits that the infringer made then the defendant must show their deductible expenses, otherwise the figure will be calculated gross. Statutory damages are at the court's discretion though there is a limit on the figure (which changes over time). However, if the claimant can show that the infringement was wilful, the ceiling is raised to $150,000 (at the time of writing). If, on the other hand, the defendant can show that they were reasonably unaware of the existence of copyright then the statutory minimum is reduced to just a few hundred dollars. There are no statutory damages available if the defendant can show that they had reasonable grounds for believing that their use was 'fair'[34] or if a copyright notice had been omitted from the work that was infringed. The court is permitted to award the costs of litigation to the prevailing party[35] but only if the work was registered prior to infringement or within three months of its publication.

Criminal copyright infringements

The US Justice Department (via the Attorney General) may bring criminal action against a copyright infringer if it can be shown, beyond reasonable doubt, that infringement was wilful and for commercial gain.[36] The punishment for this can be a fine and/or a jail term of up to one year but there are higher penalties for film and recording piracy. A party can also be fined for placing a false copyright notice on a work, removing or altering a legitimate notice, or making a false statement in an application for registration.

Defences – fair use v fair dealing

The 1993 case of United Feature Syndicate (UFS) v Jeff Koons[37] concerns the use of the characters from the *Garfield* comic strip owned by UFS. In 1986, Jeff Koons produced sculptures for the Sonnabend Gallery in New York, and UFS sued Koons for copyright in relation to the work, *Wild Boy and Puppy*, alleging it to be a reproduction of the character Odie. Koons admitted that his sculpture was based upon the comic strip but argued that his use was fair and a parody. The Southern District Court for the State of New York granted summary judgement against Koons, finding that it was not a parody and not fair use. They outlined the four key features that mitigated against Koons: that the copying was done for commercial reasons; that Odie was a work qualifying copyright protection; that the sculpture was a replica of Odie; and that the sculptures might harm the

market interests of UFS. Koons was found not to have produced a parody or satire because the work criticised society rather than making comment on the copyrighted work itself. This case is in line with Rogers v Koons but not the finding in Blanch v Koons (both discussed in Chapter 2).

In the case of Leibovitz v Paramount Pictures,[38] photographer Annie Leibovitz owned the copyright in her photograph of a naked and pregnant Demi Moore, appearing on the cover of *Vanity Fair* in 1991. In 1993, Paramount promoted the release of *Naked Gun 33 1/3* by creating an image of the superimposed face of the male star on the body of an apparently pregnant female model. Leibovitz sued Paramount for copyright infringement. The court held that the advertisement was parody and permitted the defence of fair use. The court found three features that might mitigate against fair use: that the poster was an advert for a commercial product; that the Leibovitz work was creative/copyrightable; and that the copying of the Leibovitz work had been extensive, but ultimately found that the film poster had transformed, and commented on, the original work, and that it did not compete in the same market as the original photograph

Defences to infringement action include 'implied licence to use', independent creation, inexcusable delay in filing a complaint, that the work has fallen into the public domain and fair use for criticism, comment, news reporting, teaching, scholarship and research.[39] The tests for implied licence to use, independent creation, delay in filing a complaint or that work is in the public domain are very similar to those described under English law. However, the defence available under US law of fair use, while sounding similar to that of fair dealing under English law, is broader in its scope. Fair use provisions are intended to protect those who borrow from works without permission, for 'socially productive purposes' (Jassin and Schechter 1998: 26).

The difference between the two defences is well illustrated in the case of Leslie A. Kelly v Arriba Soft[40] which concerned copyrighted images appearing in a visual search engine (controlled by someone other than the copyright-holder). The court determined that the infringement was justified under the fair use doctrine, and that use of the images had been 'transformative' (they were not presented as art but as thumbnails which could lead the user to the web images of the copyright-holder). This transformative purpose was permitted and although the substantiality of the portion of work used weighed against the defendant, no adverse commercial damage could be shown by the plaintiff. Transformative use is hard to show though so in the case of Perfect 10 v Google,[41] the California District Court, ruling against Google, found that while linking searches to the copyrighted works put online by a party authorised to do so was acceptable, the thumbnails Google used competed with Perfect 10's images. However, in 2007 the Ninth Circuit Court of Appeals reversed the finding and stated that Google benefitted from the fair use doctrine consistent again with the Leslie A Kelly v Arriba Soft.[42] These cases contrast with the UK instance of the estate of Matisse and Phaidon Press discussed in Chapter 1.

Factors that the court will consider in determining whether there is a legitimate defence to infringement include the purpose of the use (whether

it is for profit or not, whether it was socially productive and whether the use was 'transformative' – see above); the portion of the copyrighted work used and its importance overall in the copyrighted work; the nature of the work (for example, whether the use of lengthy quotations gives life to an otherwise boring book or whether the protected work is factual or fiction); and the effect of the use on the market value of the infringed work. The Supreme Court has held that the most determinative of these will be the market factors.[43]

The US Electronic Commerce Directive provides some protection for those offering information society services if they are the intermediaries or mere conduits of the information,[44] or caching (Electronic Commerce Directive).[45] The law does not extend to determining that the placing of images on the internet is 'implied permission to use'.

Trademarks and patents

Contemporary US law recognises the existence of patents, copyright and trademarks (note the absence of 'design' rights). The regulation of trademarks and patents is largely governed by the Lanham Act 1946 and the Trademark Law Revision Act 1988.[46] Patents (relating to techniques of manufacture) last for twenty years and there is fourteen years' protection for 'ornamentation' attached to an object for manufacture.

The primary purpose of trademark law is to protect consumers and enable them to identify the source of a product or service. Consumers, however, have never been in a position to enforce the law: it is the trademark owner who does this. A trademark under US law is a word, name, symbol or device (or combination of these) used to identify goods and their source as well as to distinguish them from other goods (a 'service-mark' does this in relation to services). To qualify for legal protection, a mark must be distinctive.

Unregistered marks are protectable, although marks enjoy more protection through state or federal registration. The Lanham Act 1946 provides for federal registration and under the Trademark Law Revision Act, trademark registration lasts for ten years and is renewable for ten-year increments by application. There are two registers in the US. The first of these is the Principal Register for trademarks and service-marks in commercial use; to be included in this register the marks must fulfil the statutory criteria. The second register is called the Supplemental Register which provides for those marks not complying with the formal requirements of the Principal Register. Since registration on the second register is only *prima facie* evidence of exclusive ownership, and contestable, marks so-registered are only protected under the rules of common law, rather than benefitting from full federal protection that accompanies inclusion on the Principal Register. The common law protection of marks allows for recovery of monetary damages and for injunctions.

The Lanham Act[47] prohibits the false description of goods or their origin. There is no need for the plaintiff to show intent to deceive; just a likelihood

of confusion in the consumer. No party has an absolute right over their own name but Picasso was held to be a trademark.[48] Furthermore, when a trademark becomes used as a noun or a verb (rather than an adjective) it may be found to be too generic to qualify for protection (consider 'aspirin').

In the case of infringement of trademarks and patents, monetary damages suffered, profits earned by the infringer, or both, are available under US law. If the infringement is wilful then punitive or exemplary damages may be available. Some states have additional 'anti-dilution' laws to allow for claims from traders who have suffered damage to their reputation as a result of infringement of a mark, or where the exclusivity of their mark has been compromised.

Moral rights

Moral rights are codified in the Berne Convention[49] but the US did not become a signatory to Berne until 1988. In 1990, Congress passed the Visual Artists Rights Act (VARA) which amended the Copyright Act to comply with Berne and came into effect in 1991. The US is one of the most recent jurisdictions to recognise moral rights. The rights apply to painting, drawing, print and sculpture[50] that exist as a single copy, or as limited editions of less than 200 consecutively numbered pieces which are signed.[51] Protection is extended to photographic images for exhibition or those existing in numbered editions of less than 200.[52] There is a cause of action for moral rights infringement even if the art is not registered with the Copyright Office; though damages may be enhanced if it is registered.[53]

The right to create a work, or not to

Under French law, a lack of inspiration has been viewed as a 'normal risk' for those who contract for work which an artist might, or might not, create.[54] Similarly, in the US, contracts for 'personal services' cannot be enforced because the constitution prohibits involuntary servitude. However, a party who breaches a contract will still be liable for damages.

The right of disclosure

In French law, the right of disclosure has included the rights of an artist to destroy or restore their work, and these supersede those of the finder of abandoned property.[55] The right to withdraw a work is not recognised in the US since the lawful owner of a work has the right to sell and display it.[56]

The right of attribution

This is also known as the right of paternity and includes the right to be named in relation to an authored work or the right not to be named in association

with a work that has been distorted, mutilated of modified in a way prejudicial to the reputation of the artist.[57] False imputation of paternity also arises in the constitutional right of privacy, as well as through common law principles of Unfair Competition, action for defamation and the Lanham Act.[58] Some states also provide rights of pseudonymity.

The right of integrity

An artist has the moral right to prevent works from being displayed, altered, mutilated, distorted or otherwise modified in a way prejudicial to the author's reputation.[59] The acts that modify the work must be intentional rather than negligent;[60] allowing a work to degenerate will not meet the threshold for engaging the right of integrity. However, works are protected from destruction.[61] State laws in New York and California are more comprehensive than federal law in relation to integrity.

It appears that the right of integrity can be quite hard to enact. In the case Gilliam v ABC,[62] the plaintiff was unable to prevent the airing by ABC of an edit of a Monty Python work that had not been authorised. At first instance, the defendant was ordered by the District Court to announce the Monty Python team's disassociation from the edit. On appeal, however, the Court of Appeals (Second Circuit) ruled that the defendant did not have to include the disclaimer ordered. When the show aired the plaintiff appealed for damages under the Copyright Revision Act[63] which grants the owner of copyright the exclusive right to prepare derivative works.

The right to object to excessive criticism

In many jurisdictions, a right of reply is provided to those who have had their work subject to extreme criticism but there is no such right in the US. Libel law potentially provides some protection but these have to be balanced against the First Amendment right to free speech.

Passing off

The offence of passing off appears in the Lanham Act[64] and applies in circumstances where a defendant has suggested that goods or services are those of another, or that they have the other party's approval when they do not. In the case of Vuitton v Crown Handbags, the defendant was found to have infringed the Lanham Act on the basis of the report of a private investigator commissioned and trained by Vuitton to locate counterfeit handbags.[65] Public confusion in this context may also give rise to a cause of action under US Unfair Competition law and trademark infringement.

A US tort – appropriation of personality

In 1979, sculptor Mihail Simeonov made a representation of a model's head (Tiegs) with her consent, later modifying it to make a plaster cast without her consent. Simeonov sued Tiegs for damages after the cast was destroyed by accident on Tiegs' property who counterclaimed that Simeonov did not have her permission to produce the likeness.[66] New York Civil Rights Law[67] prohibits the use of the name, portrait, or picture of any living person for the purposes of trade without having first obtained the written consent of such person; this is referred to as the 'right of publicity' in US law. The Court concluded that an artist can create a likeness of a person without consent and sell this without violating the law. The right to free speech is balanced against Civil Rights law, and in this case this right took precedence.

In contrast to English law, US law recognises publicity rights as a form of property right relating to personality (usually that of a public figure). This concept exists as a mixture of state and common law. Publicity rights are also protected to some degree through Federal law in the Lanham Act 1998[68] which prevents unauthorised use of trademarks and thereby, indirectly, a celebrity's likeness. The common law right was first recognised in 1953 in the case of Haelan Laboratories v Topps Chewing Gum.[69] The party asserting a right must show that they have legitimate ownership of the publicity right and that the use of it, by another party, damages their economic interests.[70]

Approaches to publicity rights vary considerably across the US due to the variation in statute and case law in each state. This book does not have space to consider these variations in detail but can attempt to establish some key approaches. The right of publicity encompasses control over name, image, voice and signature. Anyone who appropriates, for commercial benefit, the likeness

of someone else may be found liable for infringement of a publicity right.[71] Coombe refers to this as the 'tort of appropriation of personality' (1992: 365). Personality rights can include the right to anonymity and a reputation's integrity (crossing over with *false light* protection – see below), and can be assigned to others but the extent to which these rights survive death is not clear or consistent. For example, the Californian Civil Code Section 990(b) gives protection to the commercial interests of a deceased celebrity; the California Civil Code[72] (for obvious reasons) provides some of the strongest protection of personality rights in the US.

The courts have distinguished the use of an image which infringes privacy and a use which dilutes commercial interests; nevertheless, privacy claims and other causes of action may overlap with a publicity rights case. Transformative use of a publicity right may warrant protection under the First Amendment (relating to freedom of speech). In Hoffman v *LA Magazine*,[73] lawyers for Dustin Hoffman argued that being seen to endorse goods could create the impression that he was struggling to find work as an actor. On appeal, this argument did not succeed due to the absence of falsity or malice on the part of the defendant who was found to have met the threshold for sufficiently 'transformative' use, and therefore First Amendment protection.

First Amendment protections allow editorial use of someone's image for the purpose of scholarship, education, historical research and news-reporting in the public interest. To otherwise lawfully use someone's personality rights in the US, the party wishing to exploit these should seek a written release giving consent allowing the use of a name, likeness or other characteristics. The

release is effectively a promise not to sue. There are two categories of release: 'model releases' (the right to publicity) which are used in commercial contexts and 'interview releases' (in some states a written waiver is required to publish an interview). Incidental use of a publicity right will usually be protected (for example, the appearance of a celebrity in the back of a photograph used for another purpose). In addition, US copyright regulations have been used successfully to argue that the inclusion of a photograph (of someone who wished to control the commercial use of their image) in an artwork is protected by the First Amendment. This would appear to extend the defence to copyright infringement enjoyed in news-reporting to artists. In the 2002 case of Hoepker v Kruger,[74] Charlotte Dabney, joining a copyright action by Thomas Hoepker, pursued a privacy action against artist Barbara Kruger for use of an image of her created by Hoepker in the 1970s (*Charlotte as seen by Thomas*). Kruger had created a work incorporating the photograph with text that read: '*It's a small world but not if you have to clean it*'. The law employed was (as above in the case of Simeonov v Tiegs) New York Civil Rights Law[75] which requires that to succeed with a privacy claim, a plaintiff must prove unconsented use of their name/portrait/picture/voice, for advertising or trade, within the state of New York.[76] The image had been used without consent so the question of whether the defendant's use of the picture was 'for advertising purposes or for purposes of trade' was addressed. The New York legislature had sought to protect a person's right to be free from unwarranted intrusions into privacy, while at the same time protecting the American right to free speech and, as in the case of Simeonov v Tiegs, Kruger was shielded from Dabney's right of privacy claim by the First Amendment.[77] The Kruger image can be seen at http://www.moca.org/pc/viewArtWork.php?id=35.

Freedom of speech

In 1987, a Chicago art student, Nelson, painted a picture (*Mirth and Girth*) of a recently deceased black mayor wearing women's lingerie which, when it was displayed at a student exhibition, was seized by city officials and somehow damaged in the process. Nelson claimed that his constitutional rights had been violated and the Court held that city officials did not have the right to enter private views of the college without invitation or to remove art.[78] The officials could not claim immunity because it was clear at the time they acted that they were acting unconstitutionally; if public disorder had arisen as a result of the display of the painting then the Court stated that officials could arrest rioters rather than seize the artwork.

The right to freedom of expression or speech is not absolute in the US. Anything that creates a 'clear and present danger'[79] of creating situations that a legitimate government is entitled to prevent cannot be protected by the First Amendment. In 1969, the Supreme Court held that this danger must be of inciting (or likely to incite) 'imminent lawless action': the Brandenburg test.[80] Bigotry is protected under the First Amendment but only if the manner in which it is expressed is not liable to incite physical and lawless activities. US

law permits 'prior restraint' of activities in very limited circumstances as this is contrary to the First Amendment; though national security justifications can prevail (see, for example, the Espionage Act 1917).

Non-verbal activities are recognised as a form of 'speech' by the Supreme Court[81] but it has given little guidance on the range of conduct that this might include. A case concerning the burning of draft-cards in protest[82] offers a limited indication of whether a law might be justified if it conflicted with other constitutionally protected freedoms. The Supreme Court determined that the regulation in question must be no more than is essential to further a legitimate government interest.

The 'desecration' of the flag has generated heated debate in the field of free speech. In US v Eichman,[83] the Flag Protection Act 1989 was held to be 'unconstitutional'.[84] In the 1970s case the People of the State of New York v Stephen Radich,[85] flag-sculptures by Morrel were held to be 'a contemptuous use of the flag' in the court of first instance. This conviction was upheld on its first appeal by a majority rather than unanimous verdict. The judgement of the minority questioned the likelihood of the works inciting any type of unrest (of being a 'clear and present danger'). The Supreme Court upheld the ruling.[86] In 1974, however, a Federal Judge in New York ruled that Radich had been deprived of his rights under the First and Fourteenth[87] Amendments, determining that the flag sculptures in question were non-verbal communication, intended to 'speak' and that no disorder had resulted from them.[88]

In case the reader believes that free speech is relatively easy to protect in the US, it is worth investigating the history of the McCarthy hearing during the 1950s; a period during which an unsubstantiated allegation could end careers. Congressman George A. Dondero (Republican) remarked of modern art that it is 'communistic because it is distorted and ugly, because it does not glorify our beautiful country … those who create and promote it are our enemies' (Interview with Emily Genauer, cited in Hauptman 1973: 48). Even recently, the Christian Right in the States have worked hard to repress the expression of artists. Serrano's *Piss Christ* led Senator Jesse Helms (Republican) to lobby for the denial of funding to art that was deemed obscene and to apply pressure to the National Endowment for the Arts (NEA) and the Southeastern Center for Contemporary Art (SECCA) in relation to funding; Serrano had been a recipient of such an award.[89] In July 1989, the Senate passed a bill cutting NEA funding by $45,000 and banned two institutions from receiving new funding for five years (SECCA and the Institute of Contemporary Art (ICA)). These bans were revoked on the condition that awards be overseen by a Senate appropriations committee. The intention of the bill was to cut funds that:

> promote, disseminate or produce obscene or indecent materials, including but not limited to depictions of sadomasochism, homoeroticism, the exploitation of children, or individuals engaged in sexual acts; or materials which denigrate the objects or beliefs of the adherents of a particular religion or non-religion.[90]

Ultimately, while the $45,000 cut was authorised, the ban on SECCA and ICA receiving funds and the clause relating to 'obscene and indecent materials' did not survive its journey through Congress.

First Amendment protection is not available for those who commit illegal or tortious acts in the course of gathering the news.[91] The media do have considerable protection in relation to the publication of information but where it has been obtained through some unlawful act this may affect damages awarded to a plaintiff in legal action.[92]

Public officials are occasionally afforded immunity against those seeking to assert a First Amendment right. In 1999, Michael Zieper posted a short film on a web-space owned by Mark Wieger. The fiction film tells the story of a takeover of Times Square on New Year's Eve 1999. The New York Police Department notified the FBI's Joint Terrorism Task Force and although the FBI appreciated that it was a work of fiction they asked (but could not compel) Zieper to remove the film. When Zieper failed to comply with the request, the FBI employed the services of the Assistant United States Attorney, and pressured Wieger, the owner of the company hosting Zieper's webspace, to remove the film which he did. Zieper's case against the particular agent and Assistant US Attorney resulted in summary judgement against the claimant due to the 'qualified immunity' enjoyed by the defendants. Zieper appealed to the Second Circuit Court of Appeals, which upheld the district court's decision. The court acknowledged that officials had violated Zieper's First Amendment rights but enjoyed qualified immunity. The court distinguished the actions of the agent and assistant attorney as 'convincing' rather than 'coercive' which gave rise to the officials' immunity.[93]

Blasphemy

Blasphemy is speech calculated to express contempt for religion. Action traditionally succeeded, despite the First Amendment, if it was construed that there was incitement of violence. Latterly, the Supreme Court has held that it cannot suppress assault on religious doctrine. In the case of Brooklyn Institute of Arts and Sciences v City of New York,[94] the Mayor of New York had been offended by works in the *Sensation* exhibit at the Brooklyn Museum; particularly Chris Ofili's *The Holy Virgin Mary* (a painting with elephant dung). Consequently, the City attempted to withhold funds designated for the museum's use and to evict it from its site. The court granted the museum a preliminary injunction due to the irreparable harm the museum might suffer in consequence of the Mayor's actions, and its preliminary indication that the museum was likely to succeed in its First Amendment claim at full trial. The Establishment Clause of the Constitution requires separation of church and state. Similarly, in the case of Joseph Burstyn v Wilson[95] a New York statute of the 1950s permitted the banning of film by the New York State Board of Regents. The Board rescinded Burstyn's license to distribute the film *The Miracle* because it was 'sacrilegious'. Burstyn claimed the

statute to be unconstitutional, violating his right of free speech; the court agreed that such prior restraint was unconstitutional. The Court reasoned that motion pictures are a significant medium for the communication of ideas and are therefore protected by the First Amendment, and that the defendant's argument that products created for profit cannot be protected was incorrect.

Protecting reputation

Defamation

In the US, defamation is a tort and there are no federal defamation laws. Defamation involves the issue of a statement which the perpetrator knows to be false (or where the defendant has a reckless disregard as to truth or falsehood) as clarified by the case of *New York Times* v Sullivan.[96] A defamatory communication (oral or written) is a false statement made to a third party which is likely to damage the reputation of the subject (either through the commission or omission of information), lower them in the eyes of others or deter others from dealing with them. Defamation is divided into: libel, which is a defamatory statement made in a fixed medium (such as through writing or pictures), and slander, which is a defamatory statement expressed in a transitory form (such as through speech). Usually the plaintiff must show financial loss but some forms of defamation give a right of action regardless of financial damage. These circumstances include the 'intentional infliction of emotional distress' which in many US states is a stand-alone tort. Intention in this context usually includes reckless acts that caused the plaintiff's distress.

There are two forms of libel in the US: *libel per se* (where someone is identified and a false statement made), and *libel per quod*/'libel by implication' (where something false is implied). For defamation to be found, there must be a false statement of fact. The burden of truth in the case of a plaintiff who is a private citizen will lie with the defendant who must show that something was true (in which case negligence may give rise to liability). In the case of a public official, public figure or public body then it is for the plaintiff to show the falsehood and that the falsity was either known (actual malice) or that there was reckless disregard to this on the part of the defendant. In addition, public figures cannot recover damages for emotional distress.[97]

For a statement to be defamatory, it must be likely to cause injury to the plaintiff (exposing them to hatred, ridicule or disgrace) and about the plaintiff (though this can be through indirect reference by which a reasonable person could identify them). There are certain false statements that will always be defamatory; for example, those relating to criminal conduct, infection with particular diseases and uncreditworthiness.

In the event of liability being found then actual losses that arose from the defamatory act, or the costs of restoring a reputation, may be sought in damages.

These include damages for mental anguish (except in the case of a public official). If there is actual malice then punitive damages may be awarded along with legal fees. In some states there is provision for the publishers of newspaper to limit their liability by retraction within a set period (for example, forty-eight hours) but this is not available on a federal basis.

A complete defence to libel is that of verifiable truth. Expressions of opinion are not necessarily libellous but the use of 'in my opinion' is not always a shield (nor is this a shield in English law). If there is an implication of a false statement of fact then this will probably be defamatory but if opinion is based on factual information and given in good faith then it cannot generally be defamatory. A defence to defamation action can also be that parties who know the plaintiff could not identify him or her in relation to the statement.

There are certain types of privilege that excuse a person who has made an otherwise defamatory remark from liability. There are two types of privilege in the US; absolute (which exists regardless of the good faith of the person making the remark) and conditional (which is dependent on good faith); these are not dissimilar to the privileges available in English law described in Chapter 3. Absolute privilege arises in speeches made during judicial, legislative or government proceedings. Conditional privilege arises where a public interest is at stake; for example, statements that protect the public or accurately report public proceedings (bad faith on the part of the publisher or writer extinguishes this privilege).

False light

In reality, proceedings for defamation and false light in the US are often brought concurrently and may also overlap with publicity rights. Defamation protects a person against false facts and damage to reputation whereas 'false light' is more nuanced than this; the facts may be true and the damages recoverable relate to emotional distress. False light requires a legitimate objection to the manner in which someone is portrayed. A public official who claims false light has the same burden of proof required of them as for defamation (that the defendant was malicious or reckless), but otherwise (for private citizens) false light allegations do not have to meet the threshold for defamation. The statement in question, however, must be highly offensive to a reasonable person and the plaintiff must be identifiable and living. False light has been used in a variety of circumstances from misleading advertising to unauthorised use of a celebrity image. Any embellishment or distortion of the facts might give rise to a cause of action; this is even so if the false light created is complimentary but false and exposes the person to embarrassment (which would not be captured in defamation actions). Fictionalized accounts of real events can also give rise to difficulty. False light is recognized as a cause of action in over half of US states but not in New York, Florida or Texas. First Amendment protection/free speech is available as a defence to false light claims.[98]

Privacy

The US Constitution does not recognise a right to privacy in the same way that freedom of speech is recognised but the Fourth Amendment provides for the right of people to be secure in their person, housing and personal papers, and also 'against unreasonable searches and seizures'. The constitutional right to 'free speech' serves as a starting point in determining matters which are of legitimate interest to the public (and therefore legitimate defences against action). US law, with regards to the First and Fourth Amendments, cannot be compared directly to the balance sought between Article 8 and Article 10 of the European Convention on Human Rights. The Fourth Amendment was held to be violated when police, in the course of legitimate duties, brought third parties into a private home.[99] Merely causing 'annoyance' will not infringe the Fourth Amendment; the case of Demsey v National Enquirer[100] was concerned with attempts to photograph a pilot who had recently fallen out of a plane which were found not to infringe the plaintiff's Fourth Amendment rights. Where there has been an undertaking of confidentiality[101] or concealment of a journalist's identity,[102] the Fourth Amendment has been more successfully applied in case law.

Invasion of privacy is a newer tort in the US. Since the laws on privacy vary from state to state, they are hard to summarise but generally the publication of embarrassing facts, the publication of facts that create a misleading impression, or intentional intrusion into a private space will constitute an invasion of privacy. In contrast to defamation, the truth of facts found and/or revealed is not a defence. However, legitimate public concern in the disclosed facts (such as unlawful activity or the conduct of a public official) will be a defence.[103] Other defences include that there has been informed consent or release of information, death (unless the plaintiff died during the course of court proceedings), newsworthiness and inoffensiveness.

The Alabama Supreme Court recognised the tort of invasion of privacy in 1983.[104] From this, it appears that invasion of privacy requires *one* of the following: an intrusion into the plaintiff's physical solitude or seclusion (through perhaps trespass, opening mail, or surveillance, but information does not have to be published for there to have been an invasion of privacy); publicity that violates ordinary decencies; putting the plaintiff in a false light in the public eye; or appropriation of the plaintiff's personality for commercial use. New York has no common law of privacy but it does have a Privacy Statute[105] which protects against the misappropriation of commercial rights (see section on publicity rights above). In Michigan, state law creates both criminal and civil liability for invasion of privacy though it is not recognised at all in North Carolina or Indiana. The nature of the facts discovered or disclosed must generally be 'sufficiently intimate'[106] to qualify for protection and include information on health, surgery, sexual identity, prior criminal activities (where the plaintiff has long since been rehabilitated) and financial matters.

As under English law, the plaintiff's expectation of privacy (in states where this is recognised as a legitimate cause of action) must be 'reasonable' in the

circumstances of each case,[107] and this expectation must be carefully considered in the broader context of protecting First Amendment rights and 'truth'. For liability to be found, it must be foreseeable that the disclosure could give rise to emotional distress. Public figures (as with other related torts in the US) enjoy fewer privacy rights, though the legitimacy of public interest is still used as a measure of the acceptable level of intrusion.[108]

Obscenity

In the late 1980s, the Contemporary Arts Center, Cincinnati, invited a jury to view Mapplethorpe's *The Perfect Moment* prior to the exhibition opening, in order to ascertain whether they might be obscene but the request was refused. Members of the Hamilton County grand jury were among the first visitors to the exhibition and determined that several images were obscene. The arts centre and its director (Dennis Barrie) were charged with misdemeanours relating to obscenity.[109] Barrie was the first US museum director to be indicted for obscenity; ultimately the jury acquitted the defendants.[110]

The offence of obscenity in America was covered traditionally under common law through the act of using 'vulgar or obscene language' and making 'indecent public exhibitions'. This was punishable as a *misdemeanour* rather than a *felony*. State laws implemented during the growth of mass communications prohibited the buying, selling, giving, showing (and so on) of obscene, indecent or impure materials. The concept of obscenity must be balanced against the First Amendment Right to freedom of speech; this has a long history in America but is comparatively new under English law, with the introduction of the right to freedom of expression (Article 10 ECHR) via the Human Rights Act 1998. The Human Rights Act can be repealed by any government; a change to the First Amendment would require a significant alteration to the US Constitution which even if it were technically straightforward (which it is not) is guarded closely by US citizens.

The cases of Roth and Miller (below) have determined that for obscenity to be found, the material, as a whole, must appeal to prurient interest, depicting in a patently offensive way, sexual conduct, as measured by the average person, applying contemporary community standards and lacking serious literary, artistic, political or scientific value.

The case of Roth v United States[111] concerned the publication and distribution of books and magazines by Roth who was convicted of obscenity charges. The test of the Supreme Court was 'whether to the average person, applying *community* standards' the dominant theme of the material taken as a whole appeals to prurient interests (italics mine).[112] Both the context for, and the content of, a work will be important in determining its tendency to 'excite lustful thoughts'.[113] In common with the Obscene Publications Act under English law, the test appears to require that a work simultaneously incites lustful thoughts and is patently offensive, creating a problem for those determining how obscenity is measured.

The meaning of 'community' was determined in Miller v California[114] concerning the circulation of allegedly obscene materials. The Miller test permits juries to apply local standards to judging whether a work appeals to prurient interests and depicts sexual conduct in 'a patently offensive way' (in addition to the test set out in Roth). Furthermore, the work must be taken as a whole and be without literary, artistic, political or scientific value, as judged by a reasonable person. The reader will note that the court did not use the term 'community standards' in relation to whether a work is without literary, artistic, political or scientific value but by the standards of 'a reasonable person', implying that in judging a work's public value, the standards of the community will not be a valid test.

How far the First Amendment protects work was tested in the case of New York v Ferber[115] where it was confirmed that pornography involving children was not protected. It was held that legislators had greater leeway in regulating for this since the materials did not have to be of prurient interest to the 'average person', the sexual conduct in question need not be portrayed in a 'patently offensive way' and the materials did not need to be considered 'as a whole' because the interests of the child usurp other freedoms of the US Constitution. Images of children are regulated through the Child Sexual Abuse and Pornography Act 1986 and the Child Protection and Obscenity Enforcement

Act 1988. In 1990, photographer Jock Sturges was subject to a search under warrant and confiscation of work stored in San Francisco by the FBI.[116] The work was impounded but Sturges was never charged, although the authorities subpoenaed galleries in Boston and Philadelphia and contacted the families of those who had been photographed. As a result, Sturges is said to have lost commercial clients. Sturges does not obtain model release from his subjects, preferring to seek permission to display each image with the subject in question on each occasion he wishes to use it.[117]

The nude has historically been one of the central subjects of art, but it remains a subject of controversy and censorship in the United States. Exhibition spaces frequently decide to censor artwork containing nudity in order to protect children from indecent material. The US Supreme Court has determined several times that artwork containing nudity of itself is constitutionally protected.[118] Contemporary US cases on obscenity and freedom of speech are generally conducted through civil, rather than criminal, proceedings which require a lesser burden of proof than 'beyond reasonable doubt' (as required for criminal acts).

Trespass and intrusion

Trespass to land and theft were originally developed as nuisance torts and are now covered in state and federal law. In the event of trespass on private property, a plaintiff can claim damages where there has been no loss or malice.[119] This means that a graffiti artist who has been apprehended before putting work on a wall is liable in trespass as well as in having 'intent' to commit an act of criminal damage.

Unlike in the UK, under US law there is a tort of intrusion[120] which covers both physical impositions and the use of apparatus to augment observation (such as audio bugging devices or telephoto lenses). Liability for this tort does not require publication or disclosure of the information but rather an 'affront to individual dignity'.[121] The fact that disclosure of the information is not required for this tort means that there is no First Amendment protection for it, and this lack of defence extends to news gatherers.

Notes

1 United States v Olivotti & Co 7 Ct Cust 46 (1916).
2 Brancusi v United States 54 Treas Dec 428 Cust Ct (1928).
3 *Disney demands removal of sculpture* Los Angeles Times 16 Oct 1992 http://articles. latimes.com/1992-10-16/local/me-341_1_mickey-mouse-and-donald-duck.
4 http://www.artnet.com/magazineus/news/artnetnews/artnetnews8-18-05.asp.
5 US Constitution Article 1, Section 8 1787.
6 *ibid.*
7 Berne Convention Implementation Act 1988.
8 Copyright Revision Act 1976 Section 101.
9 'Sonny Bono' Copyright Term Extension Act 1998.
10 Eldred v Ashcroft 537 US 186 (2003).

11 Copyright Revision Act 1976 Sections 102 & 301.
12 *ibid.* Sections 102.
13 *ibid.* Section 102(a).
14 *ibid.* Section 102(6).
15 *ibid.* Section 101.
16 Mazer v Stein 347 US 201 (1954).
17 Copyright Revision Act 1976 Section 106.
18 *ibid.* Section 201.
19 The word plaintiff is still used in the US.
20 Copyright Revision Act 1976 Section 412.
21 Washington DC 20559.
22 Copyright Revision Act 1976 Section 407(1).
23 *ibid.* Section 401.
24 Feist Publications v Telephone Service Co 499 US 340 (1991) 113 L Ed 358 (1991) (Sup Ct).
25 Bridgeman Art Library Ltd v Corel Corporation 25 F Supp 2d 421 (SDNY 1998).
26 US Constitution Article 1, S8, C18 and the US implementation of the Berne Implementation Act 1988.
27 Hearn v Meyer 664 F Supp 832 (SDNY 1987).
28 Warner Brothers Pictures Inc v Columbia Broadcasting System Inc. (1954) (216 F 2d 945 (9th Cir 1954), 200).
29 Walt Disney Productions v Air Pirates (1978) (581 F 2d 751 (9th Cir 1978) 200).
30 Copyright Revision Act 1976 Section 501.
31 *ibid.* 502 & 503(b).
32 *ibid.* Section 504.
33 *ibid.* Section 504(c).
34 *ibid.* Section 107.
35 *ibid.* Section 505.
36 *ibid.* Section 506.
37 United Feature Syndicate Inc v Jeff Koons 817 F Supp 370 (SDNY 1993).
38 Leibovitz v Paramount Pictures Corp 137 F 3d 109 (2d Cir 1998).
39 Copyright Revision Act 1976 Sections 107–118.
40 Leslie A. Kelly v Arriba Soft Corporation No 00-55521, 280 F 3d 934 (9th Cir February 6, *2002*) withdrawn, F 3d (9th Cir July 3, 2003).
41 Perfect 10 v Google Inc *et al.* 416 F Supp 2d 828 (CD Cal 2006).
42 Perfect 10 v Google Inc 487 F 3d 701 (9th Cir 2007).
43 Steward v Abend 495 US 207, 110 S Ct 1750, 109 L Ed 2d 184 (1990), *214.*
44 Electronic Commerce Directive 2000/31 Article 12.
45 *ibid*. Article 13.
46 The Commerce Clause of the US Constitution permits Congress to enact Federal Trademark laws.
47 Lanham Act 1946 Section 43(a).
48 Visual Arts & Galleries Ass'n v various John Does 80 Civ 4487 (1980), *223.*
49 Berne Convention Chapter X11 1928.
50 Visual Artists Rights Act 1990 (VARA) Section 106A.
51 VARA 1990 Section 602(1).
52 *ibid.* Section 602(2).
53 http://copyright.gov/help/faq/faq-general.html#automatic
54 Eden v Whistler [1898] (Civ Trib Seine [1900] (Cour d'Appel, Paris); [1900] (Cass Civ).
55 Carco v Camoin [1931] (Cour d'Appell, Paris).
56 Copyright Revision Act 1976 Section 109.
57 VARA 1990 (Section 603)(a).
58 Lanham Act 1946 Section 43(a).

59 VARA 1990 Section 603(a).
60 *ibid.* Sections 603(c)(1)-603(c)(2).
61 *ibid.* Section 603(a)(3)(B).
62 Gilliam v American Broadcasting Companies Inc 538 F 2D 14 (2nd Cir 1976), *250, 251, 252.*
63 Copyright Revision Act 1976 Section 106(2).
64 Lanham Act 1946 Section 43(a).
65 Vuitton et Fils, SA v Crown Handbags 492 F Supp 1071 (DCNY 1979), affirmed 622 F 2d 577 (2nd Cir 1980), *231.*
66 Simeonov v Tiegs 602 NYS 2d 1014 (NY Civ Ct 1993).
67 New York Civil Rights Law Sections 50–51.
68 Lanham Act 1946 Section 43(a) as amended by the Trademark Law Revision Act 1988.
69 Haelan Laboratories Inc v Topps Chewing Gum Inc 202 F 2d 866 (2d Cir 1953).
70 Zacchini v Scripps-Howard Broadcasting Co 433 562 (1977).
71 *Restatement of the Law, Second, Torts*, Section 652C.
72 California Civil Code Section 3344.
73 Hoffman v Capital Cities (*LA Magazine*)/ABC Inc 255 F 3d 1180 (9th Cir 2001).
74 Hoepker v Kruger 200 F Supp 2d 340 (SDNY 2002).
75 New York Civil Rights Law Sections 50–51.
76 Titan Sports Inc. v Comics World Corp., 870 F.2d 85, 87 (2d Cir. 1989).
77 http://www.legalzoom.com/intellectual-property-rights/copyrights/appropriating-copyrighted-works-or-trademarks.
78 Nelson v Streeter 16 F 3d 145 (7th Cir 1994).
79 Schenck v United States 249 US 47, 39 S Ct 247, 63 L Ed 470 (1919).
80 Brandenburg v Ohio 395 US 444, 89 S Ct 1827, 23 L Ed 2d 430, 48 OO 2d 320 (1969) *261.*
81 Stromberg v California 283 US 359, 51 S Ct 532, 75 L Ed 1117 (1931) 263.
82 United States v O'Brien 391 US 367, 88 S Ct 1673, 20 L Ed 2D 672 (1968), 263, 266.
83 United States v Eichman 496 US 310 (1990).
84 See also Spence v Washington 418 US 405, 94 S Ct 2727, 41 L Ed 2d 842 (1974), 266, 269, 270, 271.
85 People of the State of New York v Stephen Radich 308 NYS 2d 846, 257 NE 2d 30 (NY 1970).
86 Affirmed in Radich v New York, 401 US 531, 91 S Ct 1217, 28 L Ed 2d 287 (1971).
87 Fourteenth Amendment – that all citizens receive full and equal treatment in law…
88 United States ex rel Radich v Criminal Court of City of New York, 385 F Supp 165 (DGNY 1974), 270, 271, 272.
89 http://www.nytimes.com/1989/09/14/world/house-shuns-bill-on-obscene-art.html.
90 http://www.nytimes.com/1989/07/27/arts/senate-votes-to-bar-us-support-of-obscene-or-indecent-artwork.html.
91 Shulman v Group W Productions 18 Cal 4th 200, 955 P 2d 469 (Cal Sup Ct 1998) 232.
92 Dietemann v Time Inc 449 F 2d 245, US Ct of Apps (9th Cir), (1971).
93 Zieper v. Metzinger 474 F 3d 60 (2nd Cir 2007).
94 Brooklyn Institute of Arts & Sciences v City of New York and Rudolph Giuliani 64F Supp 2d 184 (FDNY 1999).
95 Burstyn Inc v Wilson 343 US 495 (1952).
96 New York Times v Sullivan 376 US 254, 84 S Ct 710, 11 L Ed 2d, 686 (1964) see also the Second Edition of the 'Restatement of Torts' Section 559.
97 Hustler Magazine v Falwell 485 US 46, 1108 S Ct 876 (1988).
98 Time Inc v Hill 385 US 374, 382, 87 S Ct 534 (1967).
99 Wilson v Layne 526 US 603, 119 Sup Ct 1692 (1999).

100 Demsey v National Enquirer 702 F Supp 927, 16 Med L Rptr 1396 (D Me 1988).
101 Barber v Time Inc 348 Mo 1199, 159 S W 2d 291 (Mo Sup Ct 1942).
102 Saunders v American Broadcasting Companies 20 Cal 4th 907, 978 P 2d 67 (Cal Sup Ct 1999).
103 Anderson v Fisher Broadcasting Companies Inc 300 Or 453, 712 P 2d 803, 814 (Or Sup Ct 1986).
104 Phillips v Smalley Maintenance Services Inc 4 35 SO 2d 705 (Ala 1983).
105 New York Civil Rights Law Sections 50–51.
106 Ramsey v Georgia Gazette Pub Co 164 Ga App 693, 297 SE 2d 94 (1982).
107 Prince v Out Publishing 2002 Cal App LEXIS 25 (3 January 2002) petition for review denied, 2002 Cal LEXIS 2390 (Cal 2002).
108 Diaz v Oakland Tribune Inc 139 Cal App 3d 118, 188 Cal RPTR 762 (1983).
109 City of Cincinnati v Contemporary Arts Center & Barrie 57 Ohio Misc 2d 9 (1990).
110 http://www.nytimes.com/1990/10/06/us/cincinnati-jury-acquits-museum-in-mapplethorpe-obscenity-case.html.
111 Roth v United States 354 US 476, 77 S Ct 1304, 1311 I L Ed 2d 1498, 14 OO2d 331 (1957); see also Alberts v State of California, 355 US 852, 78 S Ct 8 2 L Ed 2d 60 (1957), 273, 274.
112 Roth v United States, 354 US 476, 77 S Ct 1304, 1311 I L Ed 2d 1498, 14 OO2d 331 (1957).
113 ibid.
114 Miller v California 413 US 15, 24, 93 S Ct 2607, 2613, 37 L Ed 2d 419, 413 (1973) 274, 275, 276, 278, 279.
115 New York v Ferber 458 US 747, 102 S Ct 3348 73 L Ed 2d 1113 (1982), 278, 279.
116 http://en.wikipedia.org/wiki/Jock_Sturges.
117 http://articles.latimes.com/1998/mar/13/local/me-28408.
118 Osborne v Ohio 495 US 103 (1990) No 88-5986; Schad v Mount Ephraim 452 US 61, 66 (1981); Jenkins v Georgia 418 U.S. 153, 161 (1974); FW/PBS Inc v Dallas 493 U.S. 215, 224 (1990); Doran v Salem Inn Inc 422 U.S. 922, 932–933 (1975); Southeastern Promotions Ltd v Conrad 420 U.S. 546, 557–558 (1975); California v LaRu 409 U.S. 109, 118 (1972).
119 Mondello v Newsday NY Sup Ct Suffolk County (Mar 13 2004), Index No 0012821/2002/003, 774 NYS 2d 794.
120 Restatement of the law: second, torts (1977) American Law Institute, Vol. 3, 652B.
121 Shulman v Group W Productions Ltd 18 Cal 4th 200, 955 P 2d 469 (Cal 1998) 489.

Bibliography

Adams, L. (1976) Art on trial: from Whistler to Rothko, New York: Walker & Co.
Bonfield, L. (2006) American law and the American legal system in a nutshell, Michigan: Thomson Gale.
Cohen, H. (2003) Obscenity and indecency: constitutional principles and federal statutes, Hauppauge, NY Nova Science Pub. Inc.
Coombe, R. J. (1992) Author/izing the celebrity: publicity rights, postmodern politics and unauthorized genders, Cardozo Arts and Entertainment Law Journal, 10: 365.
DuBoff, L.D. (1993) Art Law (in a nutshell), 2nd edn. St Paul, MINN: West Publishing Co.
Farnsworth, E.A. and Sheppard, S. (2010) An introduction to the legal system of the United States, 4th edn. USA: Oxford University Press.
Giry, S. (2002) An odd bird, Legal Affairs, September/October http://www.legalaffairs.org/issues/September-October-2002/story_giry_sepoct2002.msp, accessed 28 February 2014.

Hauptman, W. (1973) Suppression of art in the McCarthy Decade, *Art Forum* 12(2), October: 48–52.

Jassin, L.J. and Schechter, S.C. (1998) *The copyright permission and libel handbook: a step by step guide for writers, editors and publishers*, New York: John Wiley & Sons Inc.

Madigan, N. (2014) Artists Donate Works for Legal Defense of Man Who Smashed Ai Weiwei Vase. 27 February 2014 http://artsbeat.blogs.nytimes.com/2014/02/27/artists-donate-works-for-legal-defense-of-man-who-smashed-ai-weiwei-vase/?_php=true&_type=blogs&ref=todayspaper&_r=0

Scheb, J.M. and Scheb, J.M. II (2002) *An introduction to the American legal system*, West Legal Studies/West Thomson Learning.

Appendix 1

Intellectual property, privacy and breach of confidence courts

Intellectual property disputes can be brought to the Chancery Division of the High Court. For patent disputes the Patent Court is used (a specialist court operating within the Chancery Division); there is no jury and the parties must have licensed legal representation. There is however a Patents County Court system (established in 1990) which is designed to provide a cheaper, quicker and more accessible process for patent and design litigation (CDPA 1988 Section 287). These courts can hear any case that the High Court does. A Patent County Court can transfer a case to the Patent Court in the Chancery Division on the basis of a case's complexity or where the outcome of the case is of importance to the public. It is the *Comptroller* of Patents and the Patents Office who determine the validity and revocation of patents. The Comptroller of Patents also has the power to issue a compulsory licence, to settle the terms of a licence for a patent and has some jurisdiction over unregistered design rights issues. Use of the Comptroller over such matters is cheaper, quicker and less formal than using the Patents Court, and parties can be represented by authorised patent agents rather than legal counsel. Use of the Comptroller is at the consent of both parties to a case. The Comptroller cannot, however, grant injunctive relief and in reality, therefore, is used less often. The European Patents Office is also permitted to determine the outcome of some categories of action.

Registered design rights cases can be heard in the Patents County Courts, the Patents Court (of the High Court) but not the County Courts. The validity of a design right can be heard by the Comptroller of Patents or the Patents Court. For (European) Community Design Rights, each member state must designate courts for hearing cases related to both registered and unregistered design rights (these do not have to be the same court for both types of right). In the UK, this is the High Court or any designated County Court (CDPA 1988 Section 287(1)) as well as the Patents County Courts. Issues of validity can also be determined by the Office of Harmonization of the Internal Market (OHIM).

County Courts can hear copyright and unregistered design cases as well as regional or European Community *trademarks* cases and *passing off*. County Courts do not hear patent or registered design cases. Although search orders and *delivery-up* are not available in the County Courts, these courts may award interim injunctions, damages and accounts for profits. *Copyright*, moral rights

and performer's rights cases may be brought to the High Court (Chancery Division) in certain circumstances. The Comptroller of Patents can look at the subsistence, duration and first ownership of an unregistered design right. The County Court, the Patents County Court and the High Court can hear infringement cases.

Infringement of trademark cases are heard in the High Court (Chancery Division), the Patents County Court and certain County Courts. The validity of a trademark can be determined by the Comptroller who can also hear certain counterclaims for infringements. If the trademark at issue is a community trademark then it is the OHIM who deal with this.

For passing off, it is the County Court or the High Court (Chancery Division) that hears the case though where there is an ancillary design rights question, this may be considered by the Patents County Court.

Breach of confidence claims are heard in the County Court or the High Court (Chancery Division). Privacy actions are usually heard by the Queen's Bench Division.

Appendix 2
Minimising risk

Seeking a licence to use the work of another

When asking for a licence to use the work of another, you should specify the following information: in which of your work theirs will appear; which work of theirs you wish to use; and the scope of the rights you seek. The specificities of this will vary as to whether you seek to reproduce written, visual or audio work.

The information about *your* work should include information of the following type: its title; price; date of publication; the publishers' details; a brief description of the work; and whether you intend to alter the work of the copyright owner in any way (such as cropping or reproducing it in black and white, etc.).

With regards to the owner's work, you should specify the following types of information: the author (if the owner of IP is not the author); the editor (if applicable); the title/edition of the work; the copyright year; the ISBN or ISSN number (if it is a book or periodical); the page number; the size to which you seek to reproduce their work; and any other information which will help the owner of copyright identify the work and understand your use of it.

With regards to the scope of permission you seek, you should give the following types of information: the medium or format; the activity for which the work is reproduced; the territories in which you will distribute your work; and the languages in which your work will be available.

You might say something like 'I seek the non-exclusive right to use *your work specifications*, in this and all subsequent editions or derivate works of *my work specifications* throughout the world, in all languages, for the full term of copyright' (or you might only seek to publish it in one territory and in English, in which case this should be specified).

When you reproduce, with permission, someone else's work, you should always acknowledge their kindness in granting your 'permission to use' (even if you paid more than you could afford to). If you have taken all reasonable steps to identify or contact the copyright owner of work you wish to reproduce, but have been unable to do so and decide that you need to go ahead with reproducing the work, you should state that you have attempted to identify and/or locate the owner of the rights attached to the work. If you do this, you should keep all the records that evidence the actions you took to contact the rights' owner.

Model release forms

When using subjects, particularly in works perceived to have veridical value such as film or photography, a signed model release will be useful. It will contain the following types of information: the photographer/film-maker's name, address and contact details; the model's name, address and contact details; and when/where the shoot took place. You should specify the fee the model was paid or will be paid (if a fee was involved) and where the images will be used. The part of the form that the model signs (or their legal guardian if they are not an adult) will say something along the lines of 'I *model's name* grant *photographer's name* use of the images for *state use*. I understand that part or whole of any image can be used (or not at all). I understand that in signing this form I waive rights of ownership, that the copyright for the images belongs to *copyright owner* and that the images might be sold to a third party'. The wording will vary depending on what rights you wish the model to assign to you.

Defamation

If you interview someone, it is wise to then get their permission to use the interview through an interview release form (not dissimilar to model release) specifying where you intend to use their words and in what context. Since truth is a defence to libel action, verifying your facts and the accuracy of people's statements is important. If you are writing or producing a work of fiction, include a disclaimer to this effect, similar to that seen at the start of films, that the work is fictional and similarities to living persons are coincidental. If your work has an autobiographical element, show it to anyone who might be offended and ask for them to sign a form to state that you have their consent and that they waive their right to legal action. If you cannot do this then change names, places and descriptions such that the person cannot be identified by those who know them.

For journalism or other types of work with a factual aspiration, the importance of documenting your research process, checking your facts and recording interviews (with permission) cannot be overstated. You should log the title of your source material, its author, the publisher, interview waivers and acknowledge the kindness of the person who has given you permission to use information.

I remind the reader of the disclaimer that appears at the start of this book; nothing is as good as professional legal advice that is specific to your situation.

Appendix 3
Useful websites

Anti-Copying in Design (advice on design rights) www.acid.uk.com
Authors' Licensing and Collecting Society www.alcs.co.uk
A catalogue of published works www.copac.ac.uk
Copyright Licensing Agency www.cla.co.uk
Design and Artists Copyright Society www.dacs.org.uk/
e-law resources http://www.e-lawresources.co.uk/
A site to assist in finding copyright owners http://tyler.hrc.utexas.edu/uk.cfm
Intellectual Property Office UK (government website) www.ipo.gov.uk/
Own-it Intellectual Property Advice for the Creative Sector www.own-it.org
Public domain material (US) http://copyright.cornell.edu/resources/
 publicdomain.cfm
US Copyright Office www.copyright.gov

Appendix 4
The Resale Rights Directive (2001/84/EC)

There is one further provision made under European law which remains relatively unknown among artists. It applies to original works of art that are in copyright (both the graphic and the plastic arts). The Resale Rights Directive was transposed into English law through the Resale Rights Regulations 2006 (SI 2006/346) and applies to works made by an artist, or copies considered to be original works under the artist's authority, and confers resale rights to the author of the work. This right lasts as long as copyright subsists and can therefore pass to the heirs of an artist (it cannot, however, be assigned). In the UK, the agency DACS undertook the administration of this scheme, and the Artists Collecting Society also now plays a role. The Regulations apply to resale of work by recognised market bodies (salesrooms, galleries, dealers) in the course of business (rather than to private sales or not-for-profit museums). If all the conditions set out in the regulations are triggered then a royalty becomes payable by the seller, their agent, or the buyer to the artist. Currently the law applies to sales exceeding 1,000 Euros (4 per cent of the sale) *if* the work is sold within three years of the artist themselves selling the work. The percentage payable to the artist decreases as the resale price increases, and the royalty may not currently exceed 12,500 Euros.

Glossary of terms

ab initio from the beginning.

account for profits profits made by wrong-doer (equitable remedy).

Act of Parliament written document outlining a specific law and passed by Parliament.

actio iniuriarum action seeking to protect dignity, reputation and/or physical integrity.

actus reus guilty act; the act required for a crime to be committed.

adjectival law the rules by which substantive law is administered, sometimes referred to as the 'rules of procedure'; the law that tells the judiciary how to behave.

affidavit sworn written evidence.

amicus curiae action by someone who is not a party to proceedings to assist the court – usually advice, opinion or information to indicate the broader implications of a case (literal translation: 'friend of the court').

appellant a party who appeals to a higher court concerning the decision of a lower court.

appellate jurisdiction a court that has the right to hear appeal cases from lower courts.

applicant the person who applies to the court (for example, for an injunction).

approve a senior court upholds the findings of a lower court, on appeal.

assignee the party to whom a right is transferred (for example, copyright).

authorial works literary, dramatic, musical, artistic and cinematographic creations.

balance of probabilities the standard of proof in civil cases shifting the conclusion away from the default assumption of innocence; 'more likely than not'.

Bailiwick the geographical jurisdictions of the Channel Islands' legal system.

beyond reasonable doubt the standard of proof required for criminal cases.

bill parliamentary bill; a piece of potential legislation which is undergoing its progress through the Houses of Parliament and which may become law/an Act of Parliament.

burden of proof the standard of evidence/belief required of either a claimant or a defendant (depending with whom the burden lies).

by-law a law applicable in a limited geographical jurisdiction (such as a county or London) which has been permitted by higher authority to regulate the matter in question.

Cabinet collective decision-making body of Her Majesty's Government (made up of the Prime Minister and over 20 Cabinet ministers).

canons of construction the method by which the courts interpret statute (also known as 'statutory interpretation').

(by way of) case stated if an appeal is brought before a more senior court, then counsel for whichever party is appealing prepares the argument for why the determination was at first instance incorrect and often no further evidence will be heard.

case law the law as specified by previous (binding) cases.

cause of action the facts, or circumstances, that give rise under the law for a claimant to bring a case to court.

circuit judges senior judges sitting in the High Court, Crown Court and County Court.

civil law in English law, a category of legal action between two individual parties where the likely outcome, if the claimant is successful, will be damages or remedy of some other type, and where the state is not involved in prosecuting an individual.

civil law system a system of law more common in European jurisdictions derived from Roman law where the key principle is the codification of principles, which are the primary source of the rules of that society.

civil procedure rules the rules dictating how courts function; these might include time limits for making a claim, how papers are served and so on (formerly referred to as County Court Rules and the Rules of the Supreme Court).

Civil Service the permanent offices of the administration of a state which serve the government of the day, the Crown and the electorate.

claimant the person or legal body who makes a claim to court.

clean hands an absence of unfair conduct in relation to the claim brought.

codification systematic arrangement of legal principles that regulate a specific legal jurisdiction.

common law legal principles that have been developed by judges rather than parliamentary statute.

compensation loss-based recovery (of monies).

Comptroller a controller; pronounced 'controller'.

Congress (US) legislative body made up of the House of Representatives and the Senate (both elected), meeting in Washington DC.

consideration something of value given by both parties that induces an agreement between them.

contempt an act of deliberate disobedience in relation to the rules of a court.

copyright the exclusive (assignable) right that the creator of artistic work has over that work.

counsel legal representative in court (often a barrister but sometimes a solicitor).

counterclaim term given to the action of a defendant when they 'sue back'.

court of first instance a court which hears cases at the start of legal action and which has no appellate jurisdiction.

Court of Justice of the European Union a referral court for matters of European law based in Luxembourg; it deals with matters of, for example, whether European law has been properly implemented in a European member state or if there is confusion in how a European law should be interpreted.

criminal law an area of law which is actioned by the state against an individual (R v *the party accused of a crime)*; with the possibility of imprisonment as an outcome, particularly for more serious crimes.

cross-examination legal counsel for 'the other side' puts questions to an individual in the witness box, often to undermine or disprove what they claim.

Crown the UK's state prosecution service.

crown dependency self-governing jurisdictions such as the Isle of Man, Jersey and Guernsey; not part of the UK or the European Union but the British government is responsible for their defence.

damages monies awarded to a successful claimant to compensate them for what has been lost as a result of the wrong done to them.

decision the outcome of a case as written by the judges (or other authority) involved.

defamation intentionally or recklessly false communication that damages the reputation of another, possibly inducing others not to associate with them.

defendant the person against whom action is brought and who is accused of wrong-doing (often referred to as the respondent in civil action).

delegate legislation laws made by a body which is authorised to formulate the rules controlling a specific matter by government.

deliver up surrender articles to another (for example, articles found by a court to have infringed copyright).

de scandalis magnatum 1275 statute regulating any talk about the King which might create discord between him and the people.

droit de suite a right granted to an artist to receive a fee when their work is resold (French: 'right to follow').

either-way offences offences of a type which can be tried *either* in the Magistrates' Courts or in the Crown Court (as specified by individual statutes).

ejusdem generis loose interpretation of classifications (Latin 'of the same kind').

enabling act Act of Parliament that permits another body to act on behalf of government, often through the authorised body creating delegate legislation (see also Parent Act).

entrepreneurial works film, sound-recordings, broadcast, published editions and typographical arrangements.

equity principle of application of justice in accordance with 'natural law' rather than the legal system (now limited in use though certain principles survive).

estoppel bar to action if a case, or facts, have already been established.

European Community a collection of European countries agreeing on principles of free movement of persons, goods, services and capital bound together by treaties and European legislation.

European Court of Human Rights based in Strasbourg, for use by parties who believe their human rights (as defined by the European Convention on Human Rights) have been infringed but for whom no national remedy is available, or who have exhausted the use of their national legal framework through taking the case to the most superior court in that jurisdiction.

European Union economic and political union of twenty-eight members states (also European Community).

ex post facto **law** a law that retroactively alters the legal consequences of a specific course of action committed before that law was passed

ex turpi causa non oritur actio from a dishonourable cause, an action cannot arise (you cannot, for example, claim copyright in a work created through criminal activity).

executive the Government; in the UK, made up of the Prime Minister, the Cabinet and the Civil Service.

express (permission) where permission is given in unambiguous and clear terms.

fair comment defence to defamation; statements made without ill-will or intention to harm.

false light (US) misleading information that causes a plaintiff distress or embarrassment.

felony serious crime (now more widely used in US law than in the UK).

fiduciary a legal duty between parties.

first ownership the party who first possesses the property in question (in copyright law, for example, the first owner is usually the author/creator).

frustration of contract an unforeseen event that undermines or prevents the completion of an agreement.

golden rule a principle that permits a court/judge to depart from the literal meaning of a statute to avoid an absurdity.

Great Britain England, Scotland, Wales, in combination.

gross negligence serious carelessness or indifference (to the possibility of causing harm to another).

Hansard official report of proceedings in the Houses of Parliament.

House of Commons elected body from which most legislation (acts/bills) are authored (made up of Members of Parliament).

House of Lords (Judiciary) now called the Supreme Court.

House of Lords (Legislature) the upper chamber of Parliament.

implied (consent) permission that is not expressly granted but which can be inferred from conduct or circumstances.

indictable offences offences that can only be tried by a Crown Court or above (such as murder or rape).

indictment formal accusation of a serious crime (not performed by magistrates).

injunction where a party is ordered to do, or refrain from doing, a particular act.

interim injunction an order passed that restrains the action of a party in certain respects, made by the court or a judge pending a full hearing.

interim order an order passed by a court or judge pending a full hearing.

interlocutory older term for 'interim' or intermediate act (such as an injunction prior to a full hearing).

intellectual property the non-tangible part of a creative work or invention.

invalid (contract) an agreement which is not valid under the law of contract.

judiciary in the UK, all the institutions making up the Royal Courts of Justice.

judicial review a process by which a judge reviews the lawfulness of a decision made or taken by another court or body.

Law Lords former terminology for judges sitting in what is now the Supreme Court.

LDMA literary, dramatic, musical and artistic (works).

legislature the House of Lords and the House of Commons.

letter before action formal correspondence alerting another party to the possibility of legal proceedings if they fail to comply with the request made within a specified period.

licensee party to whom a licence is granted.

license to use permission by the owner of a right granting another party the right to do things only the owner is granted under law.

Lord Chancellor senior official of UK government (formerly presided over the senior courts).

Lords of Appeal in ordinary former terminology for judges sitting in what is now the Supreme Court.

Mareva injunction now called a 'freezing injunction' – a means by which a defendant is prevented from obtaining access to funds held in their name.

member state a country that is a signatory to a particular agreement or treaty among states.

mens rea guilty mind; the state of mind required for a particular crime to be found to have been committed.

mischief rule a principle of statutory interpretation allowing the court/judge to determine which mischief the law in question set out to prevent rather than solely rely on the wording of an Act of Parliament.

misdemeanour a lesser criminal act (than, for example, a felony).

Mode of Trial hearing for 'either-way' offences, the defendant may argue which type of court is preferred for the full hearing (for example, Magistrates' Court or Crown Court).

money's worth goods or service considered to be of equal or greater value than a specified amount of money.

monopoly exclusive possession or control over a particularly property, right or service.

MP member of UK Parliament (elected to represent a particular geographical constituency).

negligent failure to take care; care that is below the standard reasonably required.

noscitur a sociis principle by which the meaning of an unclear word or phrase is determined by context ('known by the company kept').

novus actus interveniens a new intervening act (that caused damage, rather than the act of the defendant).

obiter dictum a hypothetical observation in a judgement, not binding for other cases; judicial pondering; ('sayings by the way').

objective test an assessment of factual unambiguous information.

offences triable either way crimes that can be heard by either the Magistrates' Court or Crown Court.

offences triable only by indictment crimes that can only be heard before Crown Court.

offeree the person to whom an offer is made.

offeror the person who makes an offer.

original jurisdiction courts that hear a case for the first time and that have no power to review the decision of other courts.

out-of-court settlement a settlement agreed between a claimant and a defendant without the need for a hearing in court.

overrule where a senior court disapproves the legal reasoning of a lower court on appeal, reversing or overturning the earlier court's decision; the appeal court is said to allow or dismiss an appeal (accept that the party who has made the appeal is either correct or incorrect respectively).

parent act another term for 'enabling act' by which a body is authorised to particularise delegate legislation through powers conferred on it by government.

parliamentary privilege legal immunity for a member of the legislature for certain acts done during the course of their duties such as defamation (also referred to as *absolute* privilege).

parliamentary sovereignty see parliamentary supremacy.

parliamentary supremacy the right of the elected government to make or unmake any law, regardless of what the previous elected parliament did; it also cannot bind future elected parliaments.

passing off make a false representation, such that a consumer may believe that the goods or services of the party making that representation are those of another of whose reputation they therefore take unfair advantage.

performance final execution of all the terms of a contract which releases both parties from the contract.

per incuriam 'lack of care'; sometimes used when a higher court refers to the decision of a lesser court or an earlier decision in law.

perpetuity for always.

personalty goods and moveable property owned by someone.

persuasive an influential principle that is not binding.

plaintiff in English law, this has now been replaced by the term 'claimant' and refers to the person who brings the claim. It is still used in US law.

pleadings the legal basis on which the claimant makes the case or by which the defendant resists it (now referred to as 'statement of case').

precedent a rule or principle that a court establishes which is binding on lower courts (often relating to how the statute in question should be applied).

prima facie a fact presumed to be true until it is disproved: at first appearance seems correct.

prior restraint the use of injunction to prevent an act before it happens, rather than wait until after the act to seek other legal remedy.

privilege a benefit advantage or immunity protecting a party from legal action.

public body government-financed administrative body performing a function for the benefit of the residents of a state.

public domain works for which intellectual property rights have expired and which can be used by others without fear of action for intellectual property infringement. Also used in privacy/breach of confidence cases to mean a set of facts that is already known by many.

public law the law regulating the relationship between an individual and the state.

punitive intended as a punishment rather than simply to put the claimant in the position that they would have been in had it not been for the wrong-doing.

quash reject, annul or set aside (for example, a conviction can be quashed).

quorum minimum number of members required to make a decision.

ratio decidendi the underlying principle for the decision made ('reason for deciding').

realty a form of property that is land or housing; real estate.

recorder a (usually) part-time judge with the powers of a circuit judge.

rent-seeking seeking wealth without creating it.

repudiate a refusal to perform the duties specified in a contract.

repudiatory breach of contract an act by one party which permits the other party to refuse to perform their obligations under a contract.

rescission the unmaking of a contract; an equitable remedy available at a court's discretion (not to be confused with repudiation).

respondent the party named in the legal action against whom the case is brought (see also 'defendant').

restitution gains-based recovery (of monies) (contrast with compensation).

right of action the privilege to bring a case to court .

specific performance an order of a court demanding the exact acts that were agreed under a contract.

stare decisis legal decisions of superior courts that bind lower courts and courts of equal status; if the facts are found to be dissimilar, then the court may be thought of as 'distinguishing' the case on the facts; this is a way for advocates to resolve the problems sometimes presented by *stare decisis* to their case.

statutory instrument a common form of delegated legislation under English law.

statutory interpretation process by which the courts understand and apply the law as specified in a statute.

statutory law the law as it is written in statute.

strict liability relating to a crime for which no intention is required on the part of the defendant.

subjective test an assessment performed by reasoned opinion.

subpoena (mainly a US term) a command (by the court) for someone to do something (such as give evidence or appear in court).

subsist remain in force or legally exist.

substantive law the body of rules giving legal bodies (and citizens) rights and duties.

summary conviction conviction by Magistrates' Court.

summary offences offences triable by the Magistrates' Court

Supreme Court the highest appeal court, formerly called the House of Lords in the UK; also the highest court in the US legal system.

tort a civil wrong-doing (rather than a crime); infringement of the right of another.

tortfeasor the party who commits a tort.

trademark a mark applied to goods (or services) distinguishing them from those of another trader (in US law, 'trade mark' or 'service mark').

transferee the party to whom something (a right or property) is transferred, conveyed or given.

tripartite (of politics) three-part system with bodies separated so that there is less opportunity of the concentration of power in the hands of one part of the state.

trust law system of law governing the rules if one party legally holds property for the benefit of another.

ultra vires ('beyond powers') that an authorised body has gone beyond the powers given to it; for example, if such a body enters into a contract which other authorities determine is of a type it may not enter, that contract is not lawful.

United Kingdom England, Scotland, Wales and Northern Ireland ('the United Kingdom of Great Britain and Northern Ireland').

void (contract) an agreement that is unenforceable.

voidable a contract that can be nullified.

volenti non fit injuria to a willing person, injury is not done.

Westminster the democratic parliamentary system of the UK; the geographical location of the Houses of Parliament (Commons and Lords) and Buckingham Palace.

without prejudice without detriment to an existing right to claim (refers to communications between parties that normally the courts will not see; usually used in attempts to settle a matter out-of-court).

writ the name formerly given to a legal claim form (the main method for instigating legal proceedings in civil actions).

Glossary of English courts

County Court hears civil cases with a judge or district judge; for example, landlord and tenant disputes, injuries caused by negligence, consumer law.

Court of Appeal hears two types of appeal: civil appeals in England and Wales that come from the High Court, the County Court and some cases from the Appeals Tribunals; and criminal appeals from the Crown Court or points of law from the Attorney General following an acquittal or lenient sentencing.

Crown Court hears more serious criminal offences (trial by judge and jury) by indictment, appeals from the Magistrates' Court, some sentencing referred from Magistrates' Court (the penalties of imprisonment and fines are more severe in the Crown Court than they are in the Magistrates' Court).

High Court deals with both civil claims and criminal appeals; sections of the High Court include the Family Division, the Queen's Bench Division (libel and slander, complex compensation claims, some appeals) and the Chancery Division (trusts, wills, company wind-ups, bankruptcies).

Magistrates' Court mainly hears criminal cases; some cases begin in the Magistrates' Court but automatically go to the Crown Court for trial by jury while some are heard in the Magistrates' Court itself. Magistrates also deal with some civil matters such as arrears of income tax, VAT or council tax and some cases of matrimonial dispute or the care of a child.

Small Claims Court claims for money owed of less than £10,000 (often against a business).

Supreme Court hears criminal and civil appeals from the Court of Appeal and some appeals from the High Court where there is a point of law in question or a matter of public importance to be determined.

List of statutes, statutory instruments, regulations, directives, conventions and agreements

Abortion Act 1967
Acts of Union 1707 and 1800
Administration of Justice Act 1960
Antisocial Behaviour Act 2003
Anti-Terrorism, Crime and Security Act 2001
Australia Copyright Amendment Act (Cth) 2006 Section 141A
Berne Convention 1886
Berne Convention Implementation Act 1988
Bill of Rights 1689
Case of Proclamations 1611
Children Act 1989
Children and Young Persons Act 1933
Children and Young Persons (Harmful Publications) Act 1955
Cinema Act 1985
Cinematograph Act 1909
Cinematography Act 1952
Civic Government (Scotland) Act 1982
Civil Procedure Act 1997
Civil Procedure Rules 1998
Communications Act 2003
Community Design Regulations 2002
Community Patent Convention 1975
Community Patent Co-operation Treaty 1970
Community Trademark Regulations 1996, 2006, 2009
Companies Act 1985
Consumer protection from Unfair Trading Regulations 2008
Contempt of Court Act 1981
Convention for the Protection of Human Rights and Fundamental
 Freedoms
Copyright Act 1911
Copyright Act 1956
Copyright (Customs) Regulations 1989
Copyright, Designs and Patents Act 1988

Fine Art Copyright Act 1862
Forgery and Counterfeiting Act 1981
Fox Libel Act 1792
Fraud Act 2006
Freedom of Information Act 2000
Highways Act 1980
Human Rights Act 1998
Information Society Directive 2000
International Covenant on Civil and Political Rights
Judicature Acts 1873–1875
Law Reform (Frustrated Contracts) Act 1943
Limitation Act 1980
Literary Copyright Act 1842
London County Council (General Powers) Act 1954
Madrid Agreement on the International Registration of Marks 1891
Madrid Protocol 1989
Magistrates' Courts Act 1980
Metropolitan Police Act 1839
Misrepresentation Act 1967
Nice Agreement for the International Classification of Goods and Services
 1957
Obscene Publications Act 1959
Obscene Publications Act 1964
Occupier's Liability Acts 1957, 1984
Official Secrets Act 1911
Official Secrets Act 1989
Parliament Act 1911
Paris Convention 1883
Patent Co-operation Treaty 1970
Patents Act 1977
Police Act 1964
Police Act 1996
Police Act 1997
Police and Criminal Evidence Act 1984
Post Office Act 1953
Postal Services Act 2000
Protection of Children Act 1977
Protection of Children Act 1978
Protection from Harassment Act 1997
Public Interest Disclosure Act 1998
Public Lending Right Act 1979
Public Lending Rights Schemes 1982, 1990 SI 1990/2360
Public Order Act 1936
Public Order Act 1986
Racial and Religious Hatred Act 2006

US 'Sonny Bono' Copyright Term Extension Act 1998
US Trademark Law Revision Act 1988
US Visual Artists Rights Act 1990
Vagrancy Act 1824
Video Recordings Act 1984
Video Recordings Act 2010
War Damages Act 1965
Wireless Telegraphy Act 1949
Youth Justice and Criminal Evidence Act 1999

Index of case law

Index

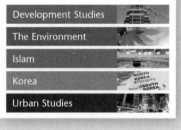